JACQUES PEPIN
Art of the Chicken

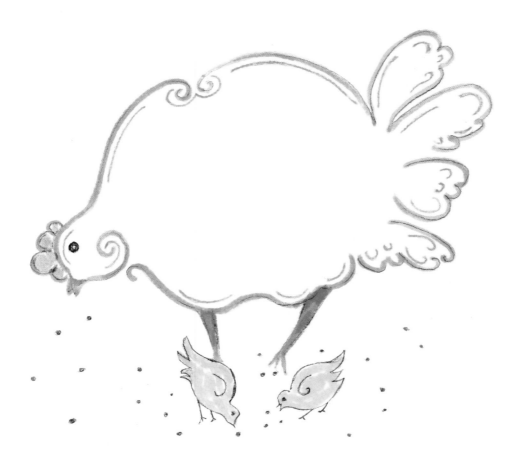

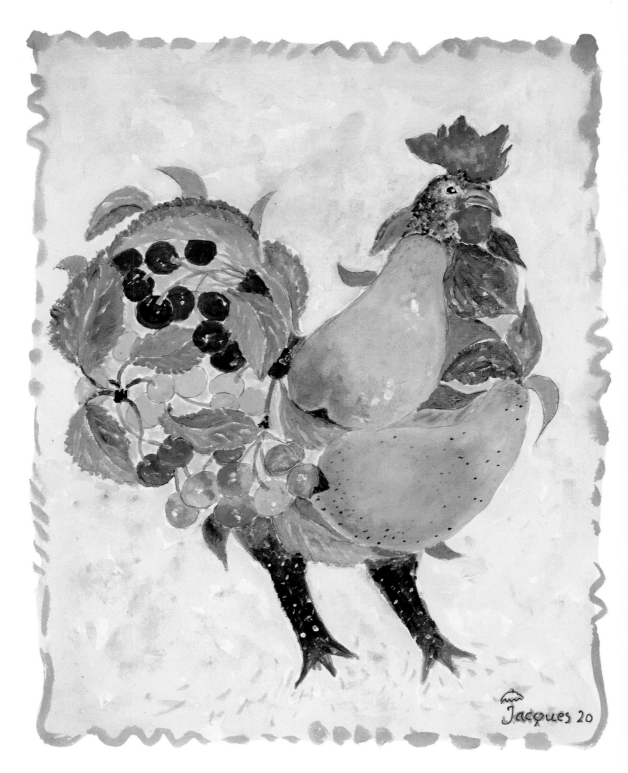

Cherry Pear Chicken, 2020

JACQUES PEPIN
Art of the Chicken

A Master Chef's Paintings,
Stories, and Recipes
of the Humble Bird

———

Jacques Pépin

HARVEST
An Imprint of WILLIAM MORROW

JACQUES PÉPIN ART OF THE CHICKEN. Copyright © 2022 by Jacques Pépin. All rights reserved. Printed in Italy. No part of this book may be used or reproduced in any manner whatsoever without written permission except in the case of brief quotations embodied in critical articles and reviews. For information, address HarperCollins Publishers, 195 Broadway, New York, NY 10007.

HarperCollins books may be purchased for educational, business, or sales promotional use. For information, please email the Special Markets Department at SPsales@harpercollins.com.

FIRST EDITION

Designed by Melissa Lotfy

Some illustrations were previously published in another format.

Library of Congress Cataloging-in-Publication Data has been applied for.

Library of Congress Control Number: 2022935618

ISBN 978-0-358-65451-3

22 23 24 25 26 RTL 10 9 8 7 6 5 4 3 2 1

To Gloria, with me, forever.

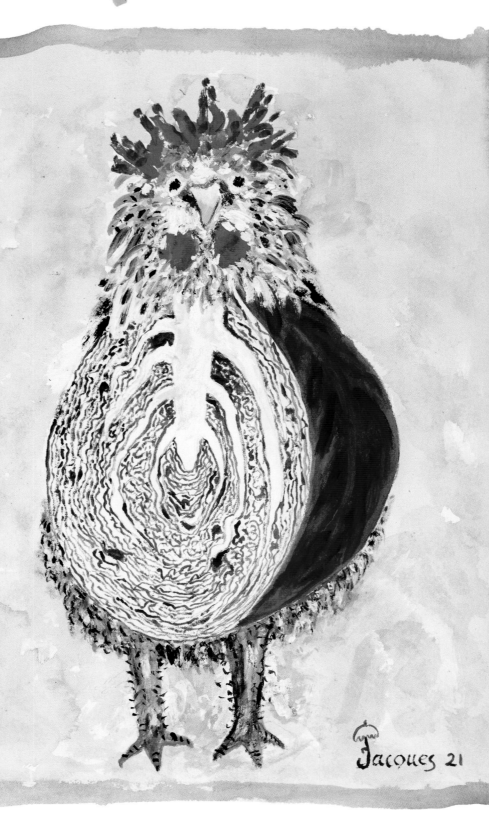

Contents

———

Paintings viii

A Life of Learning with a Friend by Tom Hopkins xi

Acknowledgments xvii

Introduction xix

Cocorico! (Cock-a-Doodle-Doo!) 1

Early Birds 11

Leaving Home 35

On My Own 51

The Capital of the World 61

Cooking for Presidents 71

New World, New Opportunities 81

A Return to the Classics 115

Beak-to-Pope's-Nose Eating 133

Cooking with Julia 161

Which Came First? 177

One Chicken, Every Occasion 213

Recipe Index 219

Index 222

Facing page: *The Red Cabbage Rooster,* 2021

Paintings

———

Cherry Pear Chicken, 2020	ii	*Cock on Yellow Background,* 2016	32
The Red Cabbage Rooster, 2021	vi	*Chicken and Leeks*, 2020	34
King of the Coop, 2018	x	*Chicken Cook*, 2021	38
Angry Chicken, 2017	xiv	*Chicken and Cabbage*, 2020	43
Proud Rooster, 2013	xviii	*Cock Too*, 2016	44
Three Chickens, 2016	xxii	*Ceremonial Rooster*, 2017	47
The Militant Chicken, 2018	xxvi	*Leaning Chicken*, 2013	48
The Cock, 2013	xxvii	*Reflecting Rooster*, 2019	50
Cocorico, 2016	xxviii	*Mr. Piper*, 2016	53
Cock and Snails, 2016	4	*Chicken and Eggplant*, 2020	54
Untroubled Chicken, 2019	9	*Chicken with Carrots*, 2020	57
The Blue Cockerel, 2020	10	*Chicken and Treviso*, 2020	58
The Irate Mother Hen, 2020	13	*Tufted Cockerel*, 2018	60
Chicken with Onion and Garlic, 2020	16	*Hen Plate*, 2000	63
Merry Rooster, 2019	20	*Shadow Cock*, 2017	66
Chicken Goddess, 2018	22	*The Tattle Cock*, 2017	67
Chicken and Herbs 2, 2020	24	*Black Mother Hen*, 2016	69
Chicken and Vegetables, 2021	28	*Royal Rooster*, 2017	70

La Grande Cocotte, 2017 73

Poulet de Foissiat, 2017 74

Les Poulets, 2014 78

Futuristic Rooster, 2019 80

Pineapple Chicken, 2020 82

Black Chicken, 2017 85

Cock on Board, 2013 87

Le Coq Gaulois, 2021 88

Claudine's Book, 2013 92

Three Chickens of Bresse, 2021 94

Lunatic Chicken, 2019 97

Wacky Chicken, 2019 98

Mighty Fowl, 2018 102

Rooster and Chick, 2018 105

Chicken and Vegetables 2, 2021 108

Stylized Rooster, 2017 110

Super Chicken, 2017 112

Chicken with Squash, 2020 113

The Classic Cock, 2017 114

Stylized Chickens, 2016 118

Startled Chanticleer, 2019 121

Sumptuous Rooster, 2018 123

Two Hens, 2016 126

Tender Chicken, 2019 130

Imperial Chicken, 2020 131

Chicken Heads, 2013 132

Fanciful Chicken, 2019 136

Stately Chicken, 2017 139

Red Chicken, 2016 141

Screaming Rooster, 2017 144

Hippie Cock, 2017 149, cover

Barnyard Brawl, 2016 152

Blue Cock, 2016 155

Frenzied Chicken, 2020 156

Polka-Dot Cock, 2017 158

Chicken and Herbs, 2019 160

Apples and Chicken, 2020 164

The Proud Cock, 2021 167

Grape Chicken, 2020 169

Chickens and Snail, 2016 172

Kitchen Chickens, 2017 175

Yellow Mother Hen, 2016 176

Chicken with Pear, 2020 180

Chicken with Artichoke, 2020 181

Blue Rooster, 2019 182

Black and Yellow Rooster, 2019 185

Dandy Cock, 2017 186

Dancing Rooster, 2019 191

Flower Chicken, 2018 193

Blue Chicken, 2016 194

Bresse Chicken, 2016 197

Poulet and Legumes, 2020 198

Eggs 1, 2020 201

Chicken and Vegetables 3, 2021 203

Chicken and Vegetables 4, 2021 204

Surprised Cock, 2017 207

Curious Chicken, 2017 209

The Rooster King, 2017 210

Imperial Rooster, 2019 211

The Harried Chicken, 2016 212

The French Chicken, 2016 215

The Refined Chicken, 2020 216

Chicken Heads 2, 2019 218

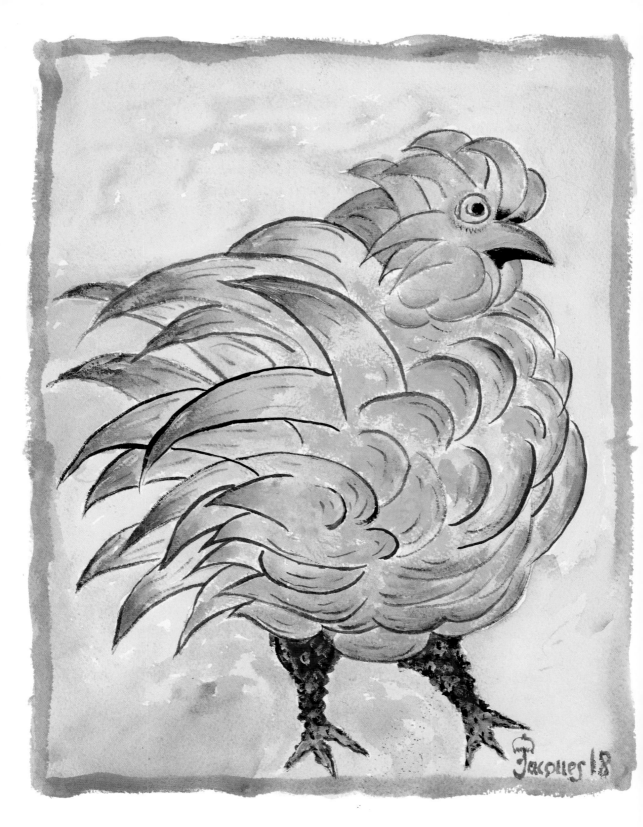

A Life of Learning
with a Friend

by Tom Hopkins

I MET JACQUES PÉPIN almost forty years ago. At that time, I had a commercial photography studio in my hometown of Madison, Connecticut, where Jacques and his family had moved. I had been working in product and lifestyle photography and photographing a large amount of artwork for color separators for lithographs and reproduction.

Jacques's publisher asked him for photographs for his new book, *Everyday Cooking with Jacques Pépin,* and his assistant called me to see if I was interested in the job. Jacques wanted someone close to his house so we could work more easily. My brother, Dan, a contractor who was working on Jacques's house, mentioned my name and the rest is history.

So, I set about shooting the photos for his book. Everything went well and Jacques asked me back for *The Art of Cooking,* which turned into a three-year project. Jacques believed the photographs should be close-ups of the recipe process and his hands so readers

Facing page: *The King of the Coop,* 2018

could learn technique from the photos. Most food photographs in those days were shot in a studio and had very little to do with the process of cooking, just finished pretty dishes. But Jacques has always been a teacher, and he felt the photos were as much a part of that process as were his recipes and notes. I found myself kneeling on his kitchen counter or straddling a ladder to get the right angle.

I learned a lot working with Jacques on that book and on many subsequent titles. I started shooting videos for many of Jacques's projects. Over the years I have shot probably ten thousand photographs and two hundred cooking videos. I learned what made a good food photograph, and I learned what made a good teaching photograph. And I learned a lot about food and especially about teaching people about cooking and food.

I also learned a great deal about friendship and loyalty. Soon after the second book, I began playing *pétanque* with Jacques and his friends (it's a French game akin to Italian bocce), and our families became good friends. We worked seamlessly together with few words spoken. We traveled extensively, sharing many meals and wine over lively conversation.

Jacques is well known for his talents in the kitchen—not just for cooking but for teaching as well. His other passion, which some people may not know, is painting. For five decades, he has been producing beautiful acrylics and oils of food, landscapes, still lifes, and abstracts. He has illustrated over forty-five years of menus from meals celebrated at his house. (Many of these are collected in his book *Menus*.) Years ago, I suggested we produce limited editions of some of these paintings to sell online and to use for fundraising. The Artistry of Jacques Pépin website (at JacquesPepinArt.com) has been met with overwhelming appreciation.

One of Jacques's favorite subjects to draw is chickens. All kinds of chickens. Colorful chickens, fantastical chickens, hens and their

chicks, chickens with vegetables. Perhaps it's because he hails from Bresse, a region that is famed for their plump, delicious chickens. Or perhaps it's because the chicken is such a universal staple in world cuisine. Or simply because he finds them amusing and their antics fascinating. If it clucks and scratches, it's likely Jacques has painted it!

Jacques's stories about chickens seem to mimic his paintings of them—quirky, eclectic, and mesmerizing in their character and substance. I have experienced the talent, love, and teaching in Jacques's cooking, as have so many of his followers. This book gives everyone the chance to appreciate Jacques's wonderful stories and the art of his chickens.

Tom Hopkins

TOM HOPKINS has been Jacques Pépin's friend and photographer for nearly forty years. He also curates, organizes, and photographs Jacques's artwork and is the managing member of JacquesPepinArt .com. Tom's photography work has taken him from sports and fashion to lifestyle and food, and he continues to travel the world in search of new subjects and challenges. Tom lives with his wife, Christine, and their dogs and horses in Connecticut.

Angry Chicken, 2017

Acknowledgments

———

I wouldn't have done any of my books or any of my paintings without my wife, Gloria, who supported me infallibly with her love and trust. I also thank my daughter, Claudine, for her love and support, and my son-in-law, Rollie, for his advice and help.

The making of a book is always a team project. I want to thank first Tom Hopkins for his hard work photographing all the chickens and for his friendship, trust, sensibility, and help with the project. I am indebted to Barry Estabrook for editing my writing and making it better without changing my words. I thank Kelsey Whitsett, my assistant, who made sense of my scribbling and helped me put the book together. Thank you to Doe Coover, my agent, whom I totally rely on; Sarah Kwak, my editor, for her confidence in the project; Melissa Lotfy for the splendid book design; and Rebecca Springer, Christina Stambaugh, Marina Padakis Lowry, and Jill Lazer. Thank you to all my friends for their support: Christine, Lisa, Eric, Jared, Marcel, Reza, Paula, Sandip, Sholeh, Priscilla, Charlie, and many more. I am grateful to you. Happy cooking!

Introduction

———

T HE TITLE TELLS you that this book is about art and chicken. What that really means is that this book is about my two passions: cooking and painting. The French anthropologist Claude Lévi-Strauss famously told us that "the process of cooking is the process by which nature is transformed into culture." This process involves the most basic human need: eating. The common, daily, most ordinary event of everyone's day is eating. Rich, poor, no matter your station in life, you must nourish yourself several times a day to survive. However, to elevate that daily celebration to a ritual where a family shares food around the table is to ennoble that basic need. To advance it through elegance, refinement, and beauty to a formal "meal" with several courses, wines complementing each dish, a decorated table, and elegantly dressed guests may just be the pinnacle of what civilization is. To cook for someone is the purest expression of love, and to share food with friends or strangers is a great equalizer. Around the table, social ranks fade. Rivals and opponents share the intimacy of the table, sometimes merging into friendly guests.

Painting is also a clear, pure expression of human enlightenment

Facing page: *Proud Rooster,* 2013

xix

and civilization. Cooking and painting complete me; both are the expression of who I am, and they connect in my life. But there are differences and similarities. Food is evanescent. You make a dish, you eat it, and it's gone. It is a short moment in time. What is left are food memories. Yet, these food memories are very powerful and will nourish you through the years. A painting is concrete, solid, and it remains forever as a testament to your creativity. It also continues to feed your soul and your spirit through time.

I haven't been painting as long as I have been cooking, yet it is over half a century ago that I picked up a brush instead of a knife and began finding creative fulfillment through another outlet. About fifty years ago, I began a tradition of writing down and saving the menus of the dinner parties we had at home. I illustrated my menus with whimsical depictions of animals, flowers, fruit, vegetables, vines, landscapes. Only after I had acquired a thick stack of these mementos did I realize that an unusually high percentage of my drawings depicted chickens, often in comical, mischievous poses. I reimagined the birds parading as leeks, cabbages, pineapples, artichokes—wherever my paintbrush led me. Time and time again I ended up painting chickens, and they have been a never-ending source of inspiration for me.

Looking over my feathered oeuvre, which soon extended beyond my menus to the easel that stands in my office (often supporting a chicken portrait in progress), I recall American folk artist Grandma Moses's observation: "If I didn't start painting, I would have raised chickens." Like her, I prefer painting chickens to raising them, although I have tended small flocks over the course of my life, a practice that ended when keeping them became impractical because of my travel schedule and the predations of the clever racoons that patrol the woods behind my home in Connecticut.

❧ ❧ ❧

My chicken paintings in this book express different moments in time, different moods, different emotions, a feeling, or an attitude. I usually start a new painting with an idea, which may have been prompted by looking at flowers or walking in the woods or seeing chickens. I never try to depict exactly what I see. I try to catch an emotion, a feeling. After working on the canvas for a while, the painting takes a life of its own and sometimes completely moves away from the original idea. I react by adding shapes, color, and lines in an impulsive, spontaneous way, just because it "feels good" or it "looks right," regardless of the accuracy of the subject matter. It is an exciting, pleasurable process that lets me express insight, emotion, and originality.

In the same manner, specific recipes express certain moments in time, certain occasions. Some recipes are fun and demand to be eaten with your fingers; some are elaborately garnished with detail; some follow the seasons; some are spur-of-the-moment or defined by an ingredient that I happened to have on hand. As a professional cook, I always start a new recipe with an idea of how to combine one ingredient with another. This idea may have been triggered by what I see in my garden or at the market, or what I ate at a restaurant or with a friend, or by reading about food. As I start cooking, adding one component and another, after a while the dish starts taking on a life of its own. At this point I react to it, tasting, adding, tasting again, increasing or decreasing the heat, correcting the seasoning with another addition until the dish transforms itself into its final form. Cooking for me is a very instinctive, intuitive, almost automatic reaction to what is happening in the pot in front of me.

Whether my chickens are defined by an expression, a demeanor, a color, or a shape, they all are meant to please and make you smile and be happy. I am aiming at contenting the palate with my recipes and the eyes with my paintings.

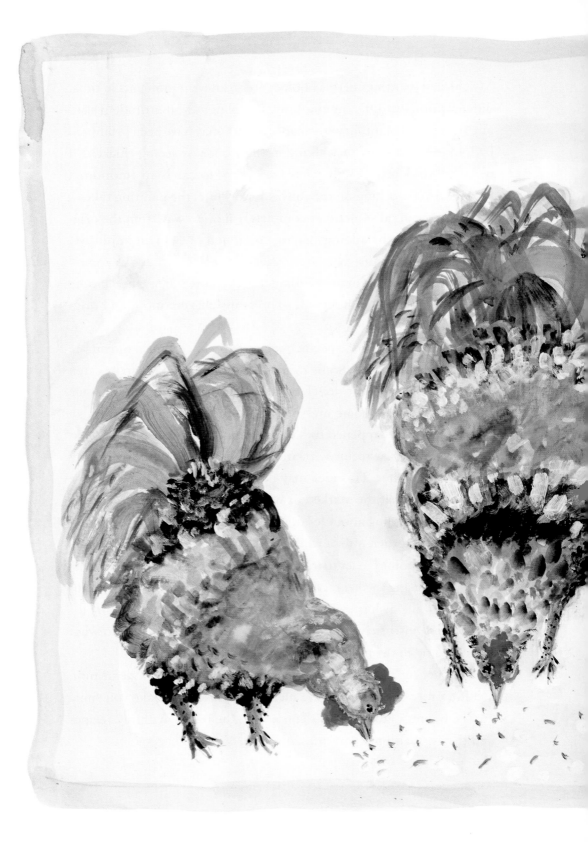

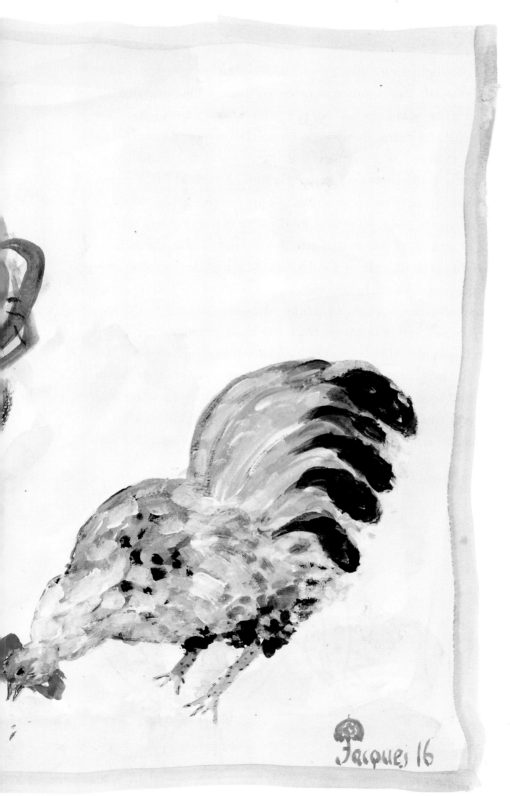

Three Chickens, 2016

Discovering new food helps you understand people, learn more about yourself, and appreciate other cultures. I have traveled the world over, enjoying chicken recipes from America to Russia, from Italy to Africa. During my voyages, I have always been amazed by the power of food to bring strangers together. I remember a small town in the former Yugoslavia where people looked at these "foreigners" with suspicion until we sat down at an outside table at the town café and ordered the local wine and food. After a few minutes, people smiled at us and we eventually shared wine and food in the spirit of conviviality. The miracle of food brought us together, and we were no longer perceived as threatening.

These recipes are meant to talk to your imagination, to the poet inside yourself. Ingredients go from the most mundane egg to the most refined and esoteric: chicken cockscomb, pig's bladder, or black truffle. Recipes are the perfect conduit to memory and imagination. Childhood food memories are powerful, visceral, and remain with us forever. This book aims to make you dream of succulent food, of happy memories, and of the generosity of sharing your table with

your family, friends, or any visitor who happens to stop by—and my chicken paintings to make you smile.

In that spirit, I talk through the recipes as I do when exchanging ideas on how to prepare various dishes with friends and fellow cooks. Rather than writing them out in a traditional, rigid format with titles, headnotes, ingredient lists, and detailed methods, I describe the preparations in a narrative fashion, relating stories as I would while chatting with a buddy, revealing the little secrets and nuances that make each dish special. It's a more poetic way of presenting a recipe and complements the tone of my paintings. Some of these descriptions are here as culinary history and stories. They aren't meant for you to reproduce. But many others are perfect for household kitchens. The narrative style will, I hope, encourage you to let your imagination fly and add your own touches to the dish. Cooking should be fun and relaxing, and to aid in this process, please cook with a glass of wine.

Happy cooking. Happy painting.

Next spread, left: *The Militant Chicken,* 2018; right: *The Cock,* 2013

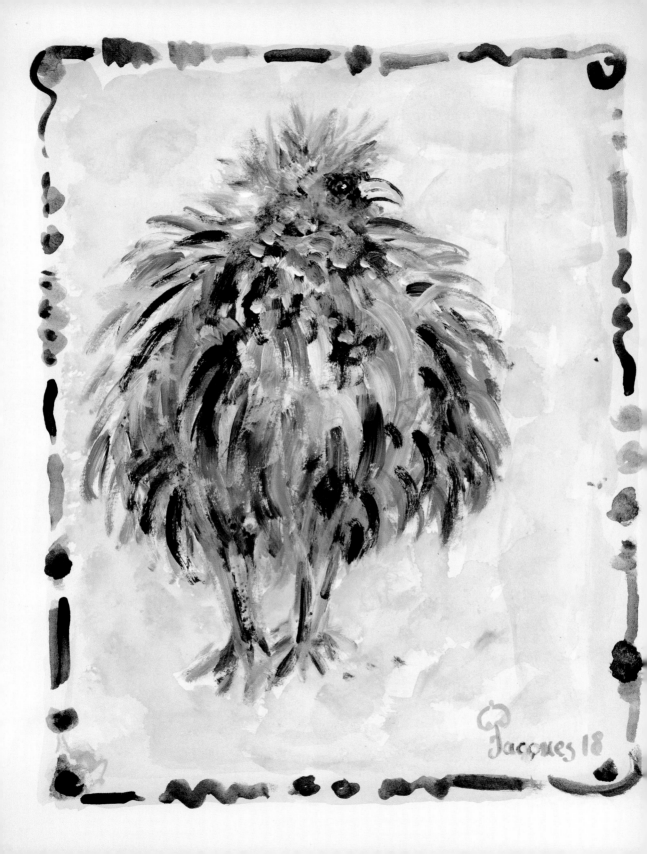

Jacques 18

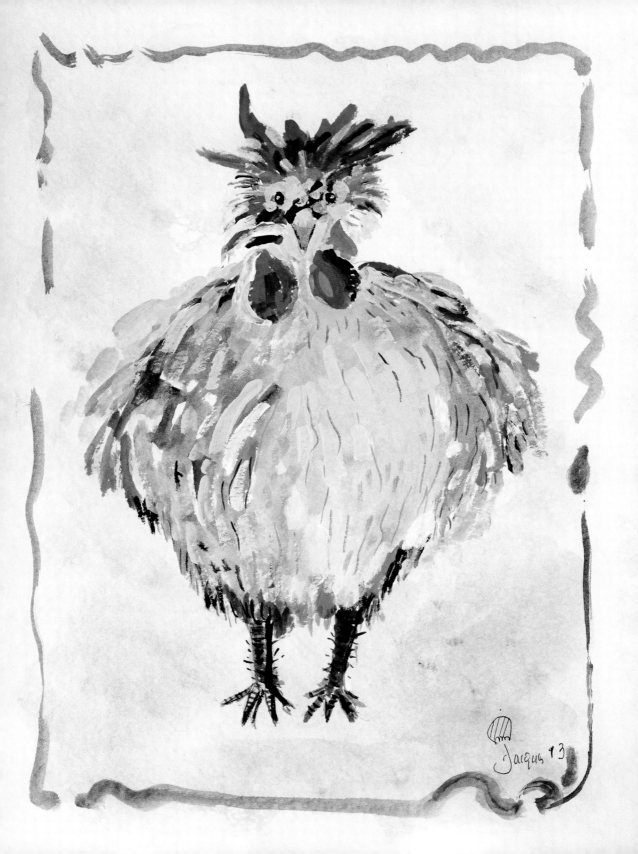

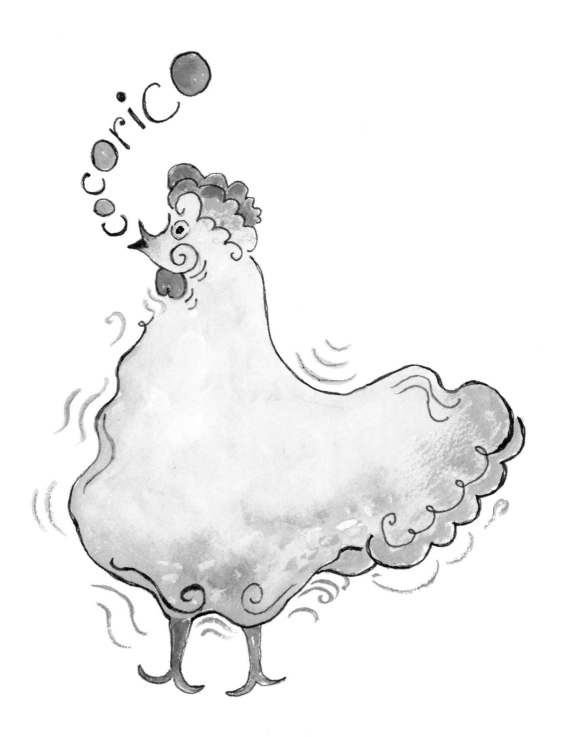

Cocorico, 2016

Cocorico!
(Cock-a-Doodle-Doo!)

———

P ROUST HAD HIS madeleine, I have chickens. As a chef, I stand
in awe of the humble bird's contributions to world cuisine. As
an artist, I marvel at the iridescent colors and varied beauty of
its plumage. And the little boy that's still in me never tires of watch-
ing chickens' social interactions and antics whether they are peck-
ing and scratching around American farmyards or on the edges of
streets in developing countries.

Whether I find myself in France, China, Italy, Spain, Africa, Mex-
ico, Greece, Canada, or here in the United States, a rooster's crowing
at sunrise is a universal language that proclaims the triumph of light
over darkness, of good over evil. "Cock-a-doodle-doo"—or "*Coco-
rico*," as French roosters say—registers as something peaceful and
comforting, like the church bells that ring in the mornings in France.
I am waking up to a friendly world.

When I think about the role chickens have played in my life, I am
reminded of Proust's musings about the affective memory, also called
the memory of the senses. Chickens satisfy and heighten all of my

senses: smelling a chicken roasting in the oven, tasting its browned skin, hearing the *cocorico,* seeing the vibrant colors of roosters, and feeling their soft plumage.

Armchair psychiatrists might claim that my upbringing pre-disposed me to be preoccupied with chickens. One of the earliest photographs of me features a plump bare-bellied, barefooted eight-month-old baby wearing a mildly quizzical expression. The photographer, a wise man, made sure that I remained still and happy long enough for him to snap the camera's shutter by letting me hold a toy chicken. So maybe my obsession is cultural and ancestral.

For any French person, the Gallic rooster occupies an emotional space as profound as the bald eagle holds in American hearts. *Le coq Gaulois,* or Gallic rooster, was a religious totem in ancient Gaul. It was a symbol of French courage against the Prussian eagle in World War I and also a symbol of the French resistance during World War II, of which my father was a member. Today, the rooster is an emblem that adorns official buildings, coins, and weathervanes, including the one atop my current home's garage.

The chicken is also prevalent in everyday language and has many different meanings in French. *Cocotte* is a very endearing word for a little chicken, and an adult might call a little girl a *cocotte.* Furthermore, a loving husband will call his wife a *cocotte* or *ma poule,* or my hen. Conversely, a loving wife calls a husband *mon poulet,* or my chicken. A *cocotte* is also a very useful piece of kitchen equipment. It is the beautiful enameled cast-iron pot to make the most succulent stew or braised meat, the most well-known being the iconic Le Creuset pot. In the kitchen lexicon, a *cocotte* is a small earthenware container used to cook eggs, as egg *cocotte,* or to serve garnishes or vegetables. In addition, *cocotte minute* in French is the name for a pressure cooker. A *pomme cocotte* is a potato shaped as an oval or football and sautéed in butter.

I've always found chickens to be gentle, convivial, and docile. As a boy visiting farms, I might be frightened by a barking dog, a huge draft horse, a sharp-horned cow, a muddy, squealing pig, or a honking, flapping goose, but never a chicken.

At the very least, my fascination with chickens has strong geographical roots. I was born and grew up in Bresse, a region about thirty-five miles northeast of Lyon. In France, Bresse is as synonymous with the luscious chickens raised there as Bordeaux is with fine wine. Eighteenth-century epicure Jean Anthelme Brillat-Savarin accurately described the Bresse chicken as "the queen of poultry, the poultry of kings."

Like Bordeaux's vintages, the chickens of Bresse are honored with an *appellation d'origine contrôlée,* which legally guarantees that a bird bearing the label is the specific Bresse de Bény breed, raised in the region, and allowed to forage on pasture for most of its life. Typically, only a few dozen Bresse birds occupy each henhouse. The houses are mounted on wheels so the farmer can move them to a fresh location once their inhabitants have thoroughly scratched and pecked the vegetation in one area. During warm months, farmers reduce the quantity of grain rations to encourage the birds to devour flies and beetles drawn by the manure left by cattle that traditionally precede the poultry flocks in the fields.

By definition, such practices rule out industrial-scale agriculture, where thousands of fast-growing birds are raised in vast, warehouse-like structures and never see the sun or feel the wind. Humane, natural husbandry that allows food-producing animals to express all of their instincts limits their supply. And because of their reputation, upscale restaurants throughout France seek out Bresse chickens, driving the prices several times higher than those of regular chickens.

Real Bresse chickens only occasionally made an appearance on

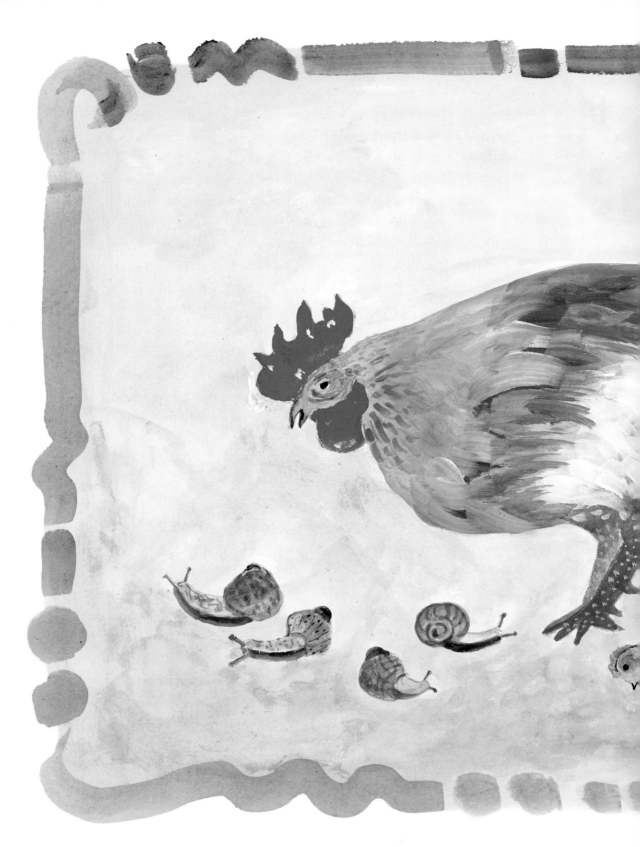

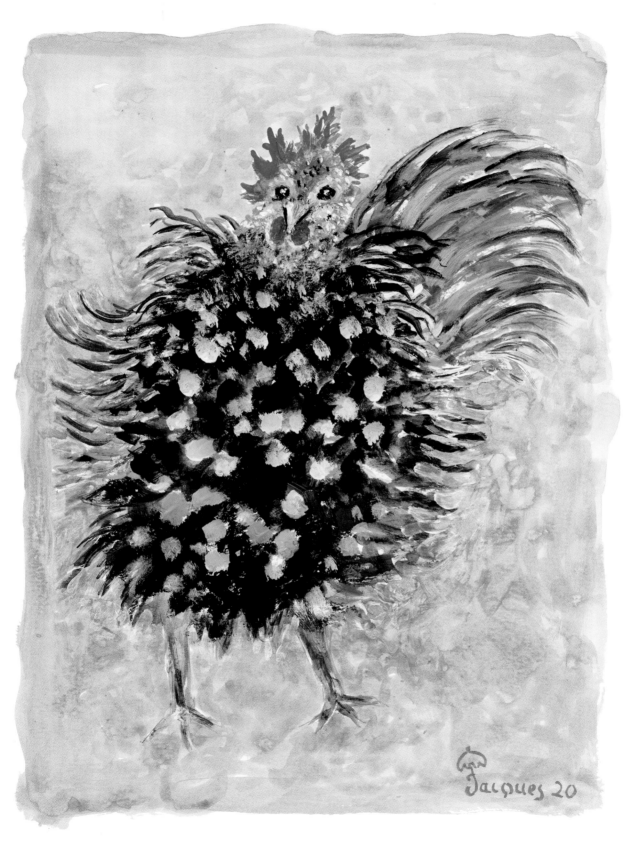

cavity with rosemary, salt, and pepper. He rubbed the exterior of the skin with oil, thyme, salt, and pepper and sealed the entire thing tightly in foil before encasing it in nontoxic sculptors' clay—not the plasticine kind, which melts—and put it in a hot oven for an hour and a half. The result was tender, juicy, and full-flavored, especially when accompanied by his sauce of Marsala and fresh parsley.

Ever the artist, Ed liked to mold the clay to look like a rooster before baking. He would then present the cooked chicken to his three children, who would paint feathers, a comb, and other features in a whimsical way before presenting the dish at the table, accompanied by a hammer that he used to smash it open in front of guests.

Whole Chicken Baked in Bread Dough

❧

Ed inspired me to create a recipe for a whole chicken encased in bread dough and baked. First, I completely bone out a whole chicken as if I were going to make a galantine. I lay the boned bird flat and stuff it with blanched spinach, sautéed mushrooms, and grated Swiss and mozzarella cheese. I reassemble the chicken in its original shape, truss it with kitchen twine, and sear it in a hot skillet until it's nicely browned all around. After it cools a bit, I carefully remove the twine and wrap the entire thing in bread dough, being sure to orient the seam underneath. I let it proof at room temperature for 30 minutes, then bake it in a 425°F oven for 1 to 1½ hours, until beautifully browned on top and cooked to 165°F inside. It should rest for 15 minutes before carving.

Soon after the war ended, the Pépin family decamped from Bourg to the small town of Neyron near Lyon, where my parents took over a

restaurant with the misleading name L'Hôtel l'Amour. There wasn't much to love about the decrepit, long-out-of-business eatery. But it was all we could afford—probably more than we could afford. The dining room and kitchen got a thorough cleaning. Maman applied her natural gifts as a cook to prepare tasty but simple and inexpensive fare. She immediately began to draw customers from around the neighborhood, and soon the once-moribund place flourished. Meanwhile, Papa, a cabinetmaker by trade, directed his attention to fixing up the rooms, doors, and windows and repainting the restaurant. He then went on to refurbish the cellar, painting it white and stocking it with barrels of young wine he acquired on tasting trips to nearby vineyards.

Out back, a dozen or so chickens occupied a hutch in the deep shade of a massive linden tree. The flock had the run of our property. Although Maman quickly shooed them away when they dared to venture anywhere near the front door of her pristine dining room, Papa maintained laxer standards, and one or two would occasionally wander undisturbed through his cellar.

No morsel of food was ever wasted in our household. We fed the chickens any leftovers too far gone to be repurposed for restaurant customers, and even then, Papa regretted that food once intended for humans had to suffer that fate. I recall him mournfully kissing crusts of moldy bread before tossing them to the flock. We supplemented kitchen scraps with armfuls of clover my brothers and I harvested from surrounding fields. Our little flock also gulped down whatever bugs and worms crept into the yard. In return, the hens kept L'Hôtel l'Amour supplied with a good portion of the eggs that Maman used in the kitchen, a sizeable contribution to the restaurant's razor-thin profit margin.

My constant sidekick in those days was a little black mutt named Bibiche, who weighed perhaps fifteen pounds. Like all diminutive dogs, Bibiche had no idea that he was small, and he loved to harm-

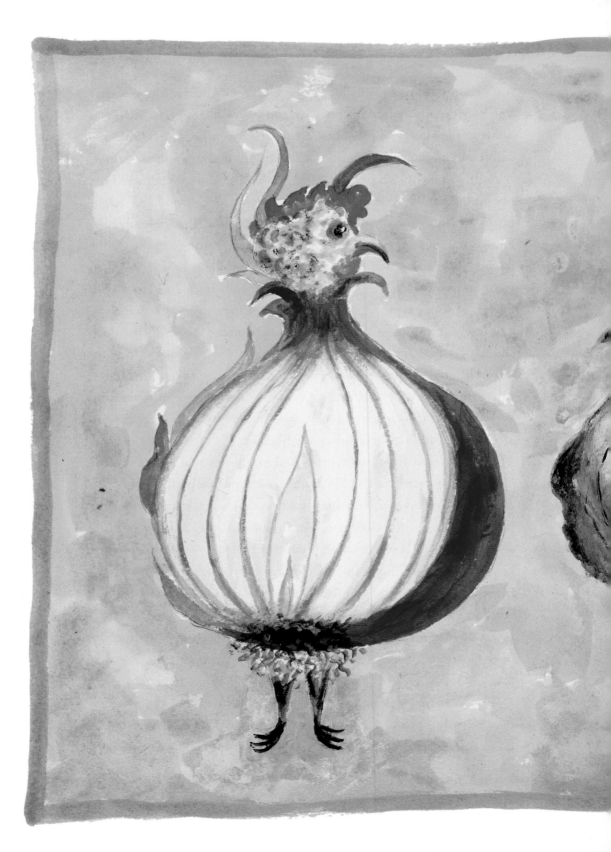

Cock and Snails, 2016

the menu in my childhood home because of the expense, but I became familiar with them from my apprenticeship and thereafter. Most of the fancy restaurants I worked in over the years would feature Bresse chickens, killed at about five months. The flesh is firm but moist, and the skin is very thin and delicate.

In addition to being delicious, the chickens of my home region are beautiful creatures, large with striking blue legs, brilliant white feathers, and bright red combs: *bleu, blanc, rouge*—the colors of the French flag.

I do recall roasting one in New York not long after my arrival in 1959, to introduce the chicken of my hometown to some new friends. It was a big bird with a pronounced V-shaped breastbone that rose like a ship's keel. The fragrance that emanated from my 425°F oven was intoxicating, and the taste was more chicken-y than that of the bird's American cousins. It was tougher, but in a good way (you had to chew and pull a bit to get the meat off the bones), yet juicier than this country's fowl.

After more than seventy years behind the stove, I could probably compile a thousand recipes using chicken and never grow bored with the results. André Simon, in his *Concise Encyclopedia of Gastronomy,* writes, "Like bread, potatoes, and rice, chicken can be eaten constantly."

Perhaps that's why the sixteenth-century King Henry IV, who cared greatly about his subjects' welfare, issued an edict that every French schoolchild memorizes: "I want no peasant in my realm so poor that he will not have a chicken in his pot every Sunday." A few centuries later, American president Herbert Hoover "borrowed" the good king's sentiment as a campaign pledge (it is worth noting that he did not promise a bald eagle in every pot).

Not the least of the gifts of chickens to humans is that they provide us with eggs, one of the most healthy and versatile ingredients

in the kitchen. I cherish eggs. If you asked me to choose a single ingredient that I could not do without, it would likely be the egg. I eat them scrambled, hard-cooked, *en cocotte* (in ramekins), and in omelets, and I adore soufflés and egg-rich gratins. In the words of Elizabeth David from her book *French Provincial Cooking,* "Egg dishes have a kind of elegance, a freshness, an allure, which sets them quite apart from any other kind of food, so that it becomes a great pleasure to be able to cook them properly and to serve them in just the right condition."

High-quality eggs from hens fed on a good diet and allowed to flap, run, and scratch freely are well worth the premium prices they command. I freely confess that I'm normally something of a miser in the kitchen. My tightfistedness comes both from being a child of the war years and from growing up in a restaurant run by my mother,

Cocorico! (Cock-a-Doodle-Doo!)

7

who was able to make great dishes with scant, meager ingredients. Organic produce is wonderful, but I'll buy conventional if it's fresh and just half or one-third the price. In the same way, except for special occasions, I tend to prefer wines that are young and priced less than twenty dollars a bottle over an expensive *grand cru*. That being said, if at all possible, do not economize when buying eggs. Buy organic eggs of the best possible quality you can afford. Later in this book, I will introduce you to my favorites of the great egg dishes, from the classic French repertoire to those I cook at home today.

Whether I cook with their eggs or their meat (or paint pictures of them), I want my chickens to be free to roam in search of food they are naturally meant to eat. They lay exquisite eggs, with deep yellow-orange yolks high in lecithin, a healthy fat that is perfect for making a custard cream or a mayonnaise. The white albumen is high in protein, ideal for glossy meringues and glorious soufflés. With happy chickens, everyone wins: the birds, the farmer, and the cook.

Facing page: *Untroubled Chicken,* 2019

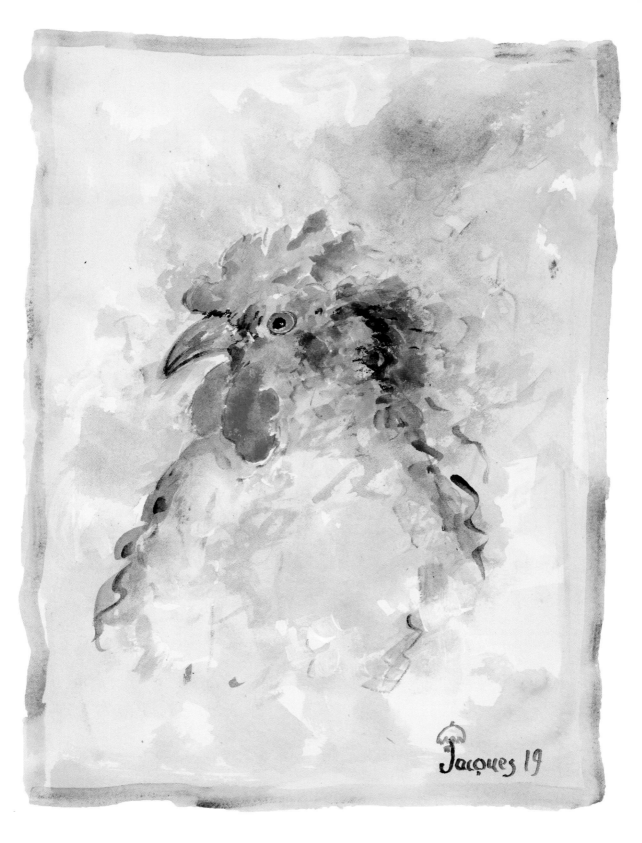

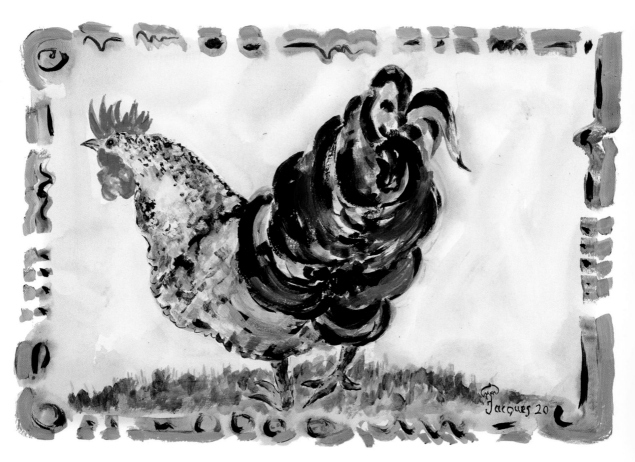

The Blue Cockerel, 2020

Early Birds

———

I WAS ABOUT SEVEN years old the first time I actively took part in cooking a chicken without adult supervision. It was wartime, and during the summer months after school let out, my pals, my two brothers, and I led lives worthy of Gallic Huckleberry Finns. As soon as we had gulped down breakfast, we dashed off to explore the countryside of lower Burgundy, around Bourg-en-Bresse, the city where my family lived. Today, it would probably result in our parents getting reported to a government child welfare agency, but we were allowed to be completely on our own—free-range boys—to explore the rolling hills, numerous ponds, and small rivers surrounding the town.

On that day, a chicken had escaped its coop to wander in a field bisected by a stream that flowed through what we considered to be *our* territory. The bird, no doubt the property of the farmer who actually owned the land, had made an unfortunate error. In those lean years, active little boys were always hungry, especially for animal proteins, which were rare, expensive treats.

Capturing a loose hen requires quick reflexes, finesse, and basic knowledge of how frightened chickens react. The older guys in our pack had perfected the technique. They surrounded the animal in a

semicircle and drove it slowly toward a thick, nearly impenetrable hedgerow. At the last second, the fastest boy lunged forward. The hen squawked, took a few running steps, furiously flapping its wings and getting a couple of feet off the ground. To no avail. One boy executed a flying tackle, wrapping his hands around the quarry, whose escape had been slowed by the hedge.

Back beside the river, we gathered a pile of dry branches and driftwood and lit a fire. An older friend, who dispatched the bird expertly by holding it by the head and snapping its neck with a vigorous flick of his wrist, instructed us to gather fistfuls of wet clay from the banks. He completely encased the chicken in clay without bothering with such niceties as plucking and eviscerating. The result did not look in the least appealing. It resembled an oblong blob of mud about the size of a football. He placed it directly on the coals, where it remained for a few hours while we splashed in the cool river and hunted frogs along the banks.

Later in the afternoon, we retrieved the hardened block of clay from the embers of the dying fire and smashed it open with stones. The feathers and skin stayed glued to the clay, leaving behind the meat for us to enjoy. It might not have been a triumph of haute cuisine, but we enjoyed the results immensely and were very proud of ourselves.

Our instincts weren't so off. I later heard about hungry chicken snatchers who would pilfer birds from farmers and bake them over a fire, feathers and all, encased in clay. Decades later, my dear friend, the renowned American artist and respected cookbook author Edward Giobbi, included an elegant recipe for chicken cooked in clay in his 1971 cookbook, *Italian Family Cooking*.

Ed slipped slivers of garlic under the breast skin of the chicken (unlike our bird, mercifully plucked and gutted) and seasoned the

Facing page: *The Irate Mother Hen,* 2020

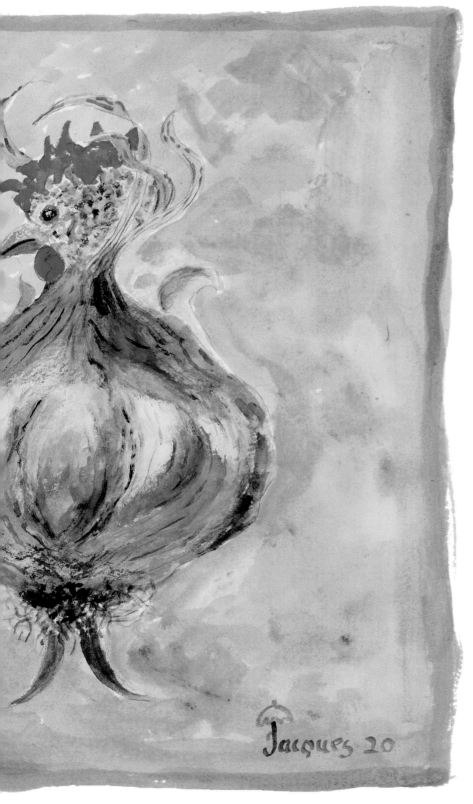

Chicken with Onion and Garlic, 2020

lessly terrorize the chickens, running after them with his tail in the air, barking savagely. The little guy was truly proud of himself.

One day I saw him approach a hen that refused to play by the rules. Instead of fleeing, she stayed on her nest. The fuzzy head of a day-old chick poked out from under one of her wings. Bibiche raced toward her, yapping and growling. The hen responded with a headlong charge, beak open, claws scratching, a demon of flying feathers and furious squawks. Bibiche's tail fell from up in the air to between his legs. He ran away terrified. I did the same. It was the last time either of us messed with a broody hen.

I killed my first chicken in that backyard in Neyron. It wasn't pretty. I held the bird down on a stump, and my brother severed its head with a kitchen knife. It began struggling. I panicked and released it. We've all heard the cliché about running around like a chicken with its head cut off. Well, they do. It raced around the yard, wings flapping, blood spurting from the stub of its neck. I was traumatized. I didn't learn how to properly slaughter a chicken until several years later. This is done by severing the jugular vein at the neck with a quick stroke of the knife and holding the chicken head down over a bowl to retrieve the blood, which was used in many dishes.

Maman's Chicken, Three Ways

Postwar shortages combined with the value of eggs meant that we rarely dined on our chickens. Unlike today, chicken was luxury fare. But once they became too old to lay, our hens were destined for Maman's stewpot and transformed into *poule au pot*, a simple preparation that involved covering the bird with water, adding a couple of leeks, carrots, and onions, along with thyme and bay leaves,

and allowing it to simmer on the back of the stove for a couple of hours. Maman separated the meat from the bones and used it to make *riz au gras,* rice cooked with chicken fat and some stock. The extra stock from the cooking of the chicken would be turned into a soup served as a meal with leftover bread and grated Gruyère cheese.

For restaurant guests, she roasted younger, more tender birds purchased from neighboring farmers, cutting the chickens into pieces and cooking them with potatoes, carrots, turnips, *lardons* made from pancetta, and white wine. We enjoyed this great dish only when there were leftovers that Maman's paying customers had not finished.

Maman reserved her chicken with cream sauce (*poulet à la crème*), a truly special dish, for festive occasions. Eating it still brings me visceral memories of joyous family holidays. She cut the chicken into parts and sautéed them gently on all sides in butter until they were barely browned, at which point she sprinkled on a tiny dusting of flour, then tossed in thyme, a bay leaf, and a chopped onion. After deglazing the pan with a good splash of white wine and adding some chicken stock, Maman covered the pan and let the contents cook for 35 to 40 minutes. The dish was finished with *crème épaisse*, a rich country cream.

When she wanted to add a little flourish as she served *poulet à la crème,* she would beat an egg yolk with a little cream and pour the mixture into the chicken sauce at the table. Adding cold egg yolks to hot sauce represented no small amount of risk that the mixture would immediately curdle and ruin the meal in front of a hungry audience. But mother's trick of stirring in a little cream meant that it never did. Instead, the yolk and cream mixture thickened the sauce and lent it a glossy finish. Simple yet elegant, chicken in cream sauce served with panache was one of the glories of her cooking.

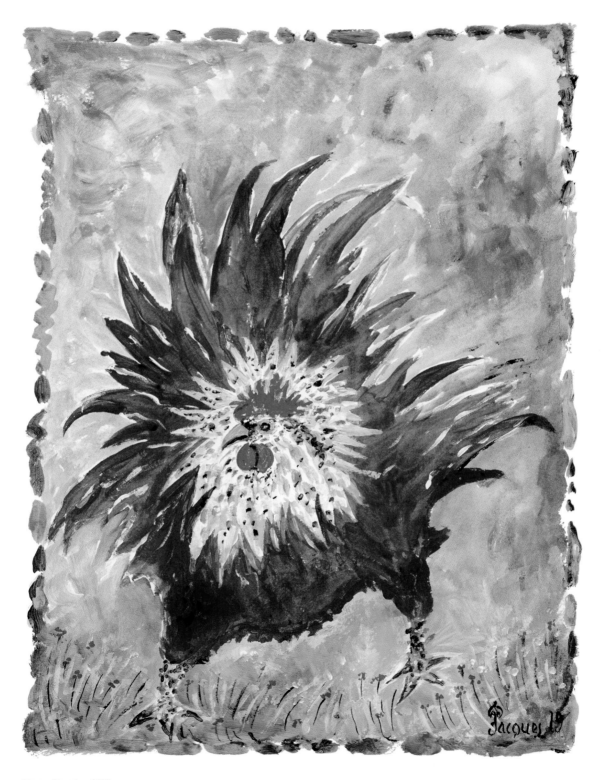

Merry Rooster, 2019

Operating restaurants that served basic but delicious country meals ran in my family. Several formidable women in addition to Maman cooked professionally. My aunt Hélène owned a small restaurant on the shores of the Lake of Nantua, just across the French border from Geneva, Switzerland. She was renowned for a chicken dish made with false morel mushrooms, or *Gyromitra*, also called brain mushrooms.

Today, experts consider *Gyromitra* poisonous and potentially fatal. Avoid them! But the fungus's toxic effects are experienced differently by different people. Many are not bothered at all. A person can eat them with impunity on one occasion and yet be poisoned on another. Proper drying and cooking can eliminate and neutralize the toxins, but it's a hard process to guarantee. In those days, many people consumed *Gyromitra*, and they were commonly sold dried at markets in that part of France, but they have disappeared even there in recent decades. Today I would never suggest eating false morels, and I would never serve them to guests.

Tante Hélène soaked the *Gyromitra* to rehydrate them and added the mushrooms and soaking liquid to a pan of lightly sautéed chicken parts, along with a little garlic and thyme, a bay leaf, and a dash of white wine. The chicken cooked in the pan until it became tender. She thickened the sauce with *beurre manié* (a paste of flour and butter) and finished the dish with heavy cream. We all enjoyed it, and none of us got sick.

Made with true morels—either fresh or rehydrated dried—the dish lacks some of the intense flavor imparted by *Gyromitra* but is perfectly safe and remains delicious.

❧ ❧ ❧

I thought about Tante Hélène's chicken one April weekend in the early 2000s while visiting my daughter, Claudine, her husband,

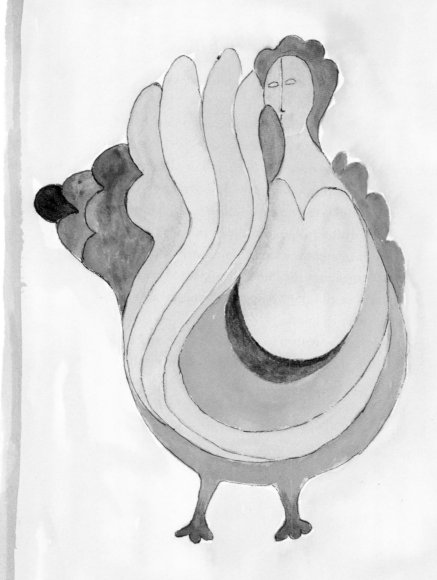

Jacques 18

Rollie (a chef, of course), and my then-infant granddaughter, Shorey. At the time, they lived in Portland, Oregon. I had been taping a television series in San Francisco with my best friend, Jean-Claude Szurdak, and we arranged to pay a visit to the new parents and my grandchild.

Spring is prime foraging season in the Pacific Northwest, and I have enjoyed gathering wild mushrooms as a hobby since boyhood. As a treat for me, Claudine had arranged for a friend of hers named Lars, a semiprofessional forager for several restaurants, to take us on a mushroom hunt. For hours, we huffed and puffed up and down a recently clear-cut mountainside, and all we had to show for our exertions was a couple of handfuls of true morels. But we encountered *Gyromitra* everywhere—the mushroom of my youth!

Lars looked at me skeptically and grimaced when I described Tante Hélène's chicken and other tasty delights involving false morels. He remained unimpressed, to say the least, allowing that he had a few Canadian customers who bought them occasionally, but that locals did not go for them. So, Jean-Claude and I decided we were done with the *Gyromitra* and instead would make Tante Hélène's chicken with morels or even regular mushrooms, easily available at the supermarket.

Facing page: *Chicken Goddess,* 2018

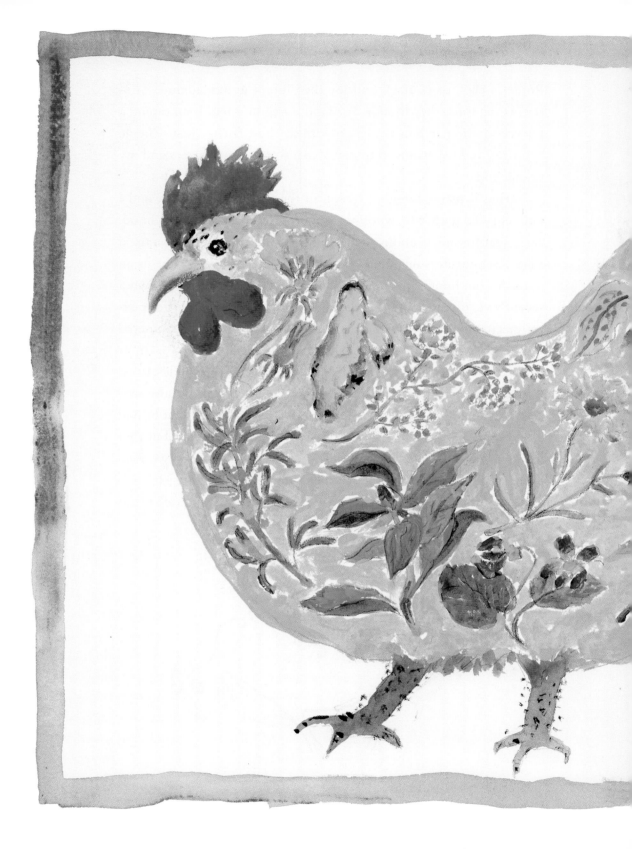

Chicken and Herbs 2, 2020

Cousin Merret's Chicken Liver "Cake"

✦

Cousin Merret, yet another exceptional cook, owned Le Petit Café, a restaurant/café/bar in a borderline seedy neighborhood in the heart of Lyon. Merret's roast chicken was legendary, but I absolutely loved her *gâteau de foies de volaille,* a chicken liver custard that I still make. She selected about a half dozen beautiful chicken livers called *les blonds*—literally blond livers—which were fatter than darker livers and considered much better tasting. To make her "cake," she used a paring knife to clean the livers, carefully removing the sinews and the small, oval gallbladder, a bag full of a deep green, extraordinarily bitter liquid that renders anything it touches inedible.

She chopped the cleaned livers by hand into a purée with some garlic and parsley mixed with eggs and heavy cream, salt, and freshly cracked pepper. Today, she would have made an easier, faster job of it with a spin or two in a food processor, but that appliance's invention lay decades in the future. She poured the mixture into a dinner-plate-sized soufflé mold, as you would a custard, and cooked it gently in a double boiler until it had set.

She then ringed the *gâteau* with a sauce of cooked tomatoes that she put through a food mill, to which she added fresh skinned diced tomatoes that she had stewed in butter. Lastly, Merret tossed in green olives, sautéed chanterelle mushrooms, and fresh herbs.

To make the dish even tastier, she served it accompanied by pike quenelles, a specialty of the Lyon area. Back then, fishmongers offered only local, freshwater species, and we relished them. Her quenelles were very light dumplings that resembled glorified gefilte fish. She made them with a purée of pike combined with choux paste, the fat from veal kidneys, and seasonings. She shaped the mix-

ture into ovals a little smaller than an egg and poached them in boiling water. They expanded like cream puffs, and she served them immediately beside her chicken liver *gâteau*. Quenelles like these are now sold in charcuteries in Bourg and Lyon. Most home cooks and even many professionals opt to buy them rather than go through the fuss of making them from scratch the way my cousin did.

Chicken Quenelles

❧

I still make pike quenelles occasionally, but more often make them with sole, and in the classic style of the great nineteenth-century chef Georges Auguste Escoffier, where the choux paste and kidney fat are replaced with cream. I also sometimes substitute chicken for the fish, and the resulting quenelles have the same texture but, of course, a different taste. I dice boneless breasts and pulse them in the food processor, then chill. When it becomes cold, I dribble heavy cream into the meat slowly—a few tablespoons at a time until incorporated, then toss in some chopped fresh chervil or tarragon. Using two spoons, I mold the mixture into quenelles about the size of a quail's egg and poach them for just a few minutes. I frequently serve them with *duxelles,* a purée of mushrooms cooked with shallots and heavy cream.

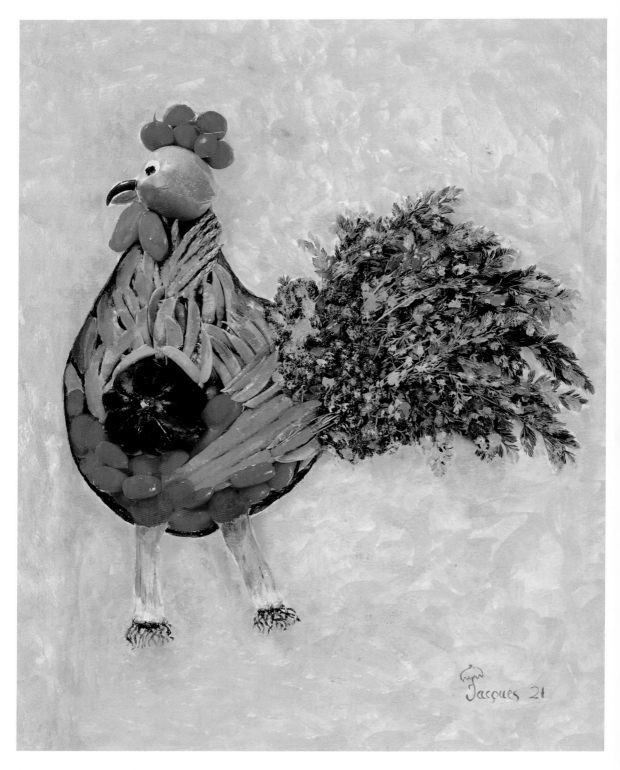

Chicken and Vegetables, 2021

Chicken with Vinegar Sauce

Poulet au vinaigre is another culinary gift from Lyon that I devoured in my youth and continue to make often for friends and family. I use bone-in, skin-on thighs, cutting into the meat about ½ inch deep along the bone on each side to help them cook faster and more evenly. I place the thighs skin-side down in a nonstick skillet without adding any fat—the thighs do a fine job of adding their own while they cook. They get sprinkled with a little salt and pepper, and that's about it. For the first few minutes, I keep the heat high, then I cover the pan and turn the burner very low for another 20 or 25 minutes, leaving the thighs skin-side down the entire time. Covering the pan captures steam, which cooks the tops of the thighs. This method renders out all the fat and makes the skin deliciously crispy. I remove the thighs from the pan and add copious amounts of chopped garlic to the rendered fat, a couple of tablespoons of red wine vinegar (the very best I have on hand, naturally, since the dish is named for this key ingredient), and a shake or two of Tabasco. After that reduces, I add a chopped fresh tomato and about 2 tablespoons of demi-glace. I pour the sauce over the chicken, along with a sprinkling of fresh tarragon.

Chicken Bouillabaisse

✢

One of the great culinary memories of my youth is when I first tasted bouillabaisse. My father had taken me to a small bistro called a *bouchon* in Lyon, where the chef-owner was known for his fish dishes. Bouillabaisse is a famous fish stew from Marseille in the South of France made with many different types of rock fish like red mullet, scorpion fish, and especially *rascasse* (hogfish) and sometimes *langouste* (spiny lobster). The stew is flavored with saffron, garlic, onion, tomato, fennel, thyme, white wine, and Pernod. It is served with a *rouille* (rust-colored) sauce—a mayonnaise loaded with garlic and flavored with the broth from the fish stew, which lends the finished product a deep reddish color.

A few years ago, I decided to make a *bouillabaisse de volaille*. I replace the fish and shellfish with chicken and sausage but keep the same flavoring ingredients. I first marinate the chicken pieces with olive oil, saffron, garlic, onion, carrot, celery, herbes de Provence, and salt and pepper. When it is time to cook, I cover the mixture with white wine, tomato, hot sausage, and potatoes and let it simmer for 45 minutes. Meanwhile, the *rouille* is made in a food processor by emulsifying egg yolks, garlic, salt, black pepper, cayenne pepper, and some liquid as well as a potato from the stew. The mixture is finished with a generous addition of the best-quality olive oil available, which creates an unctuous sauce, full of flavor. It's a delectable spin on a classic, and yet another delicious way of enjoying chicken.

All the women in my family starting with my mother were great cooks, and most of the small bistros, brasseries, and *bouchons*, as well as many of the renowned restaurants of Lyon, had a woman

head chef—they were "les mères de Lyon," the mothers of Lyon. As a child and later as a young cook, I remember enjoying the food of La Mère Blanc, La Mère Guy, La Mère Filloux, La Mère Charles, Lèa de Lyon, among others. But the most renowned was La Mère Brazier.

The legendary chef Eugénie Brazier of La Mère Brazier served one of the most sought-after dishes in Lyon. She founded her restaurant in 1921 and won three prestigious Michelin stars at a time when few women headed renowned kitchens and fewer still won accolades from Michelin. The British food writer Elizabeth David, who introduced regional French cooking to the English-speaking world, described Madame Brazier's food more accurately than anyone when she wrote that it was "of a sumptuous simplicity, but lighthearted and somehow all of a piece."

Called *poulet en vessie,* Mère Brazier's famous dish featured a whole chicken cooked inside a pig's bladder, which trapped steam as it inflated during cooking, creating a moist environment and producing results similar to the modern sous vide hot-water bath that has become so popular among trend-conscious restaurant chefs in recent years. Madame Brazier inserted truffles beneath the skin of a Bresse chicken, which she placed in the elastic bladder, along with leeks and carrots. The preparation steamed slowly and arrived at the table with the chicken encased in the fully inflated, translucent, balloon-like bladder, which a server burst with a knife for a dramatic and magical presentation. The chicken was accompanied by its natural cooking juices, to which butter was added, and came with a leek and carrot garnish. Although it seems exotic, at heart it is a straightforward, flavorful preparation. I hasten to add that it retains none of the taste of what the bladder contained during the pig's life. I can think of no finer fate for a Bresse chicken than having been served at La Mère Brazier.

Cock on Yellow Background, 2016

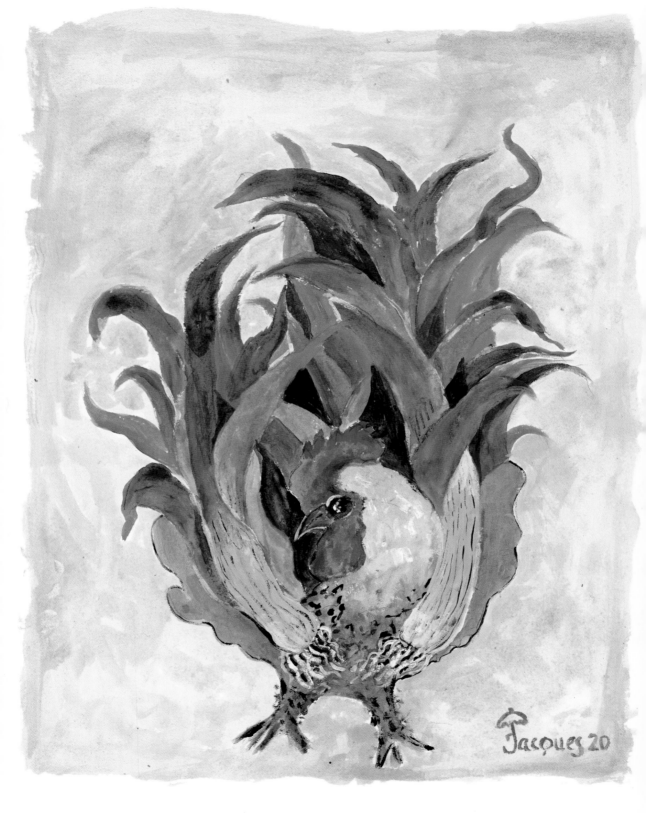

Leaving Home

————

I N 1949, at the age of thirteen, I left home for good, to sleep under my parents' roof thereafter only for visits and vacations. I had finished primary school a year ahead of most students my age, and I passed the final exam. As far as the government cared, I could legally bid adieu to the classroom. Although I thought of myself as every inch a man, I was only five feet two inches tall and weighed less than one hundred pounds. Maman still insisted that I dress myself in short pants—a sure sign in France in those days that the wearer was still a boy. But I was ready to move on. And I knew exactly where I wanted to go. I loved the heat and bustle of the kitchens of our family's restaurants. I would be a chef.

The new life I embarked upon also represented a homecoming of sorts. My parents had arranged for me to serve my apprenticeship at L'Hôtel de l'Europe in Bourg-en-Bresse, the town where I was born. But the hotel was situated on a fashionable boulevard on a wealthy side of town that bore little resemblance to the working-class neighborhood of my youth. The building was a grand edifice on a street lined with mansions. Maman and I entered through a portico with a

Facing page: *Chicken and Leeks,* 2020

glass-domed roof. The mosaic tiles of the foyer's floor featured floral patterns. The wall facing us had a tiny, delicate marble fireplace with armoires on either side, their dark wood festooned with bas-relief lilies.

The kitchen, clearly visible through glass doors in the reception area, impressed me even more—a veritable wonderland for someone who aspired to become a professional chef but had experienced only the kitchens of modest restaurants that catered to neighborhood working people. The floors and walls were covered in brilliant white tiles, copper pots and pans gleamed from shelves, and the domed ceiling was fashioned from stained glass.

The cooks on duty at the time wore the uniforms of true pros. The eldest, a grown man, had a high white toque, white jacket, white scarf, and blue-and-white checked pants. A couple of boys not much older than I—apprentices, I guessed—also wore checked pants but had on blue jackets. All manner of machines that I did not know existed filled the room: a giant automatic mixer, an electric meat grinder, and a dishwasher to deal with a chore that I had always thought could be done only by hand. An enormous black coal- and wood-fired stove occupied the center of the kitchen, and the cooks bent over it as if praying at some sort of high altar.

Before I entered that splendid workspace, the oldest apprentice greeted me and led me upstairs to the dormitory-like room we trainees shared. He pointed to a folded stack of clothes on the foot of a bed. "That bed's yours," he said. "Welcome! And you better change into those clothes and come down to the kitchen. Chef Jauget wants to see you."

The bundle included a pair of long trousers. I could not conceal my delight as I hoisted them up over my hips. Even though their cuffs bunched up around my ankles, the blue-and-white checked pants of a chef were the first long pants I had ever worn.

I started out at the very bottom, literally: cleaning the floor. I also scrubbed the stove, pots, pans, and worktables and hauled in endless armloads of firewood and buckets of coal to feed the hungry black behemoth that dominated the room. But other than bringing in fuel, I was forbidden from tending the stove in any other way. That was for far more experienced hands than mine.

Eventually, Chef Jauget entrusted me with more responsibility, but only a little. I started stripping parsley leaves from stems, peeling vegetables, scaling and gutting fish, and prepping chickens, which, this being Bourg-en-Bresse, were the stars of our restaurant. Chicken was the most sought-after item on our menu, and the chef prepared it in many different ways: plain roasted, in a cream sauce, in a red wine sauce, with crayfish, cold in aspic, and in a salad, to name a few.

Older apprentices or the gardener handled the task of slaughtering poultry at L'Hôtel de l'Europe. But as soon as they dispatched the birds, I took over and plucked them, doing that job as fast as I could because feathers come out more easily when the carcass is lukewarm, and leave behind unblemished skin. I passed the newly plucked bodies over a flame to singe off any remaining hairs and pinfeathers, then set about gutting the birds. Step one in that process involved removing the neck and thrusting my index finger into the cavity to loosen the internal organs. Next, I turned the bird around and made an incision below the tail large enough for me to insert my fingers in that end and withdrew the innards, which, when done properly, came out all together in one shot. I then trussed the chicken or cut it into pieces, depending on how Chef wanted to cook it. Mastering how to properly pluck, eviscerate, and dissect a chicken served as a mini-apprenticeship in itself.

Early on, I wondered whether Chef Jauget even knew my name. He only ever called me "*P'tit,*" meaning "Kid." As the lowest-ranking person in the kitchen, I was also subjected to a barrage of

Next spread: *Chicken Cook,* 2021

Jacques 21

good-natured hazing. One day, Chef urgently asked me to run as fast as I could to L'Hôtel de France, which was on the other side of town. "I lent the chef there my chicken boning machine. I need it as soon as possible," he said. "*Vite! Vite!*"

Always eager to please, I dashed off without hesitating and arrived at L'Hôtel de France's kitchen door drenched in sweat and puffing to catch my breath.

"*Non, non, non,*" the chef there told me. "I don't have Chef Jauget's machine. I lent it to the chef at L'Escargot," which was a little restaurant about twenty minutes in the opposite direction. "It's there now."

I jogged to L'Escargot, more slowly now because of my previous exertions. The chef there met me with a frown. "Yes, the machine is here," he said, holding out a large, cloth bag fastened at the top. "It's all cleaned and ready to go. But I should tell you that Chef Jauget just called, and he's waiting for you. You'd better bust ass. You've been gone a long time. He sounded none too happy."

I grabbed the bag and raced back toward our kitchen. As I breathlessly rounded the final corner, L'Hôtel de l'Europe came into view. Oddly, Chef Jauget, the other apprentices, and all the waitresses were standing outside the door, looking in my direction. But they did not seem to be angry. Or worried about the delay. In fact, they were all laughing hysterically.

A shadow of doubt crossed my mind as I carefully lowered my burden and looked inside. The "chicken boning machine" was nothing more than two cement blocks. I felt like the dumbest human being in the world, but like every other apprentice, I'd survived a rite of passage.

I worked hard and performed well, but I still had a larkish streak and loved to play pranks on my peers—so long as Chef was not

around to see them. I might deposit a handful of fish guts into the back pants pocket of another unsuspecting apprentice. I'd perfected the art of using a paring knife to deftly flick the stub of a carrot I was slicing at the head of the boy across the counter from me. But when I snuck a raw egg into a bowl of hard-cooked eggs a comrade was peeling and Chef saw the resulting mess, he became furious. As punishment, he sentenced me to stay in the kitchen during the break between lunch and dinner, when normally we had a couple of hours to rest in the dorm or walk beside the river.

I passed the time mopping the floor and cleaning the walls. I was about to polish the stove when I noticed a pot simmering in a back corner. I had a vague memory that Chef had said something about that pot before he left, but I could not recall his exact instructions. A disgusting, grayish crust had formed on the surface, and the liquid below simmered through a hole in its center. To my inexperienced eye, the pot begged to be stirred, so I grabbed the biggest whisk available and went to work vigorously until that ugly crust disappeared and the liquid thickened and went from clear to opaque. I had no idea that I had just ruined the clear consommé Chef had been nurturing along to serve at dinner. When he saw what I'd done, he grew livid, blurting, "You fool!"

It was one of the few times I heard him raise his voice—and the last time I wrecked a consommé.

Basic Chicken Stock

✤

In time I became proficient at making stock, the basis for Chef's consommé and many sauces and flavor agents used in our kitchen. The main ingredients in our stock were chicken bones, heads, necks, wing tips, and gizzards. I immersed them (either uncooked for white stock or roasted for brown stock) in a pot of cold water and brought it to a boil, skimmed off the scum that rose to the surface, and added thyme, bay leaves, peppercorns, cloves, carrots, onions, and celery. The pot simmered slowly, uncovered, for a couple of hours, and then I strained the liquid through cheesecloth.

It took nearly a year, but one evening Chef Jauget addressed me by my given name for the first time. "Jacques," he said. "Tomorrow you start at the stove."

My initial reaction was disbelief—followed by a wave of terror that overshadowed any excitement I might have felt after finally realizing a goal I had strived toward from the moment I first laid eyes on the stove. He might as well have asked me to get behind the wheel of the large automobile belonging to Monsieur Denizot, the owner of the hotel, and take it for a spin around town. I knew nothing about what happened at the stove, which until then had been off limits, an enormous, black mystery in the middle of the kitchen.

But I surprised myself. Little did I know that all along I had been learning how to cook by what amounted to osmosis, looking, listening, smelling. I'd never operated the stove (aside from filling it with wood and coal), but I'd seen Chef and the other apprentices attend to it and could imitate their actions. For the first time I was no

Facing page: *Chicken and Cabbage,* 2020

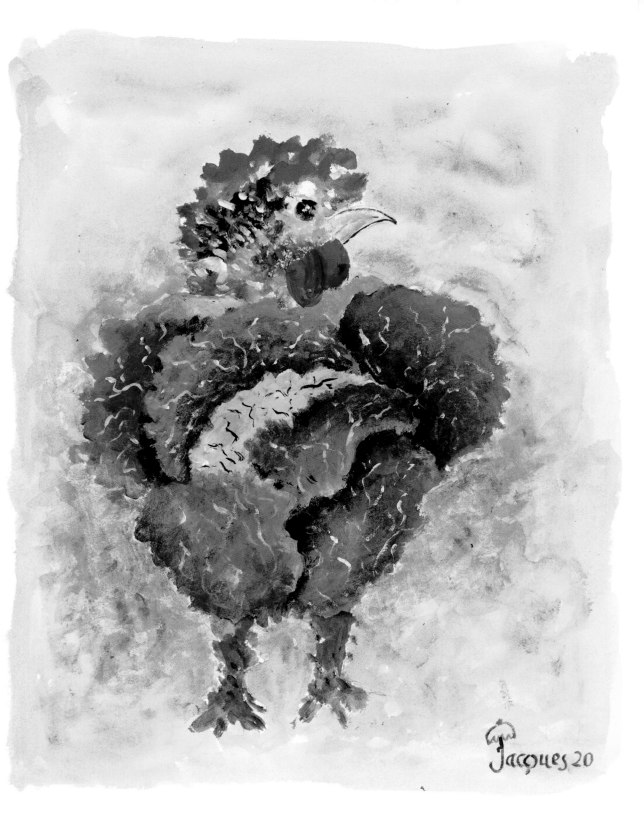

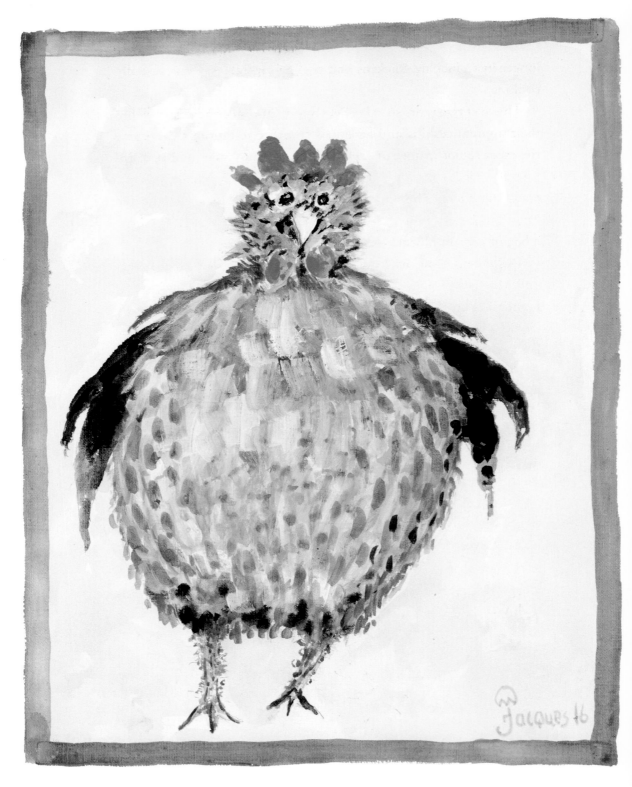

longer just plucking chickens and peeling vegetables. I was actually cooking.

The next two years sped by. One by one, the older boys completed their apprenticeships and advanced to other restaurants. I became the most senior trainee at L'Hôtel de l'Europe. I now told new apprentices what to do and how to do it. I stood among the kitchen veterans laughing on the steps of the hotel while a younger boy, the one Chef Jauget now called "*P'tit,*" came running up, breathlessly toting a bag of cement blocks.

Despite my seniority, I was still only fifteen years old. Chef Jauget and Monsieur Denizot governed my life in every way. I had to ask permission to leave the premises, to walk downtown, to attend a movie. I was still far from having mastered my trade and maybe becoming a little too cocky.

One night around nine thirty, well after Chef Jauget had gone home, the urgent voice of my favorite waitress, Angèle, woke me from the profound, dreamless sleep I inevitably fell into the moment I lay down in the upstairs dorm. "Jacques, you have to come down immediately. Guests have just arrived. They've had a long day traveling and need something to eat. They're famished."

Being the most senior apprentice meant that in the absence of Chef, I was responsible for the kitchen. I jumped into my work clothes and ran downstairs. First off, I checked the stove. Thank God, the thing retained heat and still had a few glowing coals from dinner service, which meant that I would at least be able to cook *something*.

Angèle came in from the dining room. "Okay, I have two couples. They want some pâté to start."

I exhaled with relief. The pâté was already made and resting in the refrigerator. I just had to slice it and arrange it on a platter with pickles and watercress. No problem.

Facing page: *Cock Too,* 2016

"Then they will have the *poulet à l'estragon.* You'll be okay with that, yes?"

The truth, which I dared not utter, was, I hope so.

Tarragon Chicken

❧

As apprentices, we were never taught anything, or rather not taught in a formal sense. Nor did we have cookbook recipes to consult—or any other recipes, for that matter. Such things simply did not exist in any professional kitchen in France at the time. We learned to cook by using our senses to guide us.

I had seen Chef Jauget prepare tarragon chicken several times and set about replicating his actions. I first placed the legs skin-side down in a saucepan and gently sautéed them until my fingers told me that they had become firmer, and my eyes saw that they were just barely browned, or browned *à blanc,* about 10 minutes. During that time, I chopped some shallots and started the breasts cooking. When the breasts became *à blanc,* I flipped them, added the shallots, a bay leaf, some thyme, white wine, and chicken stock along with the legs. I let the mixture simmer for about 25 minutes, until the familiar aromas arising from the pan told me that the breasts had reached the point where Chef always transferred the chicken to a serving platter. I thickened the remaining pan juices by whisking in *beurre manié,* an uncooked mixture of butter and flour, a bit at a time, as Chef did, until I'd achieved what looked and felt like the right consistency, and then I let it cook gently for a few more minutes. I finished the sauce with thick, fresh cream and a few generous pinches of chopped fresh tarragon.

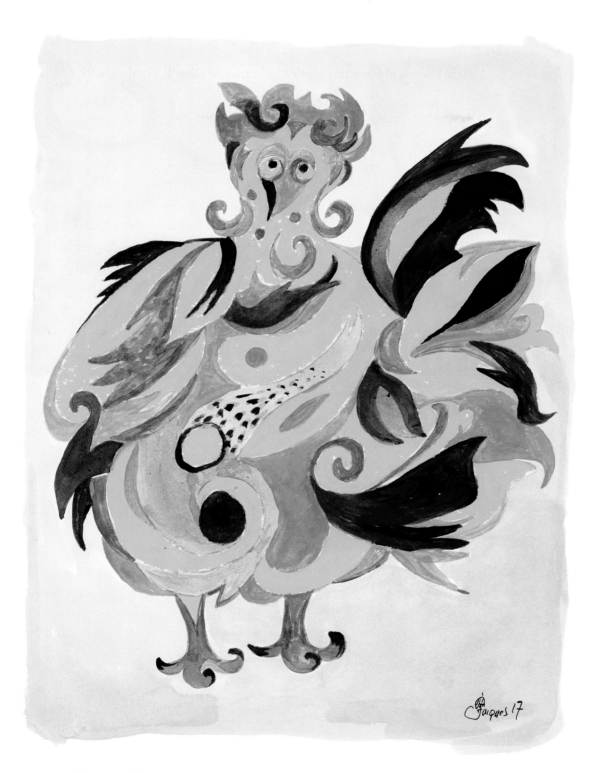

Ceremonial Rooster, 2017

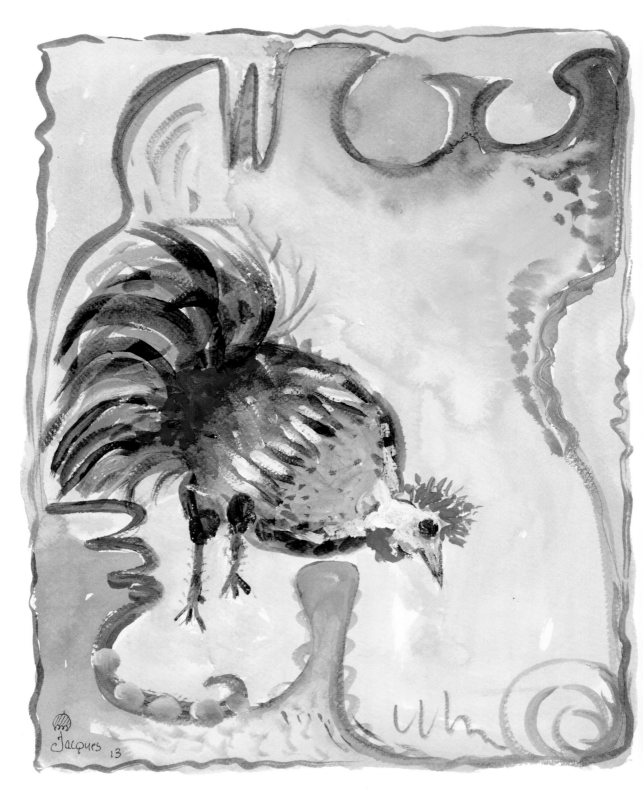

Jacques
13

Angèle scurried off into the dining room with the platter, and I was left alone in the kitchen, fearing that if the couples did not like their meal, it might be the first, and the last, time Chef would entrust me to singlehandedly prepare *poulet à l'estragon,* or anything else.

I began cleaning up, but the suspense became too great. I crept up to the door separating the kitchen from the dining room, a social-class boundary that those of us who prepared the food never dared cross. Through the little round window in the door, I saw two well-dressed, middle-aged couples tucking into my chicken dish and sipping from glasses of white wine. From that vantage point, they seemed content, so I returned to the stove and continued cleaning while I waited for judgment to come down.

Nothing prepared me for what Angèle said when she returned. "Well, they loved the chicken and they want to see the chef," she said.

See the chef? That was unheard of. Chefs, even the most famous ones, performed their jobs professionally, even flawlessly, but did so behind the kitchen doors, out of sight and mind of guests. No one had heard of the notion of open kitchens or cooks emerging to schmooze with diners, shake hands, and bask in adulation. Red-faced and flustered but proud, I tagged along behind Angèle to meet the customers in the dining room. I don't know what they expected to see, but it certainly wasn't a five-foot-three-inch-tall child who had yet to fully grow into his apprentice's uniform. That my first culinary triumph involved chicken seems utterly appropriate for a boy from Bresse.

Facing page: *Leaning Chicken,* 2013

On My Own

———◆———

N 1953, at the age of sixteen, I completed my apprenticeship and soon after landed a four-month gig for the summer—a *saison*, or season, as such stints were called—at L'Hôtel d'Albion in Aix-les-Bains, a beautiful spa town nestled in a valley beside a lake near the French Alps. Although the posting was of short duration, it was intense: seven days a week from eight thirty in the morning until ten o'clock at night, with three hours off in the afternoon.

At L'Hôtel d'Albion, I mastered the art of cooking over a live-fire grill. It was literally a trial by fire. The grill itself was as big as a bathtub and fueled by lump charcoal. Despite having matriculated from my apprenticeship, I had yet to grow much taller than I had been the day I left home, so I had to work with my face close to the hot, glowing coals, giving me what looked like a perpetual sunburn.

My boss, Chef Cullet, was an enormous man and a proud member of the old guard. He insisted that we turn whatever we were cooking on his grill with our fingers, forbidding us to deploy metal forks and spatulas—the tongs used today had yet to enter French restaurant kitchens. A fork might pierce the meat, causing it to dry

Facing page: *Reflecting Rooster,* 2019

out; metal implements of any sort would affect the flavor—or so Chef Cullet erroneously contended. The most treacherous (and most popular) dish was the mixed grill. Each portion was composed of a small lamb chop, a slice of veal liver, a lamb kidney, a slice of bacon, one small tomato, and one mushroom. It was a nightmare to turn these with my fingers. I kept a bowl of cold water close at hand, dipping my fingers in it, grabbing the piece of meat as fast as I could, turning it, and then back to the cold water right away to avoid burning myself too much. I did that for an entire summer. Of course, I ended up with all the ends of my fingers white and burned off. Most chefs who work at the stove will eventually lose their sense of heat at the tips of their fingers, but this experience was a ridiculous training mandated by an autocratic chef.

Grilled Chicken

❧

At L'Hôtel d'Albion, I learned the culinary virtues of wood, flame, smoke, and simplicity. One of our specialties was grilled chicken. We rubbed bone-in, skin-on legs and breasts with a little peanut oil, salt, and pepper—nothing more—put the pieces on the grill (with our fingers, of course) skin-side down to start, then flipped them to the other side (fingers again) to finish cooking. This would be served with a lump of *maître d'hôtel,* or compound butter, which is butter flavored with chopped herbs (usually parsley), lemon juice, salt, and pepper. On a warm summer's evening, whether beside a mountain lake or in a suburban backyard, grilling is still one of my favorite ways to cook chicken, but today I always keep a sturdy pair of tongs close at hand.

Facing page: Mr. Piper, 2016

I have chickens to thank for my first brush with media stardom and celebrity, albeit on an ultra-local, limited scale. After the Albion closed for the year at summer's end, I took another temporary job. The setting could hardly have been more different from the fancy resort hotel on a pretty mountain lake—not to mention the dozens of attractive girls my age who worked there for the season as house-keepers and waitresses.

Barely seventeen years old, I became the sole cook, and only employee other than a dishwasher, in the kitchen of an establishment called L'Hôtel de la Gare (Train Station Hotel) in Bellegarde, a sleepy French town near Geneva, Switzerland.

Fortunately, my duties were for the most part far from onerous. During the winter months, business was so slow in Bellegarde that the "real" chef at L'Hôtel de la Gare, the son-in-law of the owner, decamped to the nearby Alps to make a more substantial wage at a fancy ski resort. I served a few clients each day for lunch. Things got busier in the late afternoon, between four and six o'clock, when old regulars filtered in to play *belote* (a card game), drink wine, and eat cheese fondue. I made that in small cast-iron pots with chopped garlic, white wine, salt, pepper, and fistfuls of shredded Gruyère or Emmenthal. For a little extra money, I'd add a dribble of kirsch at the end. About the only excitement happened when a piece of bread slipped off a card player's fork and sank into the fondue. According to the local ritual, such a faux pas required that the guilty party spring for a round of drinks for the whole table.

That lackadaisical pace ended when the owner, Madame Saint-Oyant, informed me that L'Hôtel de la Gare was going to host Belle-garde's annual firemen's ball, a banquet for eighty guests, including the mayor, the priest, the fire chief, the chief of police, and the school principal—everybody who was anybody in town. I had to prepare

Facing page: *Chicken and Eggplant*, 2020

the feast single-handedly. For the main course, Madame Saint-Oyant and I chose straightforward roast chicken, which I knew how to prepare, even though I had never cooked for such a large gathering. But, to ensure the guests enjoyed the meal, she ordered two bottles of wine, one red, one white, for each attendee. In the event that the main course fell short of perfection, ample wine might dull the guests' tastebuds.

Roast Chicken with Winter Vegetables

✦

I acquired two dozen plump fowl, placed them in copper roasting pans, each large enough to comfortably accommodate eight birds. I added diced potatoes, carrots, onions, and cloves of garlic, seasoned everything with salt and pepper, and popped the loaded pans into the kitchen's two hot commodious ovens. Once they were done, I quartered the chickens and arranged the pieces on trays with the vegetables and then covered them with cooking juices from the pans in which everything had roasted. The chickens were served with bowls of salad. The meal started with cold poached *colin* (large hake) with mayonnaise and was rounded off with an apple tart.

The annual dinner represented the pinnacle of the social calendar in Bellegarde, and in recognition of the importance of the occasion, the local newspaper sent a reporter/photographer who captured a picture of me, all of seventeen years old, smiling proudly from beneath a towering white chef's toque. Chicken had made me famous.

Chicken with Carrots, 2020

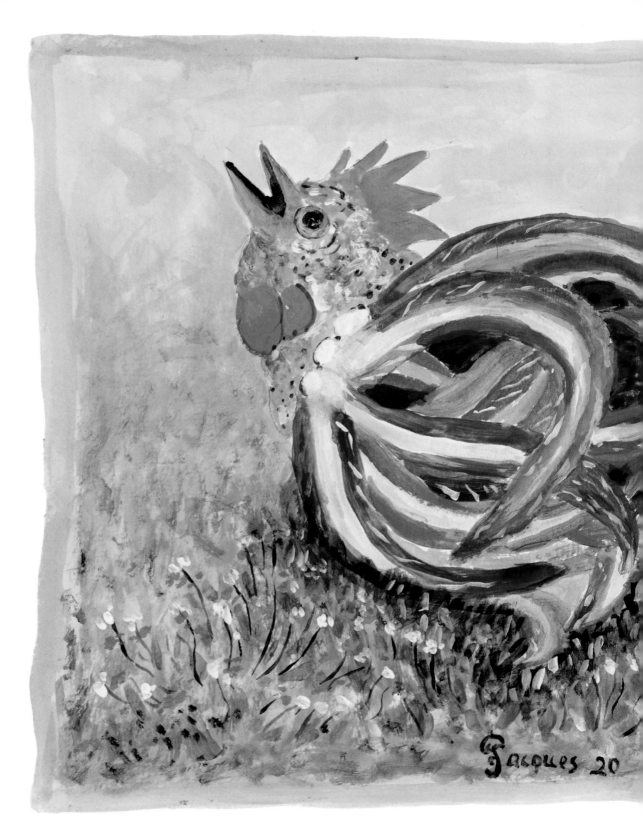

Chicken and Treviso, 2020

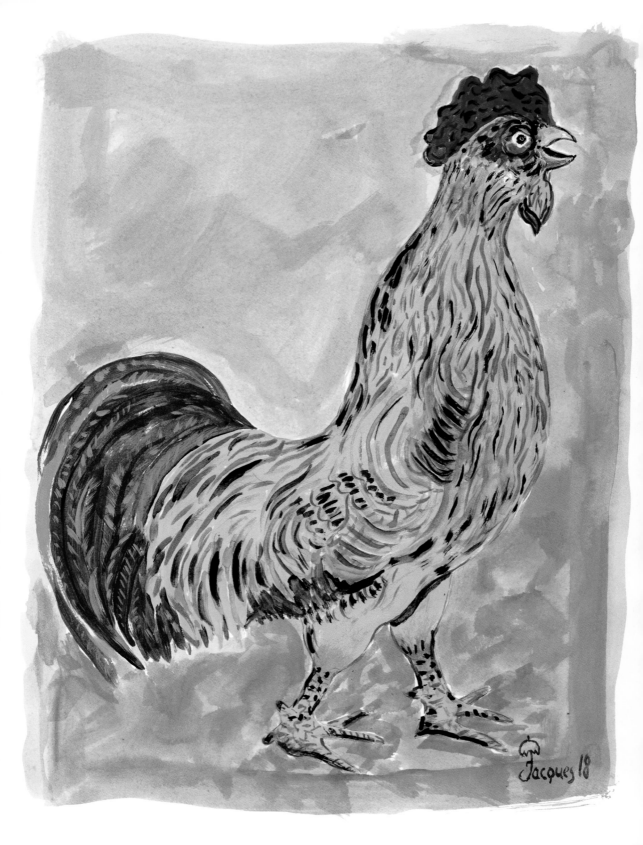
Jacques 18

The Capital of the World

━━━━◆━━━━

I FIBBED TO MAMAN. Okay, I told her a bald-faced lie. If she had known the truth, she would never have approved of me going to Paris. But I wanted to play in the big leagues, even though I was barely a year out of apprenticeship and still as parochial as you can get, having never ventured outside the region between Lyon and Geneva, about sixty miles in diameter. No one in my family had ever been to Paris.

So, I blithely assured Maman that I had a place to stay in the city and a good job lined up, even though all I had was the smudged pages of a letter I'd received in Bellegarde from Robert, a fellow former apprentice at L'Hôtel de l'Europe, who'd found work in Paris. He suggested I come there, too. I would love the place.

I arrived at Paris's Gare de Lyon with an old suitcase containing a few changes of clothes and a wooden box my father made for my collection of knives. After trudging through the unfamiliar streets, I somehow found my way to Robert's apartment. He let me sleep on his floor for the night, and the next morning showed me the way to a work agency for cooks. By evening, I had secured a job at a

Facing page: *Tufted Cockerel,* 2018

nondescript brasserie. Cooking simple food like steak, onion soup, and roast chicken there kept me fed and allowed me to rent a room (Maman could rest easy) but didn't provide the learning experience I'd hoped to find in the city.

After a few other less-than-satisfying positions, I landed at Le Meurice hotel, which was (and still is) one of the most elegant and chic hotels in Paris. I stayed there for six months. During that time, I was exposed to the cuisine of Escoffier and learned to make many classic dishes. Eventually I moved to the three-star Hôtel Plaza Athénée, one of the biggest and finest hotel restaurants in the city. Like the Meurice, its reputation continues to this day. There, I joined a regimented brigade of forty-eight chefs who each day prepared classic French cuisine for about 250 guests—a high employee-to-customer ratio. "Brigade" was an apt description. The chef managed the kitchen staff with military precision and discipline. He rigidly assigned us to well-defined sections—pastry, sauce, grilling, vegetable, fish, and *garde manger* (where cold dishes were prepared and meat and fish portioned and refrigerated). A *chef de partie* commanded each section, the equivalent of a military officer. He oversaw a first, second, and third *commis,* the brigade's enlisted soldiers. Once a third commis had mastered the duties at one station, he rotated to another until he had worked at every station, at which point he got promoted to second commis if his work was satisfactory. He repeated the cycle to become first commis. Beginning as a lowly third commis, I thrived under the system. The Plaza was everything I had ever dreamed of, and I stayed there for close to eight years.

I eventually became *chef de partie* for the night shift, which started at six o'clock in the evening and finished at two in the morning. But we were young and, after all, this was Paris, so even at that hour we had plenty of options for food and drink after work. Often, we ended

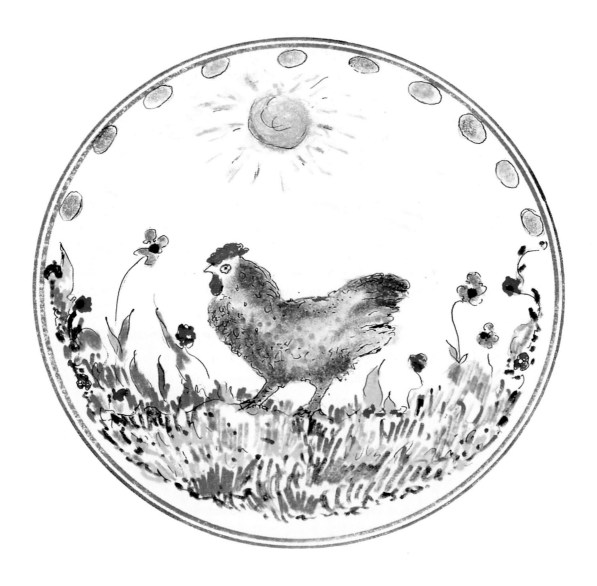

Hen Plate, 2000

up at Les Halles, the labyrinthine Paris market. At five in the morning, the place bustled with revelers dressed to the nines who had just come out of fancy restaurants or nightclubs. They rubbed shoulders with butchers in blood-stained aprons, farmers in boots with brown mud stains, and chefs in crisp white jackets just starting their workday. Shoppers picked through the aisles to procure the finest Les Halles had to offer, which included more different chicken breeds than I knew existed: reddish Estaires from northern France, Faverolles with feathered ankles, crested black-and-white Houdans, jet-black savage-looking La Flèches, and of course, my *bleu, blanc, rouge* Bresse chickens. Vendors proudly displayed them hanging from rails with the neck and head feathers still in place, enabling knowledgeable shoppers to determine their age.

Working at the apex of Parisian haute cuisine meant that I had to master difficult classical preparations, many of them for chicken. For the *poularde Trianon* the chicken was browned nicely in a saucepan first, then a small amount of chicken stock was added, and the chicken continued braising in a hot oven, covered, until fork-tender. Chicken quenelles were made by pounding chicken meat with a large mortar and pestle first, then the mixture was pushed through a tamis, or fine sieve, using a wooden tool called a mushroom (because of its appearance) to get a very smooth purée of chicken meat. The purée was placed on ice, and heavy cream was incorporated spoonful by spoonful to produce a creamy, soft, and smooth mousse.

The mousse was divided into three parts, and each part was differ-

ently seasoned—one with chopped black truffles, one with chopped cured tongue, and one with herbs such as chervil, parsley, and basil. Three seasonings, three tastes, and three colors: black for the truffle, red for the tongue, and green for the herbs. The quenelles were molded into miniature footballs using two spoons and poached in salted water. At serving time, the braised bird was presented whole with little batches of quenelle in alternating colors placed in small cooked pastry shells around it. The chicken was coated with a supreme sauce made with thickened chicken stock and finished with cream and a purée of foie gras. The top was decorated with extra slices of truffles. This classic tour de force was carried out to the guests in the dining room by a skilled maître d'hôtel. This glory of classic French cooking would be difficult to duplicate in a home kitchen!

The Very Best French Toast

❧

I also put in a stint as a breakfast chef at the Plaza Athénée. We prepared one of the finest versions of French toast (*pain perdu*) I have ever tasted. Eggs played a key role. I first "borrowed" some rich, custardy vanilla ice cream from the pastry section. The cooks there made it by whisking 3 egg yolks into a cup of a 50:50 mixture of milk and cream flavored with sugar and vanilla beans. (You can use any premium vanilla ice cream at home.) I let the ice cream thaw in a bowl on the counter until it became liquid and then dipped in slices of brioche, which I sautéed with plenty of butter. We served the *pain perdu* with maple syrup from Canada or honey from Alsace.

Next spread, left: *Shadow Cock,* 2017; right: *The Tattle Cock,* 2017

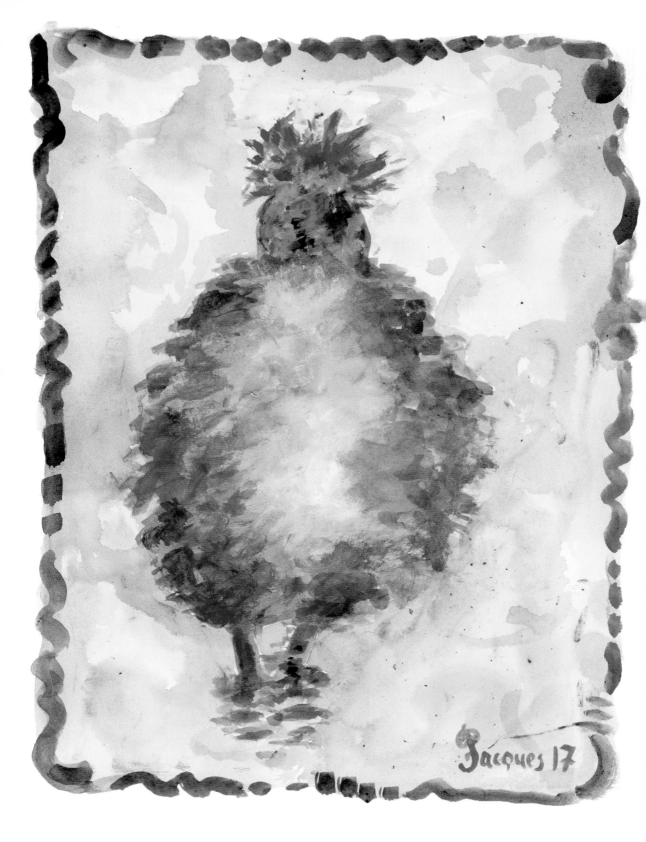

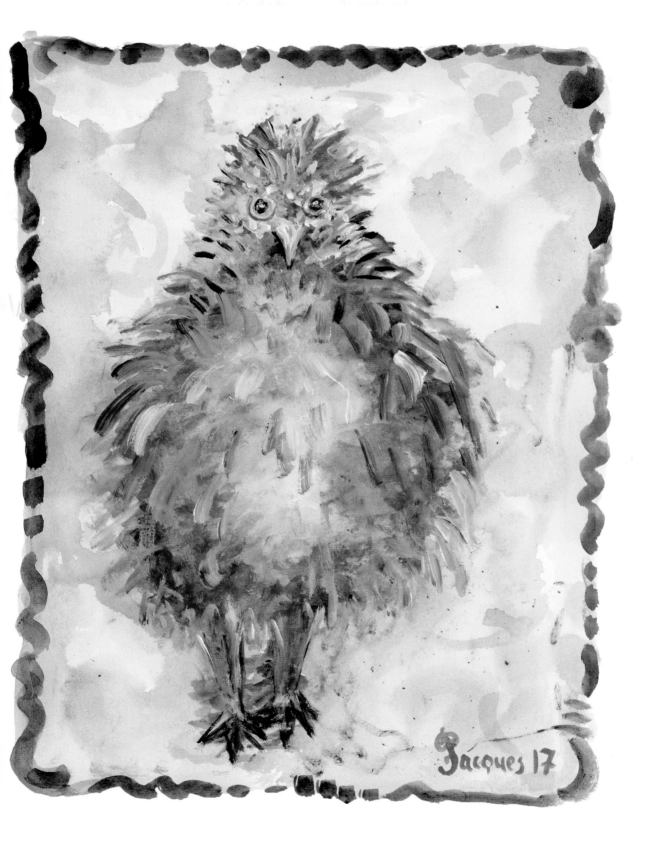

Snow Eggs

❧

The same custard cream is used for classic *oeufs à la neige,* or snow eggs, a favorite dessert at Easter time. I whipped the egg whites left over from making the custard cream into a meringue, beat in sugar, and shaped it into balls about the size of a lemon. Using two large spoons to give them an egg-like shape, I lowered the balls into boiling milk and poached them for a couple of minutes, just long enough so that they retained their shape but were still soft and creamy inside. Once they cooled, I plopped the "snow eggs" on top of the custard cream or crème anglaise and liberally sprinkled them with caramel just before they went to the tables.

Facing page: *Black Mother Hen,* 2016

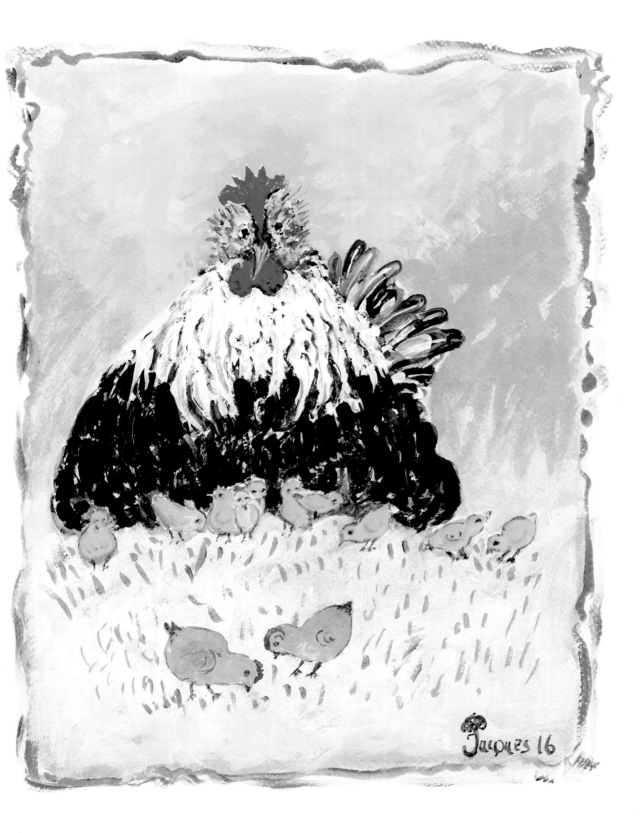

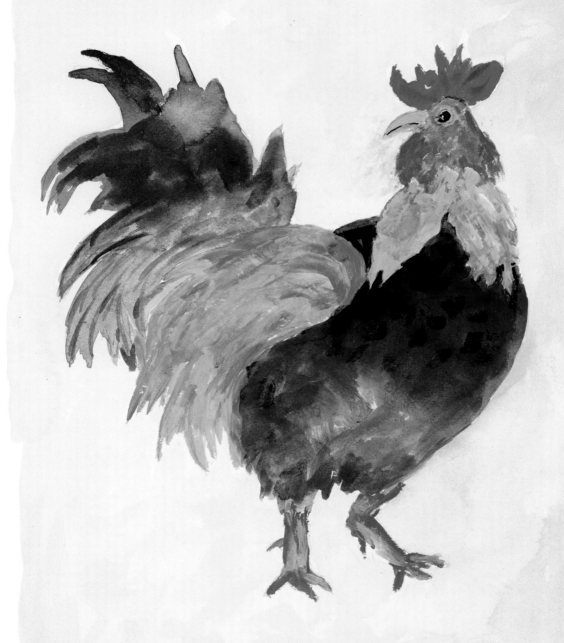

Jacques 17

Cooking for Presidents

———

M Y HAPPY DAYS and nights at the Plaza came to an abrupt end in 1956 when I received a curt, official letter informing me that I had been drafted into the French Navy. After I spent a few short weeks getting basic training at a boot camp in southwestern France, the government could have shipped me off to Algeria, where France was bogged down in a futile war against rebels fighting for the country's independence. My big brother, Roland, sixteen months my senior, saved me from dodging bullets in the sands of northern Africa. The government had a policy of never sending two draftees from the same family into battle at the same time, and Roland was already serving in Algeria.

At boot camp, they made me take a test to determine whether I—who had just spent the better part of a decade cooking for the most discriminating palates in the world—had the requisite culinary skills to sling chow in a military mess hall. The guy who administered my exam was supposedly a professional cook. He ordered me to prepare *oeufs bénédictine*, a recipe created at New York's Delmonico's restaurant in the nineteenth century by Charles Ranhofer, who named it after one of his regular guests, Mrs. Legrand Benedict.

Facing page: *Royal Rooster,* 2017

I breathed a sigh of relief. I'd cooked *oeufs bénédictine* hundreds of times at the Plaza as well as at Le Meurice and Le Fouquet, top Paris establishments where I occasionally filled in on my days off to earn a bit of extra money. With a few subtle differences, eggs Benedict were mostly the same everywhere I had worked.

Eggs Benedict

Conventionally, eggs Benedict consists of a slice of ham placed on a toasted brioche bun, onto which you place a poached egg, then pour hollandaise sauce on top and garnish it with a slice of black truffle, if you have it. I could also make hollandaise blindfolded: Whisk 3 egg yolks in a saucepan with a few dribbles of water and lemon juice, then heat and whisk until the yolks thicken. Take the pan off the heat and slowly work in about ½ pound of clarified butter.

I presented the results to my examiner. He snorted and said, "You call yourself a cook? Everyone knows *oeufs bénédictine* calls for poached eggs, served on a purée of salted codfish, and topped with a cream sauce."

Huh?

I'd never heard of that concoction and only later learned that the recipe for it had appeared in Escoffier's *Le Guide Culinaire*, which appeared in 1903. As far as I knew, no professional chef had prepared eggs Benedict that way for fifty years.

Even though I flunked that test, my credentials must have caught the attention of someone higher up in the ranks than my examiner. French military brass cared deeply about the quality of the food they ate, and most would eagerly snag the services of a former Parisian

Facing page: *La Grande Cocotte,* 2017

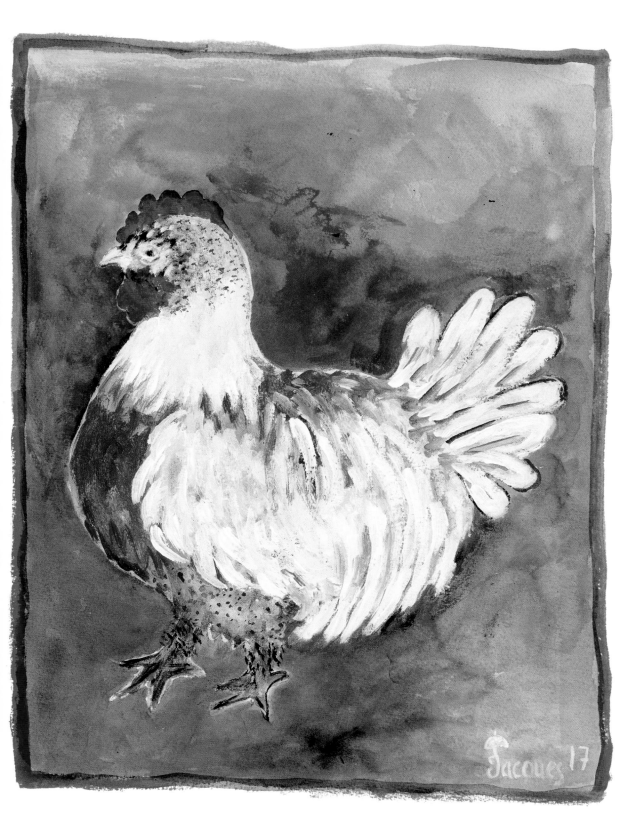

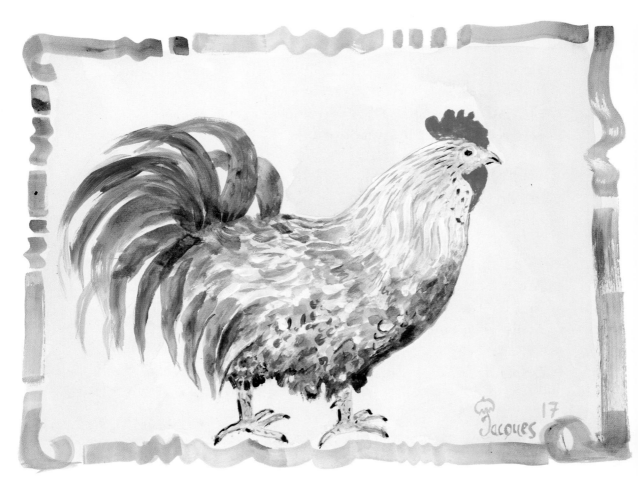

Poulet de Foissiat, 2017

chef for their canteens. The Navy ordered me to return to Paris and report to the kitchen at their headquarters, aptly named La Pépinière, in the center of the capital.

I put in a brief stint there before a fellow Navy chef got me assigned to a job cooking for Félix Gaillard, the secretary of the treasury on the Rue de Rivoli. Suddenly, I found myself rattling around the vast kitchen at the Palais des Tuileries, which housed the treasury department. The kitchen dated back to the seventeenth century, when more than one hundred chefs cooked there for the likes of Louis XV (also called the Well-Loved King). The place was as cold and damp as a dungeon dating from the same era, but a predecessor of mine had converted one small corner into something that resembled a twentieth-century kitchen.

During France's Fourth Republic, governments fell with regular frequency. Four months after I started working for him at the treasury, Gaillard moved up to become the President of the Council of Ministers, or Prime Minister. Accordingly, I suddenly found myself as France's First Chef and moved to the kitchen in L'Hôtel Matignon, the official residence of the French head of state.

Gaillard had a fully staffed mansion of his own in Paris, and he returned to it every evening after work to have dinner and spend the night. Although I cooked his lunch almost every day, he took the evening meal at L'Hôtel Matignon only on special occasions, such as visits from foreign leaders. However, one of his directors of cabinet resided full-time at L'Hôtel Matignon and more than made up for the absence of the president. Monsieur Aicardi dined on my fare every night. Knowing that the government would foot the bill, Aicardi made sure he ate very well indeed. A gourmand and complete food snob, he delighted in perusing vintage cookbooks (among them a 1935 edition of *L'Art Culinaire Moderne* by Henri Paul Pellaprat, founder of the Cordon Bleu school of cookery) and then challenging

me—a brigade of one—every evening to prepare the intricate and often obsolete dishes they described. I found many of his requests as challenging as anything our four-dozen-member-strong brigade had prepared at the Plaza.

Mr. Aicardi's Roasted Poularde

To begin with, a *poularde* is not your typical barnyard chicken. Traditionally, it is a spayed hen (spaying keeps the meat tender) that farmers fatten on an extremely rich diet—the female counterpart to a capon. And it commands a price that reflects the extra care entailed in raising such a pampered bird. For Monsieur Aicardi, I stuffed a *poularde* with a mixture of rice and wild cèpe mushrooms and then roasted it in a 425°F oven for a good hour, until the skin became golden and the meat moist and tender. I accompanied the chicken with a truffle sauce made from reduced browned veal stock, port wine, butter, and chopped truffles. The dish also included whole truffles in puff pastry casings and slices of foie gras terrine. The maître d' presented the bird to Aicardi whole and carved it in the dining room in front of him. That single meal contributed substantially to the republic's national debt.

True to form for the period, Gaillard's government collapsed, and Aicardi found himself out of a job, without a magnificent palace to call home, and lacking the services of a personal French chef. I, however, kept my position. That a cook had better job security than a prime minister says something about the political turmoil in France at that time.

My new boss was none other than the great statesman Charles de Gaulle. Technically, I answered directly to Madame de Gaulle, known to the entire nation as Tante Yvonne (Aunt Yvonne), and she called me Petit Jacques. Despite their eminence, unless I was preparing a state dinner or a meal for visiting leaders of other nations, when we spared no expense, the de Gaulles enjoyed simple, straightforward food, unlike Aicardi. Also, unlike Aicardi, on Sundays after church (they were devout Catholics), when the extended de Gaulle family usually gathered at L'Hôtel Matignon, they insisted on paying for the family meal out of their own pocket. I presented a separate accounting each week to Madame de Gaulle, and she directly reimbursed the government.

Chicken Chasseur

The de Gaulle family enjoyed simple, bourgeois fare, like chicken *chasseur* (hunter's chicken), the French take on Italy's chicken cacciatore. I cut a chicken into pieces and sautéed them in butter until they had browned on all sides. Into the same pan, I tossed sliced mushrooms, the regular cellar-grown kind known as *champignons de Paris,* with shallots and garlic, cooked them for a few minutes, and deglazed the pan with a splash of white wine. I added a couple of peeled diced fresh tomatoes and simmered the dish covered for 20 or 30 minutes. Then I smothered the chicken pieces with the sauce, sprinkled on some chervil or tarragon, and served the chicken *chasseur* with basic sides like string beans cooked with shallots and a potato gratin. Simple stuff, which added up to a family meal fit for a president.

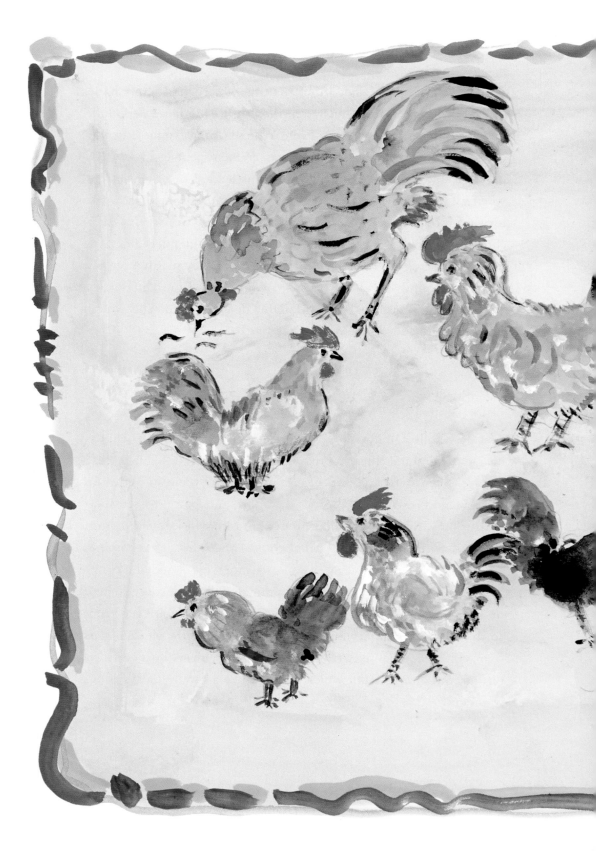

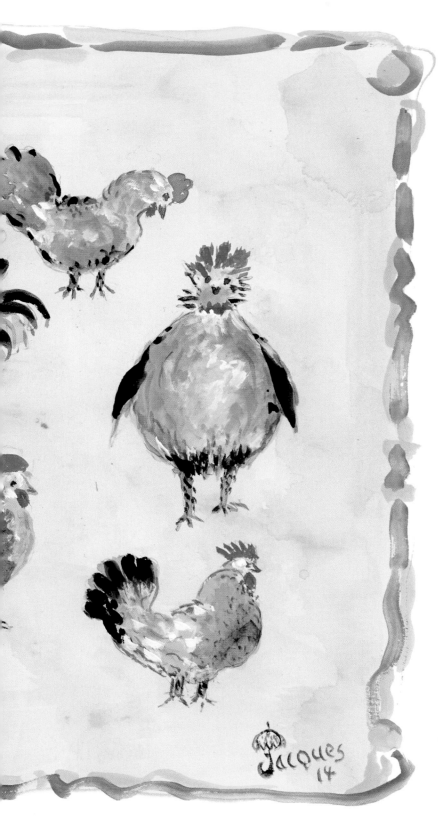

Les Poulets, 2014

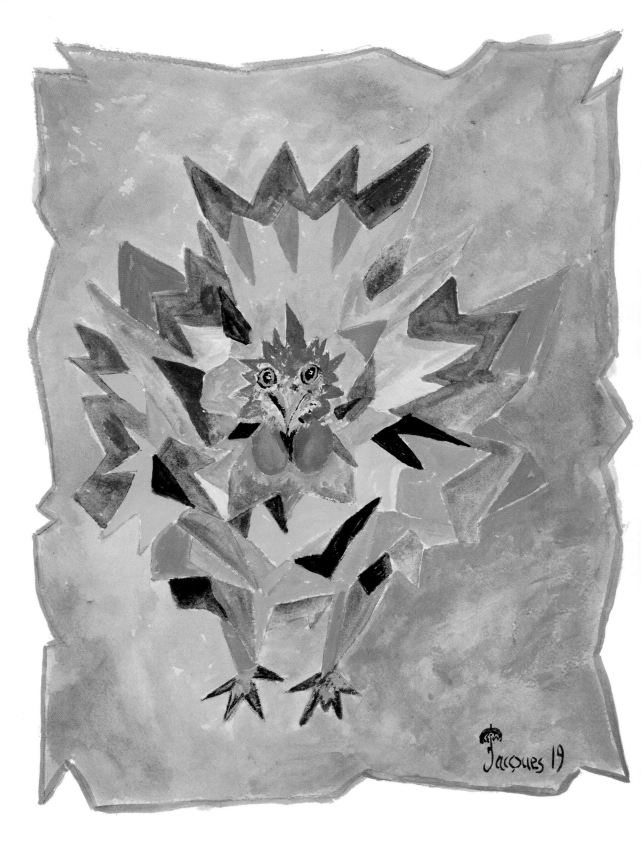

New World,
New Opportunities

―――――

I HAD LONG DREAMED of traveling to America, which I viewed as some sort of El Dorado. After getting discharged from the Navy (which spelled the end of my gig at L'Hôtel Matignon), I returned to the Plaza for a short stint before I met a New York restaurant owner who agreed to sponsor me. I had a simple plan. I'd learn English while I worked in America for a couple of years and then return to the real world of Paris. That was in 1959. My stay turned out to be over half a century and counting.

I found a spot on a student boat from Le Havre in France to Quebec City, then a train to New York's Grand Central Station, and finally a cab to my final destination, La Toque Blanche on East Fiftieth Street, the restaurant owned by my sponsor, Ernest, a French man from Alsace. The next day, Ernest escorted me to the kitchen of Le Pavillon, then recognized as the finest French restaurant in the United States. It was owned by Henri Soulé, who maintained the highest standards of classical cuisine with an iron fist but comported

Facing page: *Futuristic Rooster,* 2019

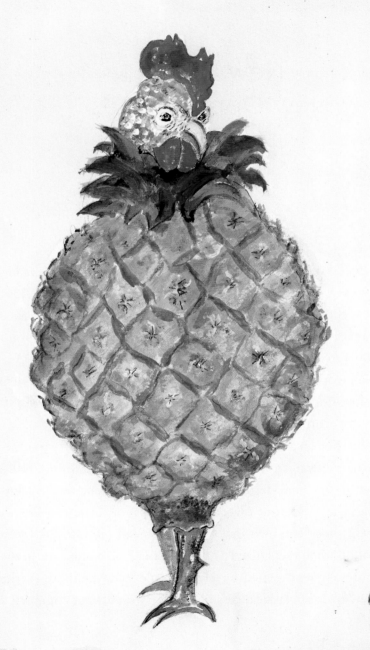

Jacques 20

himself like a tin-pot despot. The best I can say of him is that he was an equal-opportunity crank. Politicians, movie stars, business titans, haughty members of the social register—even Joseph Kennedy and his son Jack, the future president—and kitchen staff all felt his regal disdain. I doubt whether I would have lasted long if I reported to him directly. Fortunately, Pierre Franey, the chef at Le Pavillon, possessed both great talent and an amiable disposition. He hired me on the spot. That I was French and had cooked at the Plaza Athénée in Paris was all he had to know by way of a curriculum vitae. I got along great with Pierre, and we became a tight working team—as well as very good friends.

❧ ❧ ❧

Le Pavillon was at once familiar and foreign to me. Although it served food on par with the best available in Paris, the kitchen structure was nowhere nearly as rigid—dare I say sophisticated—as that at the Plaza or the Meurice. In New York, we managed with a lower cook-to-customer ratio, and chefs continually shifted from one station to another according to workplace demands.

But the two most obvious differences involved the use of vegetables and of live-fire grilling. At the Plaza, we had two grills, one for meat and one for fish, each overseen by a separate chef. The Pavillon didn't have a grill—period. Instead, we used an oven broiler. Vegetables held a place of honor in France and were given respect. At the Plaza, five or six cooks worked at the vegetable station, or *entremetier,* creating at least a half dozen vegetable dishes every evening. In New York one low-ranking cook handled vegetables, preparing maybe one or two, which guests had to order à la carte, if at all. It was quite a paradox, given the emphasis modern American chefs put on vegetables and grilling.

Facing page: *Pineapple Chicken,* 2020

Poulet Pavillon

No effort was spared in preparing Le Pavillon's famous roast chicken. We always presented and carved an entire bird tableside, even for one order. We inserted a golf ball–size lump of butter in its cavity, massaged the skin with more butter, added salt and pepper all over, browned it on all sides, and roasted the chicken in a very hot oven. For a sauce, Champagne and chicken stock were reduced and then thickened with a roux of equal parts butter and flour, then heavy cream and Cognac were added. As a final step, a glaze was made by combining the cooking juices with a rich brown chicken stock and reducing it to the consistency of a heavy syrup. After positioning the roasted bird on a silver platter, it was generously covered with the cream sauce, and dotted with the glaze.

After about a year at Le Pavillon, I made what most people would have regarded as a downright stupid career move. I was asked to become the White House chef for the Kennedy administration and at the same time invited to take a job as Pierre Franey's assistant at Howard Johnson's main commissary. I had done the presidential routine in France, but the idea of learning something new combined with the challenges of mass production appealed to me. I chose HoJo's. Quitting one of the very finest kitchens in the country, I found myself standing over a grill flipping burgers and hot dogs at a Howard Johnson's in the nether reaches of Queens.

Howard Deering Johnson regularly dined at Le Pavillon. He admired Pierre Franey and enticed him to come to work in the company's huge commissary to improve the quality of the menu items sent

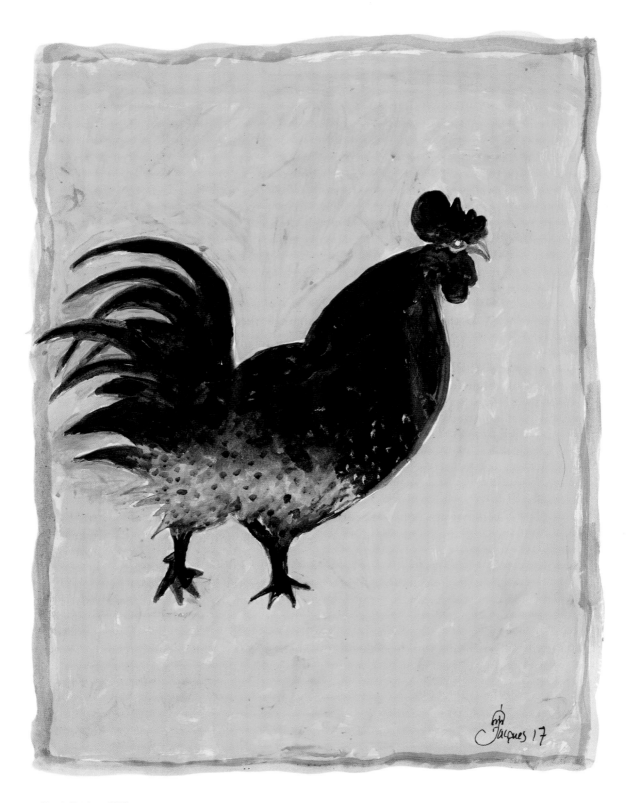

Black Chicken, 2017

from that central kitchen to more than a thousand outlets across the country, making Howard Johnson's the largest restaurant group in the nation at that time. Pierre invited me to join as his assistant. But before Mr. Johnson allowed me to work in the commissary, he shrewdly insisted that I put in time on the line at one of the company's restaurants to gain an understanding of the real, on-the-job working conditions for the minimally skilled cooks who would be preparing the menu items Pierre and I developed.

And learn I did. It was my first exposure to a real American restaurant, American food, and American cooks, who all happened to be young men of color. No one spoke French, and no one had ever heard of the fancy restaurants I had worked for in France. It was a very equalizing experience. Nothing in my career cooking high-end French cuisine had taught me the finer points of preparing food on a flat-topped griddle. I scrambled eggs, cooked them sunny-side up, and flipped them over hard. Piles of hash browns sizzled beside the eggs, along with hot dogs, hamburgers, cheeseburgers, and pancakes.

After a couple of months in the culinary boondocks, I was ready to rejoin Pierre at the commissary in a warehouse-like building in Queens Village out by the airport. Mr. Johnson gave us carte blanche to create whatever inspired us, so long as the ultimate end was better food for his restaurant empire, which, despite its size, had a reputation at the time for quality family fare—the antithesis of a local greasy spoon or drive-in burger stand.

I found myself in a brave new world. I needed to familiarize myself with all-American tastes and dishes: fried clams, New England clam chowder, Boston baked beans, Southern fried chicken, and of course, apple pie.

Facing page: *Cock on Board*, 2013

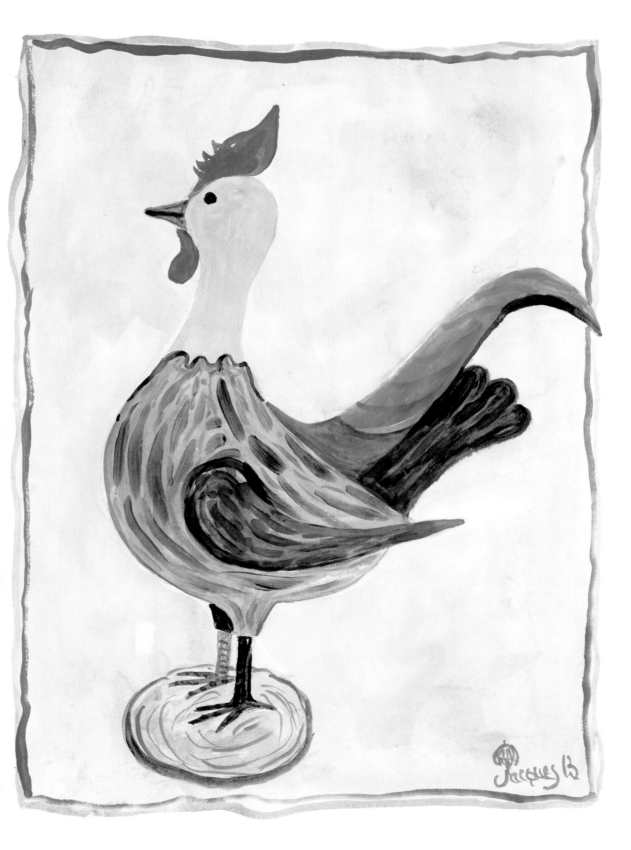

Jacques 63

Le Coq Gaulois, 2021

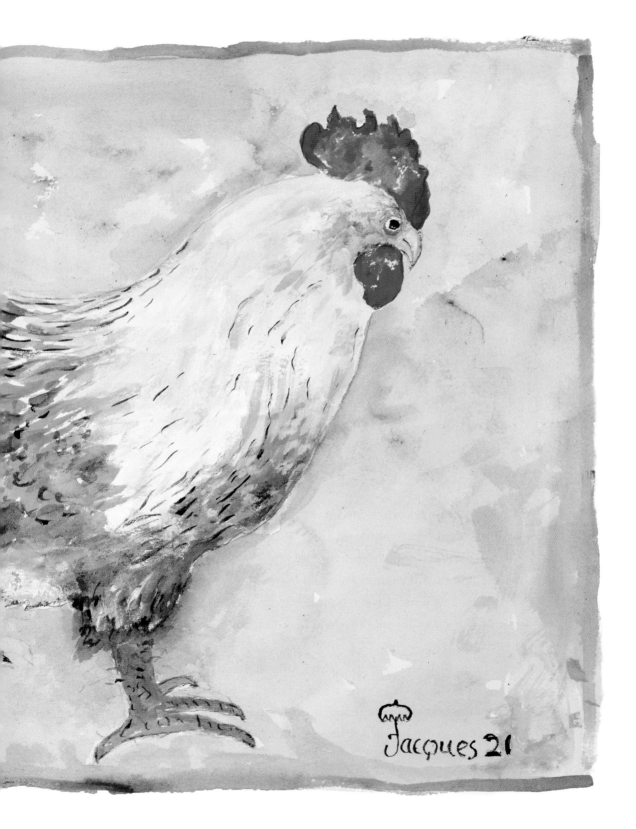

My Home Version of HoJo's
Southern Fried Chicken

✤

I had never encountered a dish prepared quite like the chain's famous Southern fried chicken, with its delicious crispy coating. We used a piece of equipment I'd not seen before, a combination deep-fryer and pressure cooker. I enjoyed that chicken so much that I often duplicated the dish at home, making a few adjustments for a nonindustrial kitchen. I began by cutting a chicken into pieces and soaking them for 24 hours in buttermilk and a bit of Tabasco sauce. While I heated lard and peanut oil in a large cast-iron skillet with a tight-fitting lid, I shook the buttermilk off the chicken and rolled the pieces in flour mixed with a little baking powder—making in essence a self-rising flour. When the fat reached 325°F, I dropped the chicken pieces into the pot and put on the lid to replicate the moist conditions of the pressure cooker for 20 minutes or so. The result: chicken at its most succulent.

In addition to providing an on-the-job education in my adopted country's culinary traditions, HoJo's was a crash course in the basics of food science and chemistry. Any lapse in the sanitary conditions at the commissary could have sickened thousands of customers, so I also had to master food safety protocols. New terms entered my cooking vocabulary, among them bacteria, coliform, salmonella, and specific gravity.

Along with learning to fry in a pressure cooker, I mastered new ways to cook, such as retort sterilization, where food is cooked in hermetically sealed containers, a process similar to that used in canning. I fast-froze finished dishes with dry ice.

The resident chemist, a Greek man named Christopoulos, or Chris for short, analyzed new dishes as we developed them, and how they tasted was far from the only criteria by which he measured them—he wanted to understand how they worked on a chemical basis. He explained what caused a new sauce formula to separate. He determined the correct temperature at which to maintain a dish and which starch was appropriate for a specific cooking method.

Chris made another contribution to my culinary education when he invited me to his home to partake in the family's traditional Greek Easter meal of lamb. As the guest of honor, I was given the most sought-after portion—the entire roasted head with eyes still in their sockets. With the extended family watching, I swallowed an eye, grateful to wash it down with one of the brimming glasses of ouzo that were also de rigueur at Chris's Easter table.

Much of our kitchen equipment incorporated space-age technology and had Brobdingnagian dimensions: a novel machine called a radar range (that morphed into today's microwave ovens), thousand-gallon steam kettles with metal ladders on the outsides to allow us to climb up to their tops, twenty-foot-tall revolving ovens resembling miniature Ferris wheels with dozens of baking trays that rotated as their contents cooked evenly, and propeller-like agitators that could have powered a B-24 bomber, which we used for mixing. I had come a long way, technologically speaking, from the days when I prepared meals in individual saucepans in the seventeenth-century kitchen at the Palais des Tuileries.

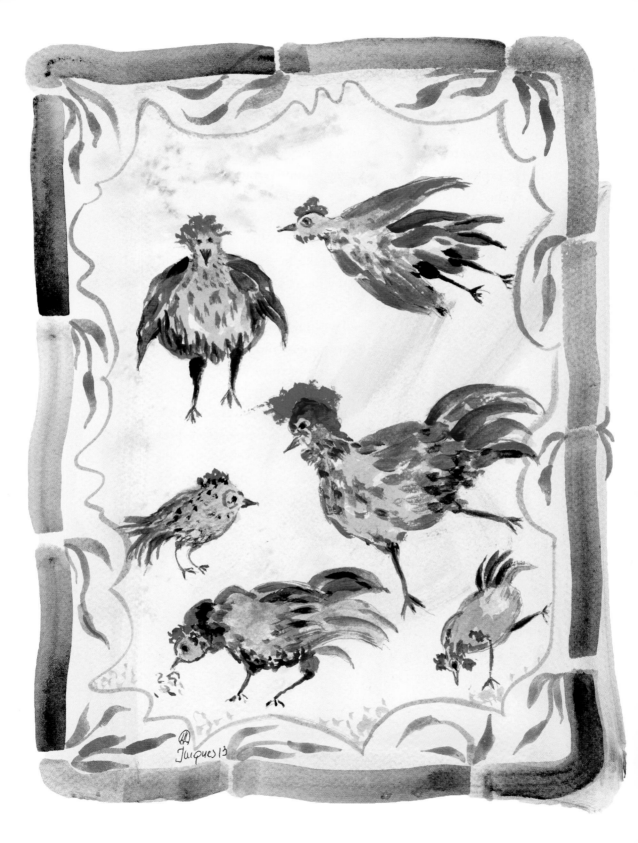

Chicken Potpie for the Masses

Our work at the commissary would have been much easier if developing recipes in quantities sufficient to serve the needs of Howard Johnson's was a simple matter of multiplying the ingredients for a family meal by several hundred. However, you can't do that and get an edible result. So, to reformulate the chicken potpie, an American classic dish served in all our restaurants, I started tinkering in my home kitchen–sized test kitchen by poaching a couple of large chickens and separating the meat from the bones. I made a cream sauce and added peas, pearl onions, and diced carrots, then assembled the dish in individual portions, which I froze. Later in the same test kitchen, I defrosted, heated, and tasted each serving. Chris analyzed and recorded the results from all of the steps.

Once that modest batch passed muster, I proceeded to poach twenty chickens in a fifty-gallon kettle. I went through the same process as I had earlier, adjusting seasonings, methods, and cooking times. We ultimately worked up to batches of three thousand pounds of chicken poached in metal baskets submerged in thousand-gallon kettles, along with the right amounts of bay leaves, thyme, black peppercorns, and salt. When the chicken was done, we hoisted the baskets out of the cauldrons with a pulley that had more in common with a construction crane than any piece of kitchen equipment I'd used up to that point. The baskets traveled along a metal beam suspended from the ceiling until they reached stainless-steel tables, at which point the bottoms opened to allow the chickens to tumble out. Teams of four or five workers would then bone them and cut the meat into bite-sized pieces. Most of the workers had little or no previous kitchen experience, so I had to train them. But after a couple of months of repetition, many could perform their tasks three times as fast as I could.

Facing page: *Claudine's Book,* 2013

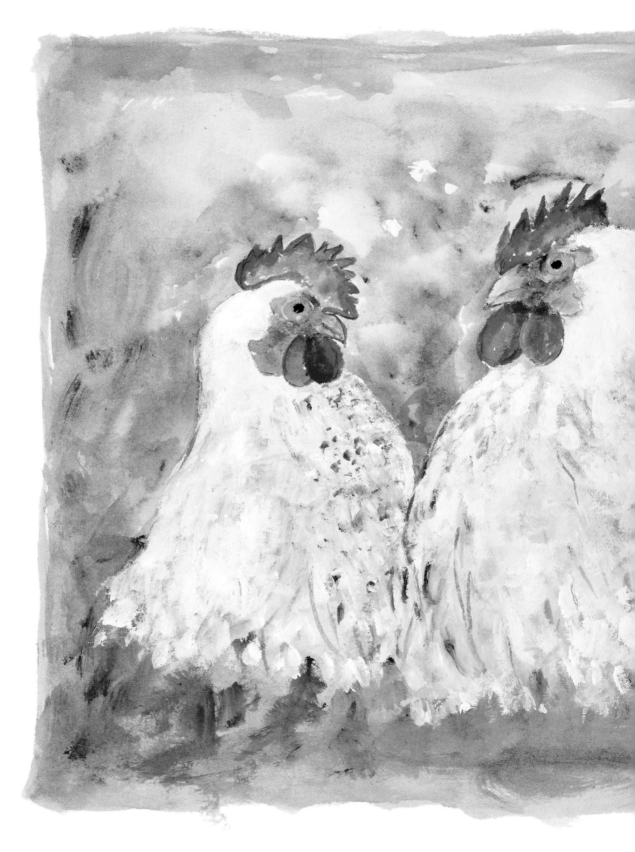

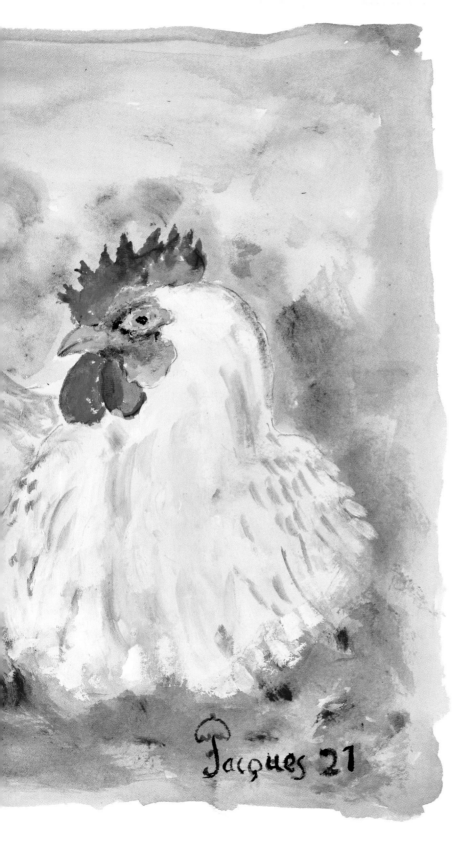

Three Chickens of Bresse, 2021

We pumped out the stock that remained after we removed the chickens and strained it into another kettle, where we made the potpie sauce. It, too, was an exercise in gigantic proportions. We made the roux by combining several hundred-pound sacks of flour with an equal quantity of delicious unsalted butter and added the mixture to the stock. A ratio of about ten parts stock to one part roux gave us the viscosity we sought—neither too watery nor too thick. That aviation-grade agitator blended the roux and stock together. Then the sauce cooked for about a half hour before being finished with heavy cream that came in fifteen-gallon jugs.

Fifteen workers standing on either side of a conveyor belt placed six ounces of chicken in individual plastic bags, along with the sauce, peas, pieces of diced blanched carrot, button mushrooms, and pearl onions. A machine sealed the bags as they continued on the conveyor belt, which took them directly into a circular freezer kept at forty degrees below zero. Forty minutes later, the belt had completed its circuit, and the now-frozen-solid bags were ready to be packed in dry ice and stored in walk-in freezers the size of squash courts, overseen by workers dressed like Arctic explorers.

From there, a fleet of refrigerated trucks delivered the potpie mix to individual restaurants. The initial plan required that the cooks slowly thaw the bags for twenty-four hours under refrigeration, microwave them for a minute, and give them a vigorous shake for a few seconds to reconstitute the sauce (which had a tendency to separate after being frozen), then place them for another minute in the microwave, before emptying their contents into a small serving dish topped with a precooked disk of pastry, which had also come from our commissary.

Or so we had hoped. Unfortunately, it didn't work nearly as smoothly in the restaurant kitchens. The cooks often neglected to

Facing page: *Lunatic Chicken,* 2019

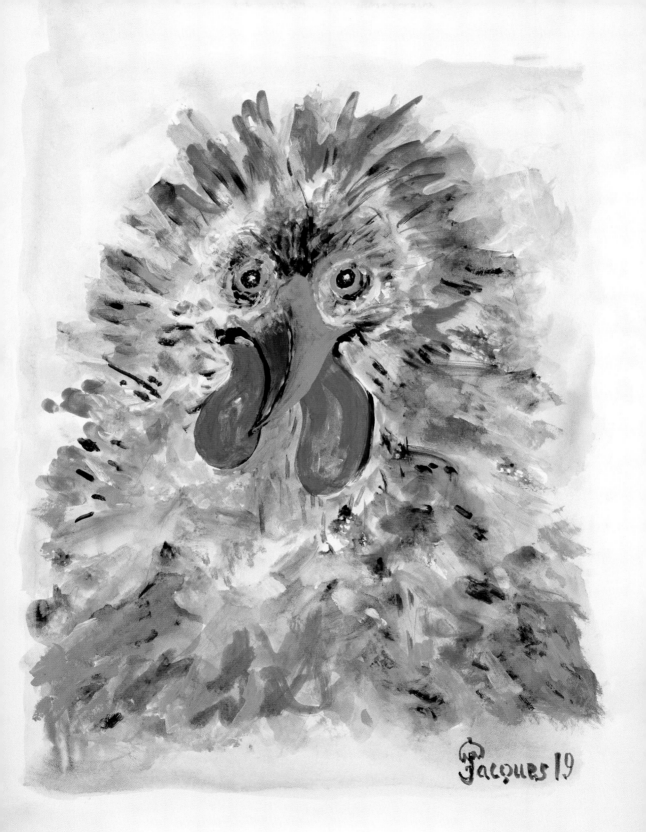

Wacky Chicken, 2019

go through the bother of shaking the bags, and the sauce, which was supposed to be white and smooth, broke up into an unappetizing watery slurry with hunks of solid matter—not the quality expected by Howard Johnson's guests. We regrouped. This time, we taught the chefs how to bring the potpie mixture to a boil in a small saucepan for a few seconds until the contents became hot and properly reconstituted. Then they poured the mixture into serving dishes, and the chicken potpie became a signature menu item across the entire chain.

The years I spent at Howard Johnson's changed my life as a cook. Learning about production, the chemistry of food, marketing, recipe writing, all made me grow and helped me develop skills outside of cooking, too. The entire process of testing and retesting, of considering a recipe from many different angles, and taking into account the scale on which it would be produced was all new to me and allowed me to use my brain in ways I never had before.

❧ ❧ ❧

The world of food in the United States has experienced radical transformation for the better since my early days at HoJo's. In the 1950s and early 1960s, there were no shallots or fresh mushrooms in supermarkets and only one type of lettuce—iceberg, or occasionally some romaine. US grocery stores seemed very well supplied with beautiful beef and lamb and lobster, but relatively few vegetables, no fresh herbs, and few varieties of oil and vinegar. Fortunately, the quality, diversity, and amount of food in the American supermarket has never been as fresh and beautiful as it is currently.

In December 1963, I finagled a couple of weeks' vacation time from Howard Johnson's, and a friend and I decided to travel to Mexico for Christmas. On our way there, I wanted to go to Dallas to pay my respects to President Kennedy, who had been assassinated there

a few weeks earlier. We flew into Dallas and stayed at the beautiful Adolphus hotel. As we checked in, I asked where the bar was, and the receptionist informed me that we were in a dry county. I had no idea what that meant. The receptionist enlightened me by telling me that alcohol was prohibited, and there was simply no bar where we could have a drink. However, we could join their private club and be served drinks with a meal at their elegant restaurant, called the French Room.

That evening we got dressed up and went to the restaurant for dinner. As the name indicated, the menu was in French (with a great deal of misspellings, but in French all the same), and the room was chic and luxurious. The waiters were dressed not just in tuxedos but with tails and white gloves. I noticed that a great many of the diners had brown paper bags at their tables—bottles of liquor they had brought to be consumed with their dinner.

I asked for the wine list, which they brought, and to my shock there were several beautiful Burgundy wines, both reds and whites, reds such as Romanée-Conti and Échezeaux as well as white Puligny-Montrachet. Some of them were from 1959, an extraordinary year, only four years old but still ready to be enjoyed. I asked, "Do you have that bottle of Échezeaux?"

The waiter responded, "Absolutely."

So, we ordered it. The price was somewhere around $20, which would correspond to about $150 now, a bargain for that special red wine from upper Burgundy. They brought the dinner menu, and we ordered but had still not received our wine. We decided on a chicken Bercy.

Chicken Bercy

❧

This classic chicken preparation is made by cutting chicken into pieces and sautéing them with shallots and butter until all the pieces are uniformly and nicely browned. After that, it is deglazed with a dry white wine, some demi-glace is added, and finally it's garnished with sliced mushrooms and small pork sausages and finished with a splash of lemon juice and a piece of butter.

We started the meal with *amuses bouches,* which came compliments of the house. To our delight, they brought us deviled eggs garnished with a little bit of caviar. But still no wine. I kept asking the maître d', but the wine eluded us. The first course came, still no wine. We kept asking, and finally our great red burgundy arrived in a bucket of ice where it had been chilling to a frigid temperature that whole time.

We took the bottle out of the ice and put it on the side, deciding we would let it come to room temperature and drink it later. We asked if they had another bottle, and could they please bring it to us without chilling, explaining we were kind of strange and preferred it that way. We ended up drinking our two bottles of wine with our chicken Bercy.

Since that time there has truly been momentous change. It is amazing to realize the amount of knowledge and expertise the world of food and wine has undergone in the United States. From the open markets to the making of cheeses, wines, bread, and charcuterie, as well as the overall quality and diversity of restaurants, produce, and products, these changes make America unique in the world.

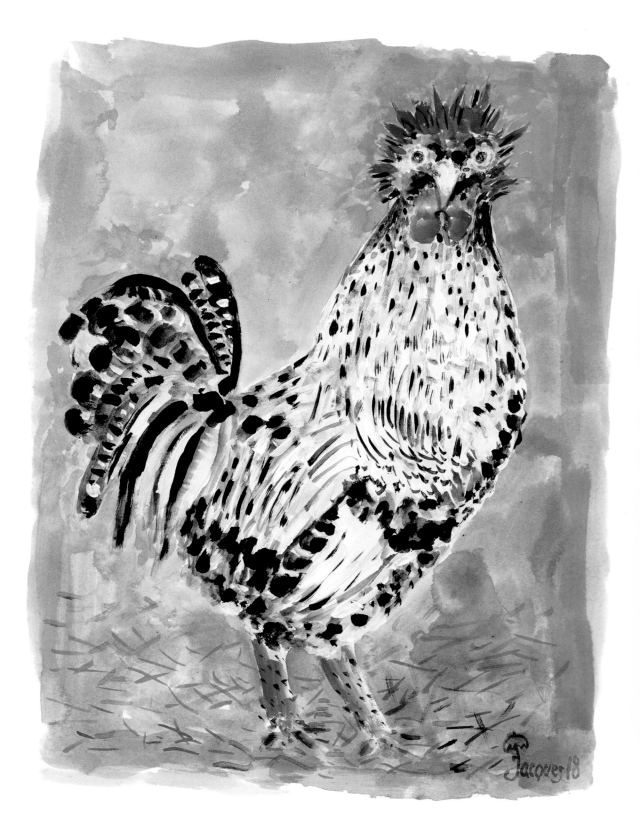

The day after our meal at the French Room, we went on to travel to Mexico and came back after Christmas ready to enjoy New York—and wine served at the proper temperature—again.

❧ ❧ ❧

By then, I had become close friends with Pierre and spent most summer weekends with him and his family at their beach house in East Hampton on Long Island. Coincidentally, Craig Claiborne, the vastly influential food editor and restaurant critic at the *New York Times,* and a friend of Pierre's, had a home next door. Craig and I also became pals. We bonded over marathon weekend cooking sessions to prepare food for the large parties that Craig loved to throw.

In the mid-1960s, Craig announced that we'd be hosting a clambake on the beach for nearly sixty guests. I had attended a couple of clambakes since my arrival in the US and was vaguely familiar with the New England tradition. But I had never cooked at a clambake anywhere close to the size Craig planned and had no idea what role Craig and Pierre expected me to play. Craig explained that we would be rising just before dawn (not a good hour for me) and spending the day cooking lobsters, clams, whole fish, corn, onions, potatoes—and, yes—chicken between layers of seaweed in a pit dug in the sand and lined with stones.

We took care of the first step the night before when we lugged a load of firewood, ranging from twigs to tree trunks, and piled it on top of stones in the bottom of the pit. On the morning of the event, that mountain of wood fueled a conflagration so fierce that I worried about some uninformed neighbor calling the town fire brigade. While the flames raged, we cut up the chickens, then tossed the pieces on a grill, not long enough to cook them through, but just enough for them to become charred where they touched the grates. We then

Facing page: Mighty Fowl, 2018

wrapped the chicken in cheesecloth, along with all the other ingredients.

Hours later, once the fire had burned down and the pit contained nothing other than a little white ash and some very hot stones, we heaped on wet seaweed, creating a billowing cloud of steam. After tossing in the cheesecloth packages, we mounded another load of seaweed on top, covered the pit with a tarp, and shoveled on a layer of sand to seal the steam in the pit. After two hours and a few well-earned bottles of wine for the cooks, we uncovered our feast and served the food with herbed butter, mayonnaise, salad, chocolate ice cream, local berries at the peak of ripeness, and many more bottles of wine. The food had the complex and flavorful taste of smoke, seaweed, and the ocean. For me, it was the taste of a whole new world and well worth the exertion.

❧ ❧ ❧

In America, my cooking began to borrow freely from a wide range of international cuisines. As Maman pronounced on one of her visits to this country, after I had presented her with a warm lobster roll drenched in butter, "Tati (my nickname), a sandwich with lobster!" Her voice was genuinely full of wonder. She had never tasted American lobster before and was surprised but enjoyed it very much. In France, lobster is extremely expensive and appears only on the tables of fancy restaurants in complicated dishes. It is rarely prepared at home. Things like accessibility and different climate played a role in being able to use ingredients in different ways as much as different cultural tastes and customs.

Facing page: *Rooster and Chick*, 2018

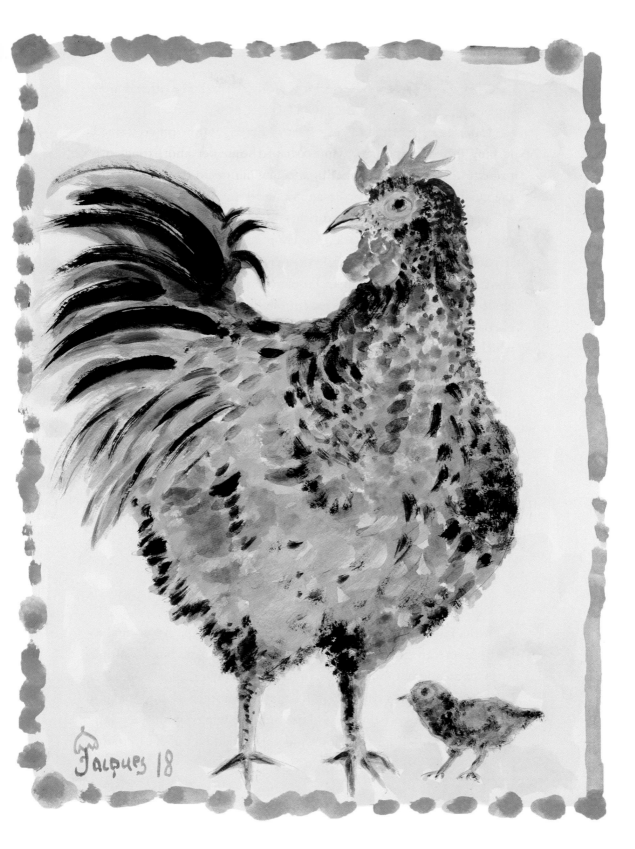

Chimichurri Chicken

❧

I enjoy trying recipes from any part of the world, and I frequently prepare chicken with chimichurri sauce. Chimichurri originated in the cuisines of Argentina, Paraguay, and Uruguay, but it resembles the persillade my mother and other home cooks in France use all the time. To make persillade, you chop garlic and parsley together. If you add oregano and a chile pepper or red pepper flakes to that mixture, you have chimichurri. I use it on steaks and fish and in omelets, but I find that it also goes exceptionally well with grilled chicken, particularly on the tiny tenders from the inside of chicken breasts, which you can purchase already separated at the grocery store. I brush the tenders with a little oil, sprinkle on some salt and pepper, and lay them on a very hot grill just long enough to get grill marks, at most a minute on each side. I arrange them on a plate and cover them with chimichurri for an almost-instant meal. Don't skimp when you make chimi. It lasts for a couple of weeks in the refrigerator in an airtight container, ready to lend its piquancy to any number of dishes.

Arroz con Pollo

❧

My wife, Gloria, loved arroz con pollo, another recipe traditional to Latin American cuisine. Gloria was born in New York, but her father was Cuban and her mother Puerto Rican. Following Gloria's advice, I make a version of arroz con pollo that her mother used to make. I sauté chicken pieces (sometimes I use only the wings) with spicy sausage and lots of chopped onions and garlic. I add a pinch of cumin,

a few drops of sriracha, Italian seasonings, and chopped fresh to-matoes. These ingredients go into a saucepan with rice and chicken stock. I cover it and cook it on the stove until the rice is done and the liquid absorbed. The key is using the right amount of rice for the liquid, which can require a bit of tinkering. Diced tomatoes and on-ions add their own moisture as they cook, so you have to adjust the amount of stock accordingly to achieve the desired moist, creamy, and slightly sticky consistency. Gloria liked regular long-grain Caro-lina rice in arroz con pollo. Before serving the dish, I add some more hot sauce and shower it with a good fistful of chopped cilantro.

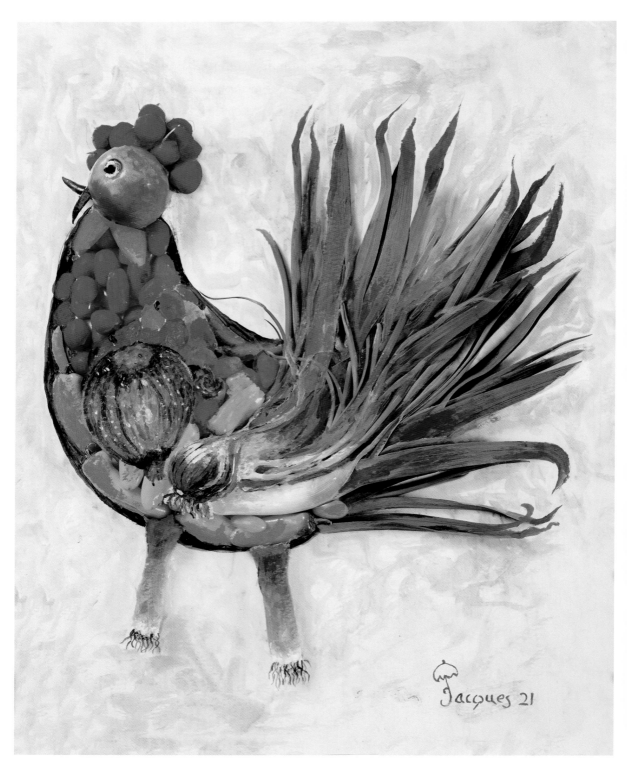

Chicken and Vegetables 2, 2021

With new foods to experience, a good job that I enjoyed, and a growing circle of terrific friends, I had no time to be homesick for France. After nearly three years in the States, I had saved what seemed like a fortune and suddenly had the desire to spend it on a vacation back home. An American friend had asked me to bring back a new Volkswagen she'd bought from a dealer in Paris, so I had a shiny, new blue Beetle at my disposal while there.

My older brother, Roland, had also come home from West Africa, where he worked. My younger brother, Bichon, had just gotten engaged to his girlfriend, Loute, and they both were free for the summer. My mother and father still operated Le Pélican, their restaurant in Lyon, but announced that they would close it for a month to take what would be their first vacation in more than two decades as restaurant owners. We decided to go to Spain, where none of us had never visited.

Our group also included Paulette, our waitress who started out working for my mother and became a dear family friend who helped raise me and my brothers. We loaded ourselves into my father's faded red Panhard automobile and the Beetle and took off.

At the time, France and Spain had no expressways. We enjoyed exploring the narrow local roads and stopping at open-air markets to procure our food for the day. Through the Beetle's windshield, I saw a blizzard of string bean ends, carrot tops, and pea shells flying out the open window of the venerable Panhard as Maman and Paulette trimmed produce for the evening's meal. Before we embarked on our road trip, Maman had made sure she equipped the cars with an assortment of pots, pans, and utensils. We pulled over to the side of the road, preferably near a cool stream for swimming, built a fire, and cooked our lunch or dinner. At night, we slept in small, inexpensive guesthouses, no reservations needed.

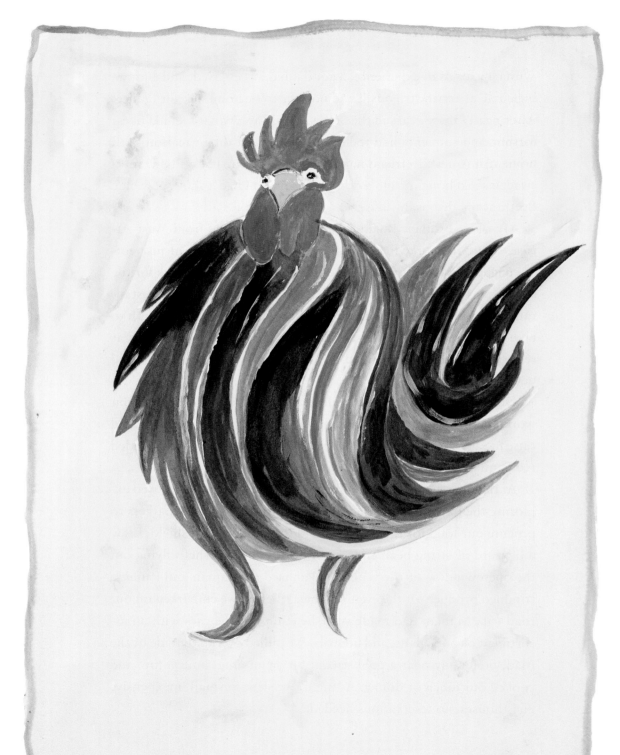

Jacques 17

My father was delighted when he found out that Spanish wine cost half as much as French. At the same time, he also discovered that great Spanish invention, the wineskin, or bota bag. He soon mastered the art of hoisting his new bota high above his head and pressing it to send a stream of wine directly into his mouth. He marveled at the amount of money he was saving, but given the quantities that flowed from his bota bag, it was a false economy.

At a bistro in Granada in southern Spain, we enjoyed our first tapas. The wine came in a very short glass with an edible lid: a piece of thickly sliced Serrano ham. It kept flies and other insects out of the glass and provided a perfect snack to have with the wine.

In addition to Papa's wineskin, we added a paella pan to our kit. At a market, we bought a rabbit and a scroungy chicken that resembled an undernourished crow. Arriving at an appealing dinner site, our roving clan gathered wood for a fire. After unwinding with a couple of glasses of wine, we began preparing our paella by cutting up the rabbit and the chicken and sautéing the pieces with chorizo, onion, garlic, mushrooms, bell peppers, tomatoes, herbs, squid, mussels (the least expensive seafood in the market), and short-grain local rice covered with white wine and water, which was all cooked over the fire in the thin steel paella pan. The rice on the bottom of our paella formed a deliciously chewy thin crust—called a *socarrat*—exactly the way it is supposed to.

Facing page: *Stylized Rooster*, 2017
Next spread, left: *Super Chicken*, 2017; right: *Chicken with Squash*, 2020

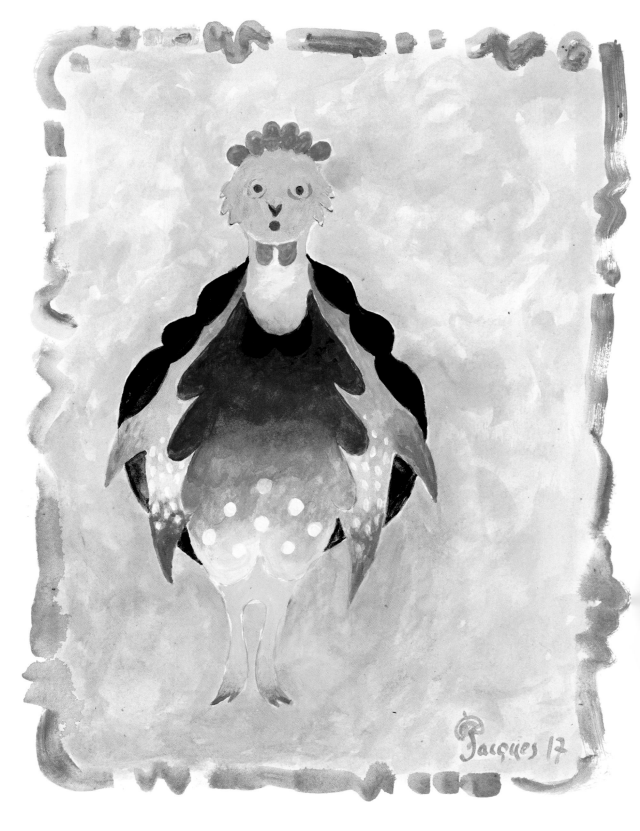

The Classic Cock, 2017

A Return to the Classics

N THE LATE 1960s, Time-Life decided to create about thirty cook-books for their *Foods of the World* series. The editor asked Craig Claiborne to provide the text and hired Pierre and me to create the food and style the photographs for the volume *Classic French Cooking*—"Classic" being the operative word. The food was intricate and complex and signaled the end of an era before the advent of nouvelle cuisine a few years later. I felt like I'd been transported back to the Plaza Athénée in Paris.

I had no written recipes for those dishes. So, I cooked from memory, and an assistant from Time-Life hovered over my shoulder, notepad in hand, to record ingredients, quantities, techniques, and timing as I worked.

Poularde à la Néva

This is a complex, ambitious recipe, which requires several stations of a classic brigade to work together. In other words, not something one would try to re-create at home. The nineteenth-century master

chef Marie-Antoine Carême invented *poularde à la Néva* in Russia when he was cooking there for Tsar Alexander I. Truly a dish fit for a tsar, *poularde à la Néva* is visually stunning: a whole, cold chicken coated with a jelled velvety sauce of chicken stock, cream, and egg yolks and glazed with shiny aspic.

In water flavored with onions, leeks, carrots, bay leaves, thyme, and cloves, I poached two large, fattened hens, called *poulardes*, one trussed with its feet still attached. I made some of the poaching stock into an aspic, clarifying it with egg whites and adding plain gelatin along with celery leaves, tarragon, and parsley. I made the rest of the stock into a velouté sauce by thickening it with a roux and finishing it with cream.

After removing the breasts from the chickens, I cut each one lengthwise into three medallions, keeping the now breastless carcass with the feet for the presentation. To make a mousse, I first boned out the other chicken and puréed its meat along with the scraps from the carcass. In those pre–food processor days, that task involved pounding the meat to mush and forcing it through a tamis, a drum-shaped sieve with tiny holes. To the puréed chicken, I added whipped cream, puréed foie gras, salt, pepper, and Cognac. I covered the medallions with some of the mousse, coated them with the creamy velouté sauce, and chilled them. I decorated their smooth surface with "daisies," making stems with blanched leek greens and petals with truffle slices. The carcass with the feet attached would become the foundation of my reconstructed whole "chicken." Using the remainder of the mousse like modeling clay, I reformed the breasts onto the bones. Next, I transferred my creation to a sterling-silver serving platter. So far, the preparation was already a major undertaking.

But the dish still required several more steps. I coated my rebuilt

chicken with the jellied velouté and poured melted aspic over it. I also glazed the breast medallions, arranging some of them on the sides of the bird and arraying the others around it on the tray. Finally, I cut aspic into ½-inch cubes and scattered them around the platter. Triumphantly, I took the finished dish into the photographer's studio and set it down with a flourish. Making it had taken two full days from start to finish.

It was so striking that the photographer decided to shoot it close-up, from the top. Everyone oohed and aahed, agreeing that the resulting picture was a work of art. But the editor said that no potential reader would have the foggiest idea of what the image actually was. I went back to the kitchen, where I repeated the entire two-day process of preparing the *poularde à la Néva*.

This time, the photographer shot it from a distance, making it easy to tell at a glance that it was indeed chicken. At the last minute, he placed a bottle of Champagne in a silver bucket on one side of the frame to give the picture a classy feel. The editor hated that touch.

Back to the kitchen for a third time. Finally, with the chicken by itself in the middle of the photograph, without any distracting inclusions, everyone was happy. This shot eventually made the book's cover.

While I enjoyed the challenge of preparing the recipe and was happy to repeat classic techniques along the way, it provided a perfect example of why such cuisine was becoming an anachronism. I was glad that Time-Life paid me by the day. And as for those chickens that failed to make the editorial cut? Let's just say that several underpaid Time-Life test kitchen employees ate lunch like nineteenth-century royalty that week.

Next spread: *Stylized Chickens*, 2016

Jacques 16

I left Howard Johnson's in the spring of 1970. After ten years, I had learned pretty much everything that the organization had to teach me. Work had become a bit dull. Worse, Howard Johnson's son had assumed management of the business, and the once-freewheeling atmosphere became bureaucratic and corporate. With Johnson Sr. in charge, we'd have meetings in which we discussed creative ways to make better-tasting food. With Johnson Jr., we endured sessions where accountants ordered us to find ways to cut food costs.

When a group of investors approached me with an offer to launch a restaurant for them, I jumped at the opportunity. La Potagerie opened in Manhattan on Fifth Avenue and Forty-Sixth Street in the spring of 1970.

True to its French name, the new venture was all about soup, lots of it. We planned to serve a thousand patrons each day. To do so, I set up a mini version of the Howard Johnson's commissary by installing three fifty-gallon kettles in the basement. Following the template used at HoJo's, I intended to create a system in which I would teach specific recipes to cooks with moderate skills so they could prepare delicious food and serve it to guests quickly, at great value, and in a beautifully designed setting, complete with ornate tiled walls and a trickling waterfall.

Past restaurant experience had convinced me that La Potagerie's business model, founded on good, fresh ingredients with low food and labor costs, would be financially successful, even though we charged only $2.25, tax and tip included (equivalent to about $12 today), for a prix fixe meal that included a bowl of one of the three soups we offered daily, with a choice of baguette, black bread, or a croissant, as well as an apple brown Betty or fruit and cheese for dessert, and a soda or coffee. A glass of wine or a beer would set guests back an extra 60 cents. Even at that time, it was a steal. The gener-

Facing page: *Startled Chanticleer*, 2019

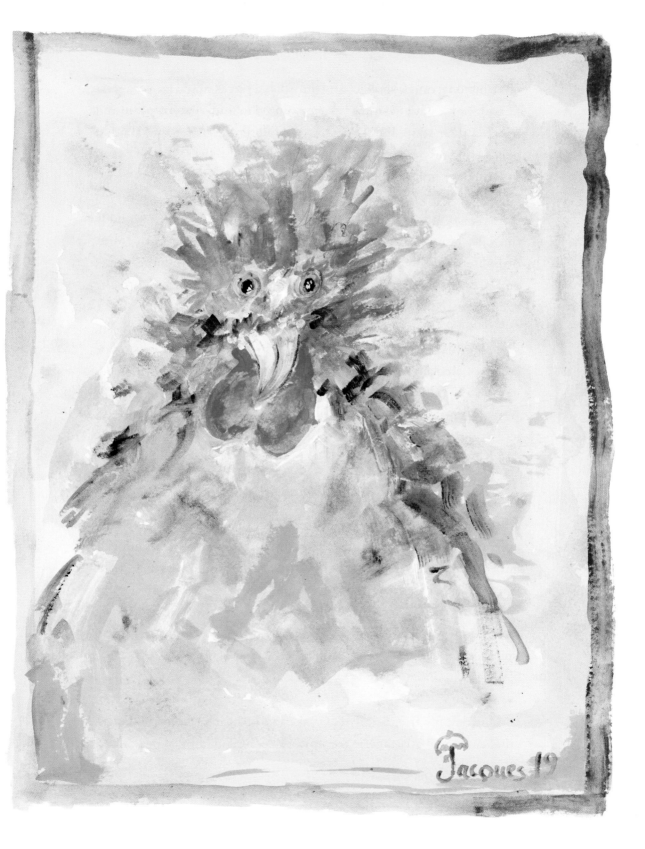

ous portions, quick service, and affordable prices made La Potagerie an instant hit with customers. They waited in line cafeteria-style and selected their soup, bread, dessert, and beverage. After they paid, a host or hostess escorted them to a table and delivered their order, bringing the soups in commodious earthenware bowls.

I created a great work atmosphere at La Potagerie. We served from 11:00 a.m. to 7:00 p.m., a single eight-hour shift, Monday through Saturday. I trained every employee to perform both front-of-house and kitchen duties. We paid higher than minimum wage, and all workers made the same amount, which contributed to the egalitarian, convivial atmosphere.

Our menu featured hearty, almost stew-like soups made from fish, shellfish, veal, beef, beans, and—naturally—chicken. My version of cream of chicken soup became the restaurant's most successful menu item.

Cream of Chicken Soup Potagerie

Step one, as in many good soups, involves starting with great chicken stock. We used tons of chicken carcasses at the restaurant and would poach chicken in water to create a concentrated stock with a lot of flavor. I thickened the stock with a roux of flour and butter and finished it with cream to make a velouté, the basis for many French soups and sauces. I added several big hunks of the poached breast meat along with a julienne of cooked carrots, celery, leeks, and mushrooms. We served this soup twice a week.

One day, my friend Sally Darr, the food editor at *Gourmet* magazine, came to La Potagerie for lunch, accompanied by Danny Kaye,

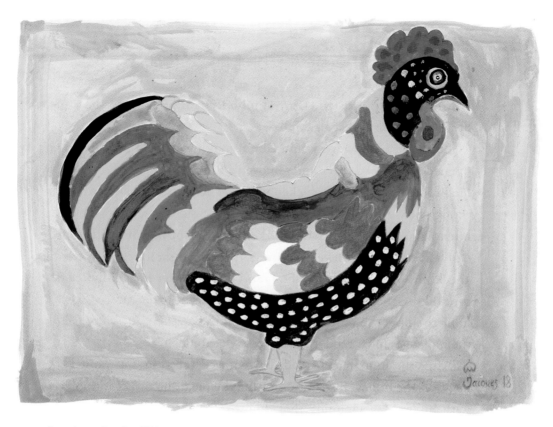

Sumptuous Rooster, 2018

the famous actor, singer, comedian, and also a world-class cook, known for his mastery of Chinese cuisine, but knowledgeable and interested in all cultures' foodways. Danny and I became friends, and when I was out in Los Angeles giving cooking classes, he often picked me up at my hotel and took me to his house so that we could cook dinner together. Coming to Danny's house involved adhering to a couple of inviolable rules. Paramount among them: You had to arrive on time. If you came late, he never invited you again. The other rule stipulated that while at the table, guests could talk about food and nothing else. I'll always remember him as the creator of an excellent chicken salad. I still use his recipe today.

The Best Chicken Salad

During one of my visits, Danny announced, "I'm going to show you how to make my chicken salad."

I thought I knew everything about making chicken salad until he opened a kitchen drawer and removed a handful of spoons and forks. He proceeded to stuff a chicken with the utensils. I looked at him as though he was crazy. Placing the bird breast-side down in a stockpot, he explained, "They're so the chicken stays on the bottom of the pot."

He covered the chicken with water, added an onion, a carrot, and a leek, brought the pot to a boil, and let it simmer for 5 minutes before taking the pot off the heat and setting it aside covered for an hour to allow the residual heat to cook the chicken. It made one of the moistest, most tender birds I've ever eaten.

After the hour had passed, he removed the skin and pulled the meat off the bones. Instead of cutting the meat, he tore it into pieces with his fingers, claiming that doing so made the meat even more tender—if that was possible. While it was still lukewarm, Danny dressed the chicken with chopped garlic, Dijon mustard, red wine vinegar, peanut oil, and walnut oil.

The flavor alone makes the salad a standout, but I went one step further by having some fun with the presentation, which I reproduced in my book *The Art of Cooking*. I mounded an oblong heap of chicken salad on each plate and put a slice of hard-cooked egg on one end to create the head of the chicken. Carved pieces of radish placed in the center of the yolk and on its periphery became an eye, a beak, a comb, and wattles. A splayed-out fistful of chives on the other end of the salad mound served as a splendid rooster tail. A few pecans rolled up in basil leaves provided a garnish. It was a treat for both stomach and eye.

Toward the end of the 1980s, I started teaching at the French Culinary Institute in Manhattan, on Spring Street near Chinatown, a food-lover's paradise. I'd never experienced Chinese food before I arrived in the United States. Because of its colonial history, France had Vietnamese food, but not much Chinese. Shortly after I settled in New York, a group of friends and I started a tradition of going to Chinatown, usually on Sundays, to dine at the small restaurants lining its crowded streets.

While at the French Culinary Institute, I availed myself of the food markets in Chinatown, particularly one on Grand Street that sold live squab, rabbits, and chickens, which became teaching aids for my classes. I'd buy a chicken, have the store clerks kill it for me on the spot, and then bring it back to the institute to demonstrate the finer points of plucking and evisceration. Some of the students became nauseated and fled the room.

One market on Mott Street became my go-to urban source of very large live frogs (at our country home in rural upstate New York, friends and I made midnight forays to the area's streams, ponds, and bogs to procure bullfrogs). On a buying expedition to the Mott Street store, I noticed the most bizarre chicken I'd ever seen. It lay displayed in a market's window: fully plucked, only about half the size of a typical roasting chicken, and with black skin. I bought it.

As it happened, I had invited Pierre Franey over to my place for dinner that evening. I guessed that, like me, he had never seen such a chicken. The outlines of a great chef-to-chef prank began to form in my head.

Two Hens, 2016

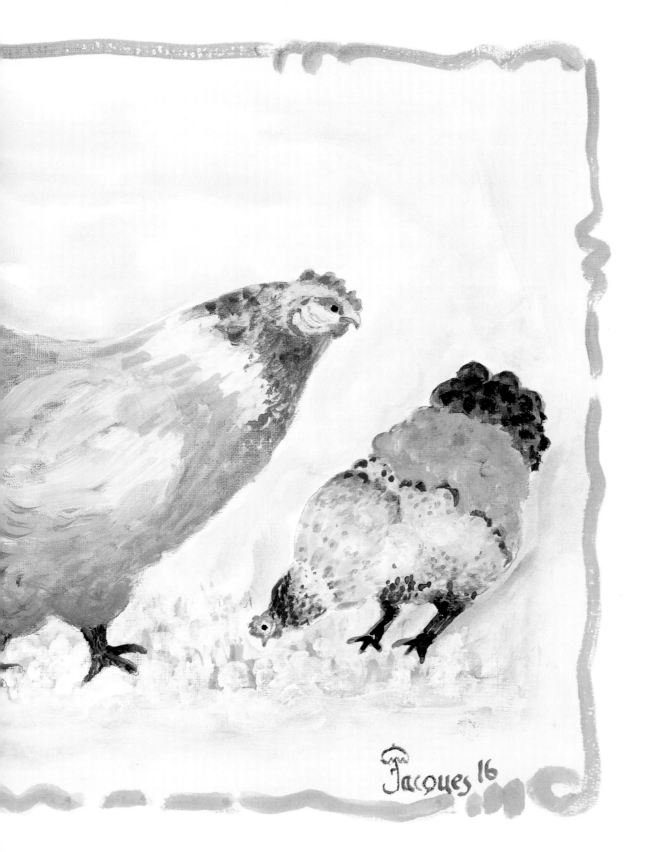
Jacques 16

Peking Chicken?

I decided to cook my diminutive, black-skinned chicken Chinese style, like Peking duck, so I steamed it for about 15 minutes and then roasted it at a high temperature for another 45, brushing it with a mixture of soy sauce, hoisin sauce, chili oil, and sesame oil. Pierre arrived. I fixed him up with a glass of wine. Making sure he noticed me, I opened the oven door to baste the chicken.

"What is that?" he said, recoiling.

I calmly said, "It's a chicken."

"A chicken that's black?"

"I have no idea what happened. I put a regular chicken in the oven, and I don't know what happened to make it turn out this way!"

I strung him along for a few minutes and then came clean. I'd bought a breed of chicken called a Silkie (sometimes also called a Chinese silk chicken), so named because of their fluffy, fur-like plumage. They have five toes on each foot instead of the usual four, and their "earlobes" are blue. But their most striking feature is that their skin, flesh, and bones are black. Pierre and I sat down to eat the unusual creature, which I found a bit tough but full-flavored.

❧ ❧ ❧

My "little" brother, Bichon, was actually quite a bit bigger than me—a gentle giant standing over six feet tall and weighing two hundred pounds or more. Gregarious, a bon vivant, and always happy, he followed my footsteps into the restaurant trade, working with me at the Plaza Athénée. But the fancy restaurants of Paris turned him off. He yearned to return home and go back to the country cooking served in the restaurants of Maman and our aunts. Bichon was an authentic cook, not too finicky—a trencherman with simple tastes

and a love of great food. He had the perfect character to run a restaurant like my mother's, cooking for friends and regulars. He was a good cook because he was always cheerful and ready to please customers.

Bichon's Grilled Chicken

By the 1990s, when my daughter, Claudine, and I visited France while I was doing a television show there, Bichon and his wife had their own restaurant, La Petite Auberge, in Miribel, next to Lyon. His grilled chicken drew rave reviews. To make it, he split the birds in half along the backbone, rubbed them with butter, and seasoned them with herbes de Provence, salt, and pepper. He tossed them on the grate skin-side down and grilled them until the skin had darkened, then finished them on the other side. He dotted the cut-up chicken with a compound butter made by mashing butter with lemon juice, tarragon, and a bit of paprika or hot pepper. This, a big salad, wine, and a lot of laughter made a typical dinner at Bichon's. I loved that style of eating. I still do.

Next spread, left: *Tender Chicken*, 2019; right: *Imperial Chicken*, 2020

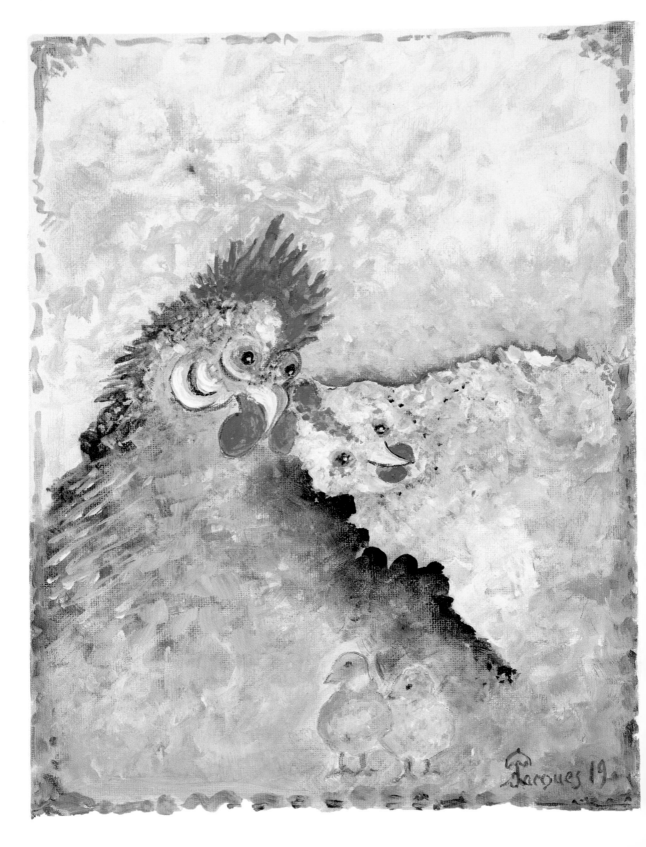

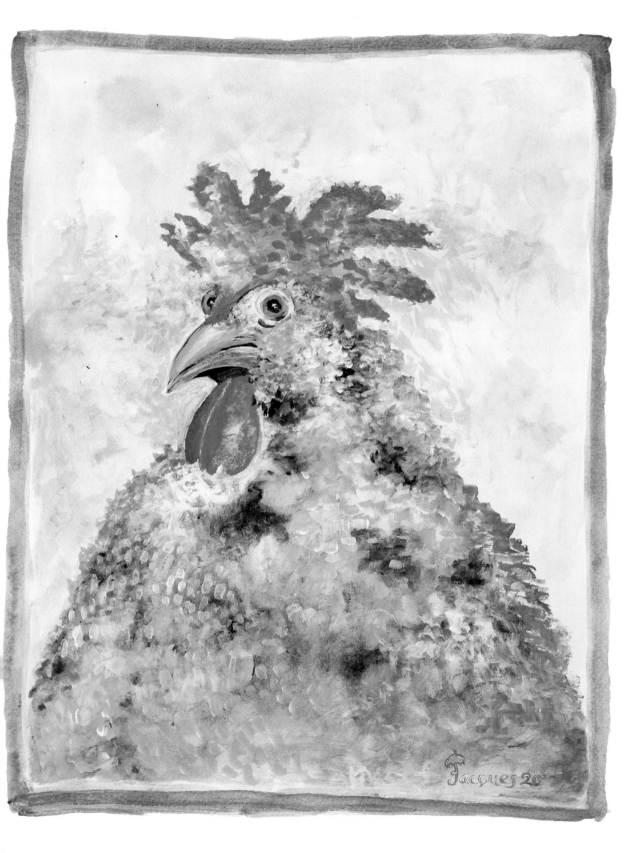

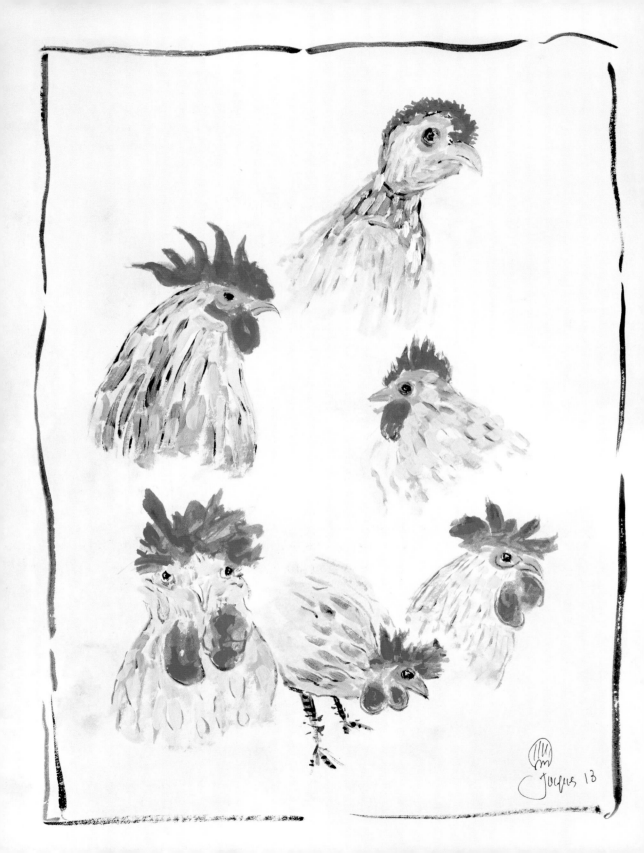

Beak-to-Pope's-Nose Eating

———

T RAVELS THROUGH DEVELOPING regions of Mexico, South America, and Asia taught me that for the world's poorest people, owning a couple of chickens can make the difference between living and dying of hunger. The flesh of the chickens is important, but often not nearly as important as what might be viewed as the ancillary products that a chicken provides: eggs, of course, but also all of the parts of the chicken that might otherwise be discarded. Hungry people never waste any edible part of the bird, and neither do I.

Everyone should use what I consider chickens' "bonus ingredients," not only for their nutritive value (high), or for reasons of economy and waste reduction, but also because some of the tastiest dishes come from the carcass, skin, feet, neck, gizzard, heart, liver, wattles, comb, oysters, and blood. The origins of these dishes might be off-putting, but I urge you to give them a try. From these humble ingredients spring some of the tastiest chicken recipes anywhere.

❧ ❧ ❧

Facing page: *Chicken Heads,* 2013

Never throw out the carcass of a cooked chicken. The bones and any bits of meat attached form the basis of a great stock (see page 42). It's simple to make, and I always keep several containers stashed in the freezer. They are essential for soups, sauces, stews, and gratins.

Or, you can just save the carcass and eat it. My son-in-law Rollie's favorite lunch is to munch on the previous evening's chicken carcass served at room temperature, along with a simple green salad. This simple pleasure was a favorite of my father's as well.

In Gascony, a region in Southwest France where farmers raise a lot of poultry, they have a yearly fair where duck and chicken carcasses are roasted in a baker's oven on big trays and brought to tables for attendees to enjoy—a treat to be eaten with the fingers and washed down with many bottles of the bold local red wine.

Chicken Cracklings

One of my favorite "bonus" chicken treats is roasted skin. I think it's better than bacon. My method of preparing chicken "bacon" originates with thighs that I poach for my miniature poodle, Gaston. After I poach the thighs, Gaston gets the meat, and the humans snack on the skin with a glass of wine.

The skins are removed from the poached thighs and placed on a baking sheet lined with aluminum foil. Be sure the "inside" goes face-down (it's a little more slippery), and sprinkle them with salt. Roast them in a 375°F oven, undisturbed. Don't be tempted to flip them with a spatula. You want the skin pieces to stick to the foil. As they cook, they become thinner and, after 20 to 25 minutes, they will have browned and become as crisp as a wafer—like ultra-thin cracklings. An added benefit is that you'll be left with plenty of rendered fat, an ideal medium for sautéing potatoes or pretty much anything else.

Never underestimate poultry fat. We cooked a lot of chicken during my apprenticeship, and woe be to any of us if we spilled a drop of rendered fat. Chef Jauget treated it like he would treat Beluga caviar. He added the precious fat to pâté, used it for sautéing vegetables and preparing rice, and enhanced his soups with it. In fact, we used it as often as we used butter. In Gascony, where there is an abundance of rendered fat from ducks and geese as well as chickens, it finds its way into salads, omelets, stews, and confits. If that sounds like a recipe for a heart attack, think again: That region has the lowest levels of cardiovascular disease in France.

Too often the little packet containing the gizzard, liver, and heart that comes with your chicken or turkey is tossed aside. I think for the most part it's simply because people aren't quite sure what to do with them—particularly gizzards.

I love gizzards and encourage you to give them a try; you will be surprised by how good they taste. And even if you don't enjoy them on their own, they will always add depth of flavor to your gravy or your sauce without diners even knowing that they're there.

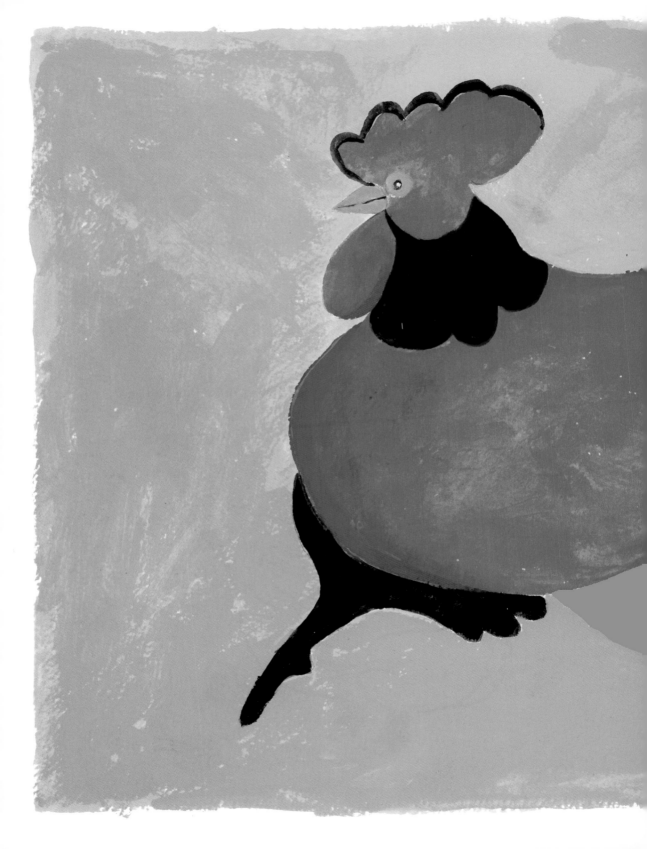

Jacques 19

Fanciful Chicken, 2019

Gizzards, Gizzards, and More Gizzards

❧

In a chicken's digestive system, the gizzard, a firm, muscular organ about the size of a small plum, pulverizes the hard grains that the bird has swallowed. The gizzard's outer layer consists of tough, connective tissue sometimes removed before cooking. To separate the deep red edible portion from this whitish covering, I deploy my smallest paring knife. Always in a waste-not-want-not mode, I save the "skin" for my stockpot.

In some cases, I skip these steps and simply sprinkle whole gizzards with salt and a dash of sugar and let them cure overnight. The following day, I cover them with chicken fat and cook them slowly in a 250°F oven to create a type of confit. In French, the word *confit* means to preserve. Prepared this way, gizzards keep in the fridge for a month or more in an airtight container—I'm not sure exactly how long because we always use them long before they have a chance to spoil. Slow cooking leaves the gizzards tender, moist, and delicious. I chop them up and pop the little niblets into salads, rice, and pasta, or as a garnish for another chicken dish.

When boiled, gizzards make a great addition to stocks, soups, and stews. On nasty winter days, I often warm up with a stew of white beans and gizzards by simmering about ½ pound of navy beans, 1 pound of gizzards, 3 garlic cloves, some onion, a piece of leek, and a couple of jalapeño peppers in water or chicken stock for 1 to 2 hours. By this time, the gizzards will have almost melted into the beans. This stew makes a great dinner with a salad and some crusty bread. Winter days might also find a ragout of potatoes, carrots, cabbage, and gizzards cooking slowly in my oven, like a pot au feu. Along with minced hearts and livers, minced gizzards also play a key role in the American Thanksgiving standby, giblet gravy.

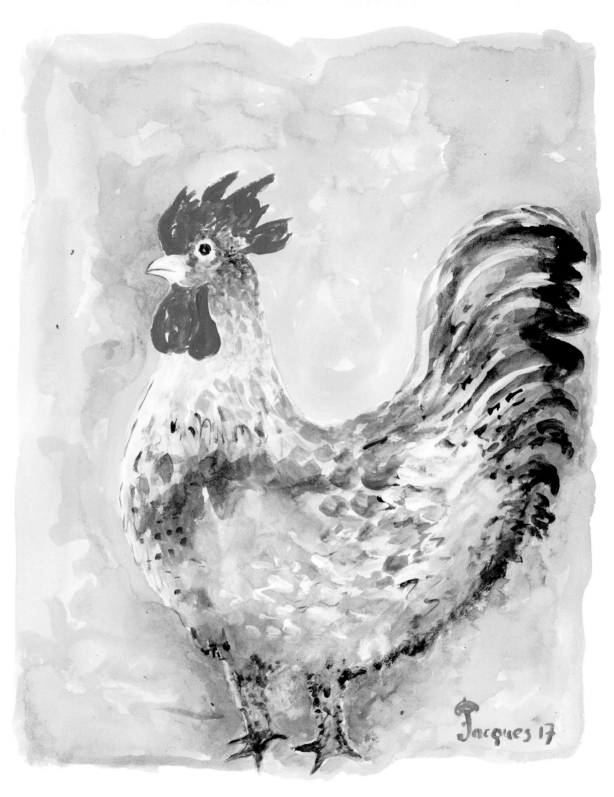

Stately Chicken, 2017

Although gizzards have an undeserved reputation as coarse fare, they had a place of pride in the dining room of the Meurice. The kitchen staff included fourteen cooks to serve, at most, forty guests. We prepared complex dishes that hewed closely to the style of Escoffier, who often made use of chicken gizzards in his recipes.

Petite Marmite from Le Meurice

I learned this version of classic *petite marmite* while working in the Meurice's kitchen. The dish takes its name from the small, lidded earthenware terrines in which it is cooked and served. We poured about 2 cups of consommé into individual *marmites* and then added tender little packets of chicken, which we made by removing the two bones from the center section of a chicken wing and stuffing the resulting channel with a forcemeat made of minced chicken flesh, cream, and tarragon. Morsels of carrot, turnip, leek, and little cubes of gizzard also found a place in the *marmites*. The little covered pots simmered for 2 to 3 hours, until the broth became rich and intense. We served the dish with croutons, grated Gruyère cheese, marrow bone, and cabbage leaves folded and crimped to resemble perfect miniature cabbages. It's hard to imagine a more haute treatment for humble giblets.

Chicken Neck Sausages and Fricassees

Not a single chicken neck has ever gone to waste in any of the houses I have inhabited. When my mother slaughtered a chicken, she carefully severed the neck as close to the head as possible at one end

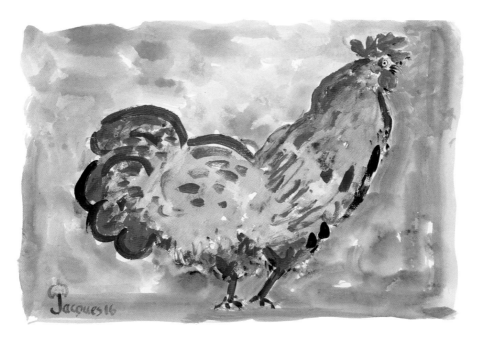

Red Chicken, 2016

and as close to the breastbone as possible at the other, freeing about eight inches of neck. She pulled off the skin to create a tasty sausage casing that she stuffed with ground pork, Swiss chard, and Comté cheese. The neck bone was used for stock or in soup. The sausages would be sautéed in a skillet and accompanied with fingerling potatoes from our garden, which cooked in the chicken fat released from the skin. Simple, but oh-so-satisfying.

Whenever we cooked chicken at home, Gloria raced me to get the neck first. On occasions when I managed to beat Gloria to the draw, I made a fricassee of necks cut into pieces a couple of inches long with onion, carrot, garlic, and pinto beans.

She and I waged similar battles to claim the succulent, fatty morsel at the other end of the chicken, the pope's nose, or tail, always the first thing professional chefs and cooks gobble down.

Coq au Vin

❦

In addition to making something delicious out of the necks, my mother saved and cooked with every drop of chicken blood she could get. She killed the bird with a swift snip of her scissors, cutting through the part of the neck just under its tongue. Then she held the chicken upside down with its head over a bowl. The final beats of the bird's heart pumped all of its blood into the bowl in a few deep crimson surges. Maman prevented the blood from coagulating by adding a tablespoon of vinegar until she was ready to use it in her coq au vin.

A dish traditional to Burgundy, coq au vin is the preferred treatment for an older bird too tough to simply roast. After dispatching an aged rooster destined for her coq au vin, Maman cut it into pieces and cooked them slowly in chicken stock and red wine, preferably a Pinot Noir, with onions, garlic, and an assortment of herbs. She removed the chicken pieces from the wine mixture, strained it, and then poured it back over the meat, studding the stew with olive-sized pieces of unsmoked bacon (*lardons* in French; *pancetta* in Italian), glazed pearl onions, and button mushrooms. As tradition required, she thickened her sauce with the blood, which resulted in a darker sauce with more texture and body than sauces made without blood. She served the dish with crouton-like slices of bread that she brushed with oil and toasted in the oven.

Like Maman, cooks in West Africa treat chicken blood like a valuable commodity. My older brother, Roland, lived and worked for fifteen years in the countries of Senegal, Cameroon, and Gambia. One time when Gloria and I visited him in Dakar, Senegal, we stayed with

his friends Carmen and Marcel Bélassé, who took us to their week-end house in the seaside hamlet of La Somine.

Senegalese Blood Sausage

❧

Carmen, born and raised in Senegal, prepared wonderful food. She regularly slaughtered chickens and collected their blood, which she used to make one of her specialties, a black pudding. Called *sanguette*, it resembled the French blood sausage *boudin*. For *boudin,* a mixture of pork blood, onions, garlic, and pork fat (and in some regions apples, chestnuts, spinach, or cream) is stuffed into hog casings and poached. The poached sausage gets sautéed, grilled, or broiled and is served with mashed potatoes or stewed apples.

Carmen's recipe omitted the casing. She sautéed onion and garlic in oil for a minute or so, poured in chicken blood, seasoning it with some herbs and hot pepper, and stirred the slurry until it firmed up. Carmen topped her *sanguette* with hot sauce and served it with fried or poached eggs for a spicy start to the day.

Carmen exercised a free hand with hot peppers in many other dishes of local origin. Just the memory of one in particular still sears my lips and brings water to my eyes. She made it with capitaine, a grouper-like fish weighing a hefty eight or ten pounds. When they speak of fresh seafood in Senegal, they mean *fresh,* as in practically still swimming. Carmen purchased her capitaine directly off the boat of a local fisherman and had it on the grill as soon as she got back to the house. She skipped scaling and gutting, instead cooking the entire thing over a blazing fire until it had completely blackened. She deftly pulled off the skin and attached scales like a glove, scraped the

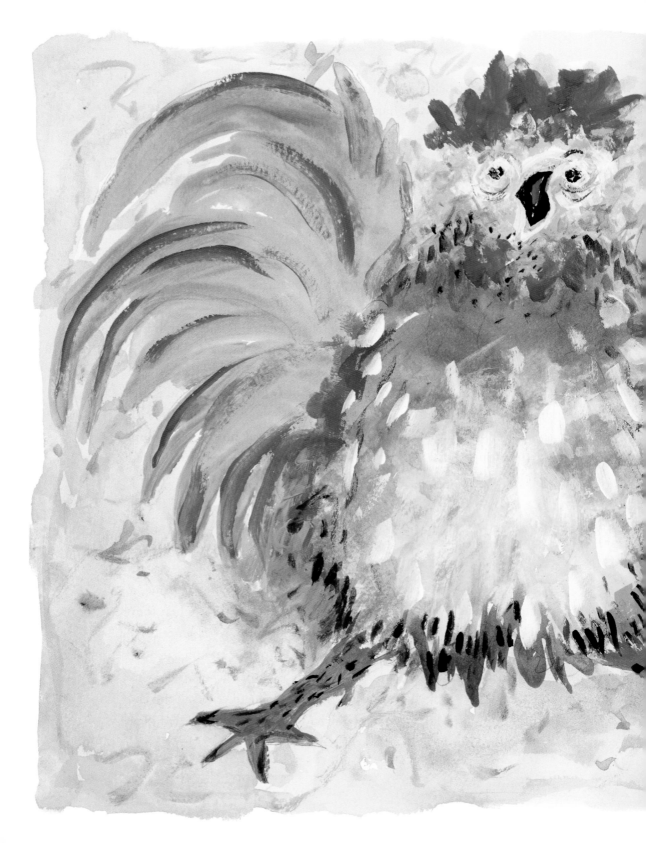

Screaming Rooster, 2017

meat from the bones, and combined it with a scorching sauce using onions, garlic, herbs, lemon, oil, tomato, and what she called a *piment enragée* (enraged pepper), an apt, if somewhat understated assessment of its potency—easily one of the hottest peppers I've ever placed in my mouth. When I first saw *piment enragée* in Carmen's kitchen, I brought a sliver up to taste and ended up with a blistered lip. But I devoured her grilled fish. Thankfully, she turned down the heat in recognition of my non-Senegalese sensibilities. I would happily prepare any large saltwater fish such as striped bass the same way, using a jalapeño, habanero, or other hot pepper—and keeping my guests' level of tolerance for spiciness in mind.

Enraged Chicken

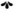

The Senegalese also use *piment enragée* in a popular chicken dish. They cut a 3- or 4-pound bird into eight pieces and marinate them for a few hours with thinly sliced onion, crushed garlic (a lot), grated ginger, salt, pepper, lime juice, and *piment enragée*. Starting with the pieces with the most fat and skin, cooks sauté the chicken in its own rendered fat for 8 to 10 minutes, until browned. They add the marinade, bring it to a boil, cover the pot, and cook the dish slowly for 40 to 45 minutes. Traditionally, West Africans serve this incendiary dish with broken rice—fragments of rice grains that have been shattered during harvest, transport, or processing. It tastes just like regular rice, but it's cheaper, making it a staple in a part of the world where money is tight.

Many cuisines, including those of France and Asia, view chicken feet as a delicacy. The feet are often left attached to the body in clas-

sical French dishes that call for the roasted bird to be served whole, either hot or cold. In the Paris kitchens where I worked, we cleaned the feet using a method called *buclé,* where we cut off the nails and exposed the feet to flames on top of the grill until their reptilian skin blistered, not unlike the technique of roasting sweet peppers over a flame before peeling. This leaves the feet flawlessly clean and bright white. But I don't relish the chore. Thankfully, a butcher near my home who caters to an ethnically diverse clientele sells chicken feet precleaned, as do many Asian and Jewish markets around the country.

I love chicken feet in soups and stews. Their numerous tiny bones are held together with cartilage and collagen, which I use for aspic. All that connective tissue gives the aspic enough natural gelatin to set nicely.

Spicy Chinese Chicken Feet

❧

I get double mileage out of chicken feet by first boiling them for 1½ hours to make a stock with concentrated flavor. Then, once the feet are cooked, I remove them from the pot and finish them in the Chinese style. I make a spicy sauce by frying garlic, ginger, and scallions in peanut oil, to which I add hot chili sauce, soy sauce, and toasted sesame oil. I thicken the mixture with a little bit of cornstarch mixed with water and cook the chicken feet in the pot just long enough for them to heat through and absorb the taste of the sauce. I serve them with chopped cilantro sprinkled on top and a side of boiled rice. Hands are the best utensils if you want to appreciate this version of chicken feet to the fullest. It's a fun, messy, lip-smacking affair best enjoyed with family or close friends.

Americans call the small nuggets of meat on either side of the chicken backbone the oysters, but I like the gastronomic message imparted by the French name, *sot l'y laisse* ("the fool leaves it"). Whatever you call it, *sot l'y laisse* stands as one of the choicest morsels on the chicken. Each bird has two, which made it easy for Gloria and me to each indulge in a nibble when a roast chicken came out of our oven. I envy the wealthy eighteenth-century gourmands who feasted on a fricassee of *sot l'y laisse,* an outrageously expensive dish that required the oysters from close to a dozen chickens to make a single serving.

Banker's Chicken

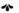

Dining on the chicken dish called *vol au vent financière,* or banker's style, also required significant financial means, even though some of its components involved parts that definitely fall well into the "bonus" category: the comb, the wattles under the beak, the kidneys, and, when available, unlaid eggs removed from slaughtered hens. To cook this dish at the Plaza in the 1950s, where our regular guests included a number of Paris's most prosperous *financiers,* I first soaked the combs and wattles in water for a day to remove their blood, leaving them perfectly white, then rubbed them with salt to get rid of the rough skin found on the upper edges. Once they became totally clean, they were cooked slowly in water or stock until tender. The combs and wattles went into a *vol au vent,* a baked puff pastry with the top cut off to reveal the bowl-like hole in the center. Smaller *vols aux vents* made a single serving, but waiters presented large ones tableside for groups.

Facing page: *Hippie Cock,* 2017

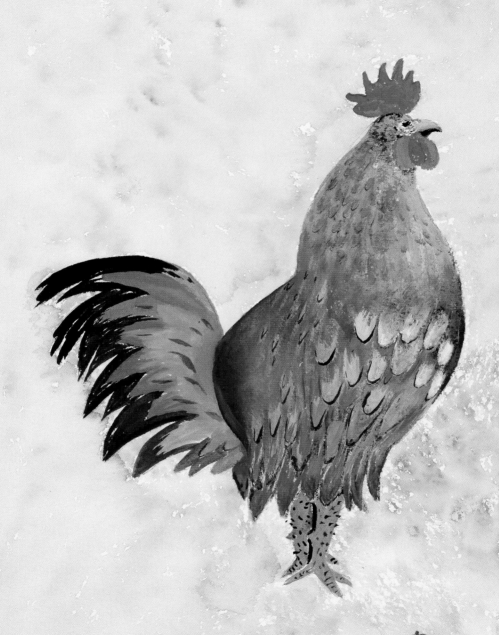

Jacques 17

Combs were only one of the delicacies that we put in our *vol au vent financière*. We also included chicken quenelles, puréed chicken meat (often mixed with cream and eggs) flavored with chervil that we molded into dumplings and poached. The filling included veal sweetbreads, along with kidneys. If we had them on hand, we added the immature, shell-less unlaid eggs, whole fluted mushrooms, diced foie gras, and sliced truffles. Finally, we drenched the dish in a sauce made with a demi-glace, reduced dry Madeira wine, and butter. It was a rich meal for gourmet guests.

Liver gets my vote for the most versatile "bonus ingredient" provided by chickens. During my younger years in France, cooks had to handle chicken livers with the utmost delicacy. In a bird that has yet to be eviscerated, the gallbladder is attached to the liver. It is filled with a very bitter liquid that ruins anything it touches. One tiny prick with a knife is enough to burst the fragile gallbladder. The only choice is to cut away the stained area. Fortunately, chicken livers today, whether they come with the rest of the giblets inside the bird's cavity or you purchase them separately, almost always have had the gallbladders removed.

For a Liver Lover

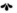

One of my favorite ways to enjoy chicken liver is also the easiest— simply sauté it in butter, making sure that you remove it from the pan while the liver is still pink inside. If your timing is correct, the liver will be delicate and exquisite. Cook it too long, and it becomes grainy and dry. You can eat sautéed liver alone, or use it in any num-

ber of variations with mushrooms, onions, or leeks. You can finish it with tomato sauce, vinegar sauce, or brown sauce. It goes well with spinach, potatoes, pasta, or steamed rice.

Gloria and I had a tradition of savoring a chicken's liver over a glass of wine while the chicken was roasting—a special treat reserved for the cooks. Sometimes I'd sauté the liver in butter, but Gloria preferred that I poach it. To do so, I put the liver in simmering water for a couple of minutes, removed it, and seasoned it with soy sauce, hot chili sauce, chopped garlic, and a dash of toasted sesame oil. I can think of few better accompaniments for a before-dinner glass of chilled white wine.

Chicken Foie Gras

✤

I also enjoy making a chicken liver foie gras, kind of a poor man's version of goose liver pâté. I first season the livers with chopped garlic, a generous amount of salt and pepper, and a bit of Cognac and leave them in the fridge to cure and marinate overnight. The next day, I place them in a gratin dish, cover them with melted chicken fat, and pop them in a 225° to 250°F oven until they are barely cooked and still pink in the middle. I put the cooked livers in a jar and pour in enough chicken fat from the pan to cover them, being careful to exclude any impurities or gritty bits that have accumulated in the fat during cooking. The livers will keep, preserved in the hardened chicken fat, in the refrigerator for weeks. Anytime I need a quick treat, I remove a liver and slice it thinly to have with a salad or simply on toast just like foie gras, for a trifle of the price.

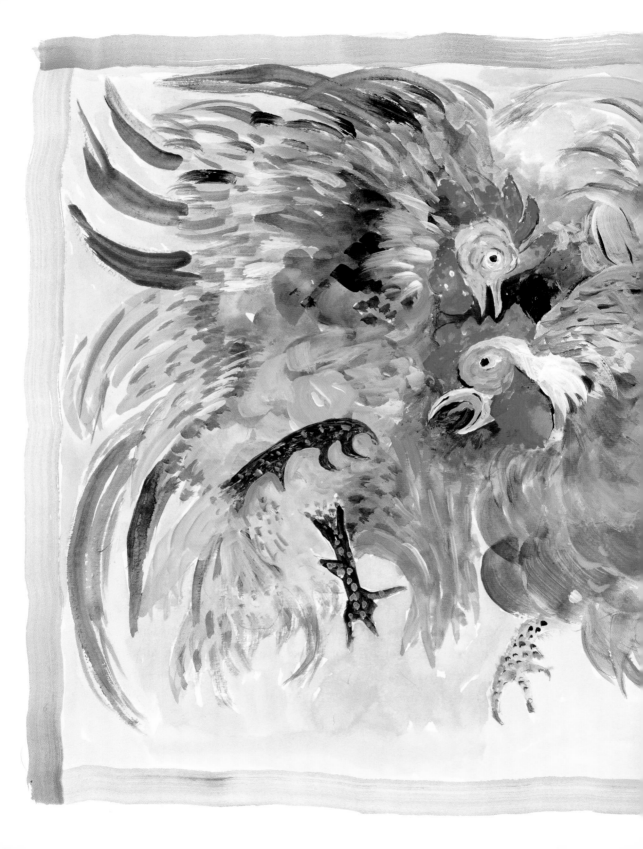

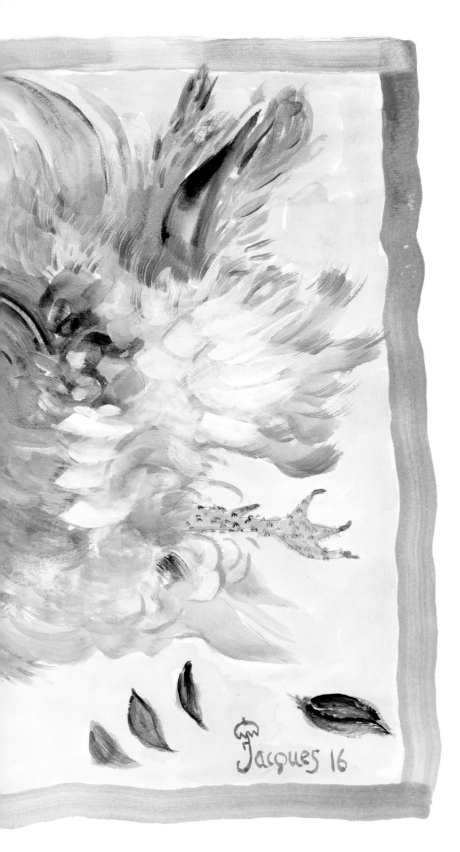

Barnyard Brawl, 2016

Chicken livers played a starring role in a restaurant Gloria and I opened in the early 1980s near our home in Madison, Connecticut. Gloria's French Café was a small bistro, serving simple but delicious food from a set menu at a cost of about twenty dollars a guest, tip included. Gloria, the boss, insisted on the highest standards and ran the front of the house. I worked in the kitchen with a young trainee and our friend Gloria Zimmerman, a talented cook. Zimmy, as we called her, baked our bread daily. I usually started the process the night before. After finishing the dinner shift, I prepared the dough in a twenty-quart Hobart mixer and let it proof in the refrigerator overnight. Zimmy reported for duty early in the morning to shape and bake about two dozen baguettes.

Chicken Liver Mousse

We went through a great deal of Zimmy's bread at Gloria's because we welcomed each table of guests with a basket of it and a complimentary hors d'oeuvre of chicken mousse in individual soufflé molds. To keep the kitchen constantly supplied with mousse, I started with two 50-pound crates of chicken carcasses that I bought every week. Before using the carcasses for stock, I removed the two lumps of fat found on each side near the pope's nose. Together, those two lumps are about the size of a chicken liver. It seems like Mother Nature herself dictated that the mousse be made with equal parts chicken fat and chicken liver.

The livers themselves arrived cleaned and ready to use in 10-pound containers. I cooked the fat in a saucepan until all that remained was clear liquid and cracklings. Then I added onions, garlic, and a spice blend of bay leaves, black peppercorns, and fresh thyme that I

Facing page: *Blue Cock, 2016*

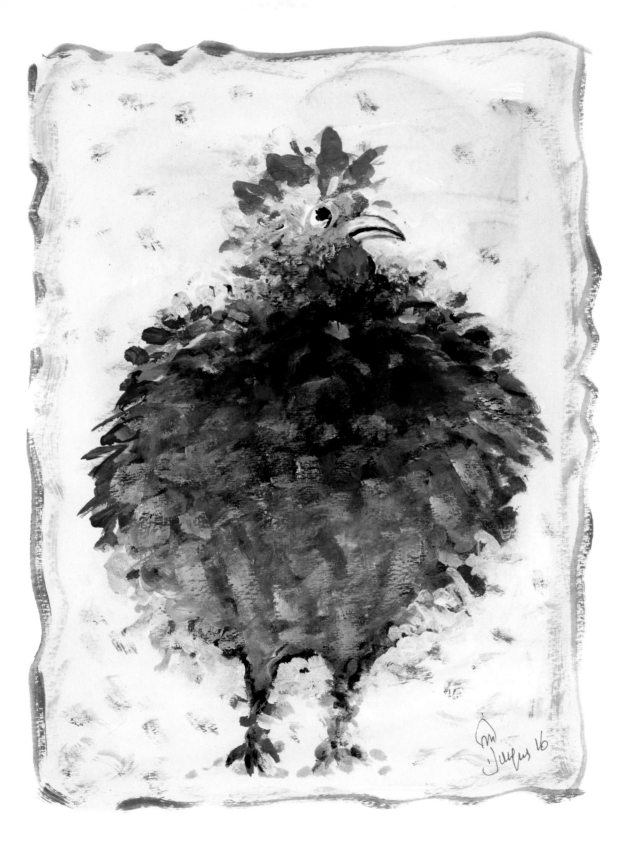

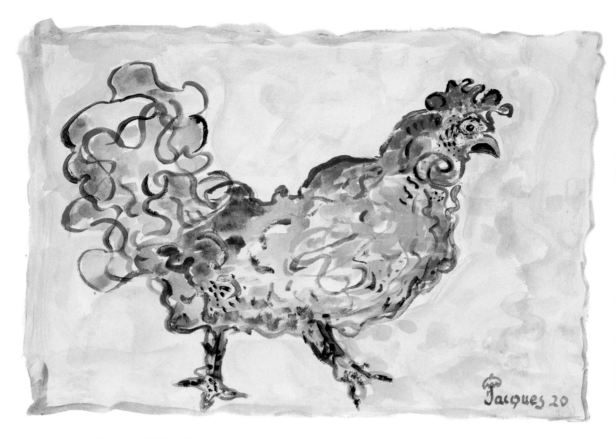

Frenzied Chicken, 2020

whizzed in a repurposed coffee grinder. I added the livers and cooked them briefly in the melted fat over high heat, being careful not to overcook them and ensuring they remained pink inside. I emulsified the mixture in a food processor, seasoned it with Cognac, salt, and pepper, and spooned it into ½-cup containers. Ten pounds of liver generally yielded about fifty containers of mousse. It was both tasty and inexpensive and soon became a signature dish at the café. Over the years, I have given this same treatment to duck, pheasant, goose, and many other livers.

Russian Tea Room Mousse

In the mid-1980s, the management at the Russian Tea Room in New York hired me to consult on their new menu and develop recipes. True to its roots, the restaurant served *zakuski*, a traditional Russian series of hors d'oeuvre eaten as a first course or with drinks before a meal. For this *zakuski*, I created a chicken liver mousse inspired by Gloria. In high school, a Jewish friend invited Gloria home and showed her how to make mousse in the family's traditional manner. As in my recipe, the preparation called for combining cooked liver and rendered chicken fat with onion and garlic, but it also included hard-cooked eggs. Instead of being processed until smooth, the mixture was coarsely chopped to give the dish texture. Before serving, I sprinkled on bits of my chicken cracklings (see page 134). It became a standard in the *zakuski* of the Russian Tea Room.

Chicken Kiev

I also tweaked the famous restaurant's chicken Kiev, a house specialty. I made a compound butter with shallots and herbs and stuffed it inside boneless chicken breasts. I then dipped the breasts into beaten eggs and rolled them in a mixture of little cubes of white bread and brioche before sautéing them gently in butter. Occasionally, unsuspecting guests who had never experienced the dish recoiled in shock when they cut into it too forcefully, causing hot, liquefied butter to spurt over the plate or on some unfortunate diner's freshly laundered suitcoat or dress.

Salade Bressane

❧

My love of chicken offal compelled me to develop a recipe combining several types in a single salad I call *salade bressane*—Bressane refers to the famous chickens of the region where I was born. I base the salad on frisée, a pleasantly bitter green also called curly endive, that I dress with a vinaigrette made from Dijon-style mustard, chopped garlic, a dash of red wine vinegar, and sometimes a bit of melted chicken fat and peanut oil. I mix small boiled yellow potatoes, skinned and sliced, with the frisée. I then slice the chicken liver, cut the heart in half, cut the gizzard into thin slices, and leave the kidneys whole. I sauté the pieces of offal briefly in butter, sprinkle them on the salad, and top the dish with crumbled, roasted chicken skin or chicken crackling for a richness that nicely sets off the greens' bitterness. Full of flavor and texture, and inexpensive, this salad pays homage to the economical cooking of my mother and aunts and the region where I was born.

Facing page: *Polka-Dot Cock*, 2017

Cooking with Julia

I MET JULIA CHILD in 1960. We immediately became friends and remained so until she died in 2004. In 1979, I joined her to do a cooking demonstration in Los Angeles for Tom Snyder's *Tomorrow Show* and ended up playing a supporting role in a famous Dan Aykroyd comedy sketch. I arrived late, and the show's producers rushed me to the studio. Julia was there and had everything we'd need piled on a table—vegetables, fish, meat, and a chicken. In that pre-9/11 era, I always traveled to events with my favorite knife in a carry-on. I proceeded to lay it out on the counter. Julia grabbed my exquisitely sharp paring knife and began to work on a shallot for a chicken dish. Seconds before the cameras were going to roll, she nearly sliced off the tip of her index finger. I pushed the cut tip, still attached by the skin, together and wrapped her finger in a towel.

Snyder panicked. "What are we going to do?"

"We are not going to *do* anything," Julia said. "We are going to go on as planned. Jacques will cook." Looking meaningfully at Snyder, she decreed, "And above all, I don't want any of us to talk about the cut."

Facing page: *Chicken and Herbs,* 2019

Despite Julia's admonition, as soon as we were on the air, Snyder blurted, "Do you mind if I tell everyone that you cut your finger?"

The following day, Julia appeared on Johnny Carson's *Tonight Show*. All he wanted to talk about was her injury. In no time, the entire nation knew what had happened.

For the *Saturday Night Live* sketch, Aykroyd, dressed as Julia, pretends to cut himself while deboning a chicken. As fake blood from the wound spurts all over the set, he falls facedown on the now-gory counter screaming, "Save the liver!"

Julia found Aykroyd's parody hilarious. As famous as she was, she retained a sense of humor and could always laugh at herself. And she knew as well as anyone the value of a chicken liver.

Julia and I cooked together frequently at television studios on both coasts, on the stage at Boston University, at her house, at my house, and pretty much everywhere in between. We became great friends and were always able to be ourselves when we were together. We never used recipes for our television programs but cooked whatever she or I had picked up at the market. This led to lots of discussion and frequent good-natured arguments, but we always had fun. We loved to argue because our verbal jousting for the most part concerned trivial matters. Julia, for example, swore by regular salt and white pepper. I prefer kosher salt and black pepper and occasionally tried to sneak these non-Julia-approved ingredients into our demonstrations. Julia was a consummate prankster, and one of her favorite tricks was to ambush me during a live demonstration or a television shoot by producing a chicken out of thin air and insisting that I debone it on the spot.

The technique and speed with which I debone a chicken has brought me a measure of fame. Many see it as an amusing parlor trick, and to an extent, it is. Although I do like to show off on occasion, publicly deboning a bird in a few deft strokes has a serious

point, illustrating the importance that practice and repetition play in mastering technique. Doing something over and over for many years can make it look simple, and when I demonstrate deboning to my classes, some of my students inevitably conclude it's easy after watching me once. Anyone can do that, they think. And then they try it. Their mistakes have led to the birth of some bizarre-looking creatures.

Ironically, I can't remember exactly how or when I learned the technique. We never did it during my apprenticeship or at any of the small restaurants where I worked in the early years of my career. But at some point, while working at the Plaza Athénée in Paris, I became adept at the task. We frequently used deboned chickens for galantine, for which we stuffed the boneless birds, poached them, coated them in aspic, and served them cold; or for ballotine, where we stuffed and roasted the boned birds that we served hot. Over the ensuing decades, deboning has become almost part of my DNA.

Despite all our squabbles, Julia and I agreed on the important things. Recipes should be simple. Taste trumps presentation. Cooking together should be fun. Use the highest-quality ingredients. We both deeply enjoyed eating with friends and loved ones, sharing food, and drinking wine—plenty of wine.

Apples and Chicken, 2020

Julia and Jacques's Dueling Chickens

❧

Julia and I never could agree on the proper way to roast a chicken. Julia liked to give hers a generous rub-down with butter before putting it in the oven. She called that step a "butter massage." She also found no need to turn a chicken in the oven and roasted birds weighing less than 3 ½ pounds breast-side up for the entire time. Julia liked to roast her chickens on a V-shaped rack in a shallow roasting pan about 2 inches deep, contending, rightly, that this method let the heat circulate around the bird for even browning.

I, on the other hand, think it's important to start the chicken on one side, flip it to the other side, and then turn it on its back for a stint, during which I baste it frequently with pan juices. The meat around the juncture of the thigh and drumstick needs the most cooking, and with the bird on its side, that joint is in direct contact with the heat and the skin becomes golden and crisp. But you must cook it in a heavy-bottomed roasting pan that allows for good heat diffusion.

Julia and I agreed that whichever approach we took, a chicken should be roasted at a high temperature—425°F. And we were totally in sync in believing that one of the greatest pleasures in life is a perfectly roasted chicken served with a deglazing sauce made from the brown bits left in the roasting pan. I will finish by saying that both techniques yield an excellent result.

Chicken Breast à la Susie

❧

My friend Susie Heller and I have been cooking together, taping television shows, writing cookbooks, and just making and sharing meals for close to forty years. She assisted me when I shot the thousands of pictures for *The Art of Cooking* in the mid-eighties. She was a culinary producer at KQED and later a coproducer when we filmed the series in Julia's kitchen, *Julia and Jacques Cooking at Home*. Several recipes, like the gâteau of crêpes and stuffed cabbage, were inspired by her.

She once came to my house and told me she was going to cook a big breast of turkey by completely covering the skin with a thick layer of hot sauce, like sriracha, combined with mayonnaise, and then roasting it in a very hot oven until the surface was practically black and the center very moist and tender. I decided to create a recipe with the same idea using chicken breasts, a super easy recipe to make. Take two large boneless, skinless chicken breasts and sprinkle them with salt. Rub the undersides with chili-garlic sauce or any type of hot sauce, and place it chili-side down in a gratin dish. Mix a fair amount of mayonnaise, about ⅓ cup, with some more hot sauce and spread the mixture liberally on top of the breasts. When ready, roast the chicken in a 400°F oven for about 30 minutes. The breasts should be nicely browned with a very moist, juicy, and tender meat inside. It's a fast and satisfying recipe to make and enjoy with a salad and a glass of wine.

Julia moved to Cambridge around 1960. For me, one of the pleasures of going to Boston was to meet with her, have dinner at her house, or enjoy a restaurant together. In the early '80s, I was asked to

Facing page: *The Proud Cock*, 2021

teach at Boston University for the newly created School of Hospitality and Hotel Management. I have now been teaching at Boston University for over thirty-five years. Being asked to join the faculty was another reason to go to Boston—and see Julia! We eventually ended up teaching classes together at BU as well.

Given my relationship with the school, when the time came for my daughter to select a college, naturally she chose Boston. She rented a little apartment, and I helped her outfit its kitchen. We affixed pieces of wood to the walls on which she could hang her pots and pans, like the ones we had at home. I built her a counter, and together we bought the basic tools she needed to prepare her own meals.

She hadn't lived there for long when she invited me over for dinner. I could see that she was eager to cook for her old man in her very own kitchen. She knew that I loved roast chicken and went to a nearby grocery to procure one. The store carried the usual selection of fryers, roasters, and packaged thighs, drumsticks, and breasts. But alongside the run-of-the-mill stuff, she spotted some larger, more expensive chickens. In the spirit of nothing's-too-good-for-Dad, she splurged. "If it's more expensive, it's got to be better," she thought, not realizing that she had gotten a big old stewing hen.

I suspect I arrived late. By the time I got there, the hen, which she served with a potato and onion gratin, had become dry, tough, and seriously overcooked. Claudine and I split a bottle of Burgundy that I had contributed to the occasion and ate, never once commenting on the meal's quality. Finally, toward the end, she could hold back no longer. "Well, what did you think of my chicken?" she asked.

I diplomatically replied, "Would you like me to answer as a chef or as a father?"

As a father, I couldn't have been prouder.

<p style="text-align:center">❧ ❧ ❧</p>

Grape Chicken, 2020

I call one of the classes I teach at Boston University "The Ultimate Meal." In it, I challenge the students to properly prepare a roast chicken with boiled potatoes and a salad. It sounds simple, but with simple recipes, the cook cannot use inferior ingredients or mask flaws in technique. The quality of the finished dish depends on correctly executing several steps, which I demonstrate to the students, highlighting the critical points. Then they taste my results.

The Ultimate Meal

To start, I explain to the students, you have to select quality ingredients—especially for the chicken, which needs to be fresh, firm, and without flaws such as torn skin and broken blood vessels. With the students watching, I truss the chicken with butcher twine, then season it inside and out with salt and pepper, and rub it with butter. I place the chicken on its side in a heavy skillet for about 5 minutes to brown the leg, then turn it to brown the other leg, before putting the skillet in a 425°F oven for 20 to 25 minutes. I then turn the chicken over to its other side and cook it for another 20 to 25 minutes. At that point, I lay the chicken on its back and cook it for a final 20 to 25 minutes, basting it every 5 minutes with its rendered fat until it is done, a little longer than an hour in total.

Then I put the chicken on a platter. At this point, some cooks cover it with aluminum foil. I never do. Steam trapped by foil tends to soften the skin and give it a reheated taste. I remove most of the fat from the pan, setting some aside for the salad dressing, then deglaze the pan with chicken stock. I boil the mixture to melt all the solidified juices, thicken it lightly with potato starch diluted in chicken stock, and strain the resulting thickened juice into a bowl.

Even with something as basic as a properly made tossed salad, the students learn important lessons. Appropriately for an instructor at Boston University, I use Boston lettuce in the salad. I demonstrate the correct technique, separating the tender leaves and immersing them in cool water, lifting them out gently with my fingers to prevent bruising, draining them thoroughly, and drying them in a spinner so water doesn't dilute the dressing.

I make a straightforward vinaigrette, with a few additions to make it interesting: good olive oil (sometimes with a dash of walnut oil), the chicken fat that I have set aside after roasting, a dash of red wine vinegar, and Dijon-style mustard. Just before serving the salad, I combine the lettuce and dressing, and I make sure the salad is cool but not cold. Coldness inhibits its flavors.

With this meal, I prefer little, round gold potatoes, all of the same size to assure even cooking. Peeling them is absolutely necessary because potato peels add a bitterness that can overwhelm the little spuds' sweet and mild flavors. I cover the potatoes with water, add a dash of salt, and boil them gently for between 25 and 30 minutes, until an paring knife meets no resistance when inserted in the center. After pouring out the water, I place the potatoes back on the heat for a minute to evaporate any remaining moisture. At the last minute, I toss them with sweet butter, chopped parsley, salt, and freshly ground pepper. Then the chicken is carved and served with the tossed salad, a few drops of the chicken juices sprinkled on top, and the buttered potatoes. Simple, savory, satisfying.

Now, the students step up. Each one has a basket containing the ingredients necessary to re-create the meal I'd demonstrated. Frequently, they stray by adding unnecessary spices or altering the cook-

Chickens and Snail, 2016

Jacques 16

ing techniques. I understand their motives. They want to differentiate their dish from those of their classmates. But they have yet to learn the important lesson that every cook is inherently different, and their individuality will always convey itself in the finished meal. I tell them that if I have twelve students in the class, I will get twelve different chickens. Some will be overcooked, some undercooked, some too cold, some nicely browned, some dry, and so on.

"If you follow your instincts and feelings," I say, offering the same advice I give to any cook who solicits it, "you will not and cannot cook exactly the same way as that person cooking next to you. Cook with your heart." So, you don't have to try to be different! You are different, and if you follow your gut, your chicken will be as unique as you are.

The lesson I hope they take away from my Ultimate Meal class: The application of good technique creates both the simplest meal and the ultimate meal.

Kitchen Chickens, 2017

Jacques 16

Which Came First?

———

T HE EGG, of course.

My source for that conclusion is Alice Thomas Ellis, a British author of fiction and cookbooks. In her 1982 novel, *The 27th Kingdom*, the narrator's eccentric Aunt Irene, who believed that the book of Genesis explained everything, observes that only a supernatural power—an angel, she supposes—could have taught humans that trickling oil onto beaten egg yolks would result in mayonnaise. Ellis writes:

> As the angel left in his fiery chariot, he must have added, "And don't forget omelets, and cake and custard and soufflés and poaching and frying and boiling and baking. Oh, and they are frightfully good with anchovies. And you can use the shells to clarify soup—and don't forget to dig them around the roots of your roses."
>
> It was obvious therefore that the egg had come first. There was something dignified about a silent passive egg, whereas Aunt Irene found it difficult to envisage an angel bearing a hen—which despite its undoubted merits, was a foolish and

Facing page: *Yellow Mother Hen*, 2016

largely intractable bird. The concentration of chickens' wings and angels' wings would have had about it an element of parody which would have greatly lessened the impact of the message.

I believe that eggs are the perfect food. Delicious, elegant, high in protein, nutritious, versatile—all of these and inexpensive at the same time. It is the modest, unpretentious, and universally democratic ingredient of any cuisine, from a French omelet to a Spanish tortilla to a Chinese egg foo yong to an Italian frittata. Eggs are extraordinarily beautiful, with a perfect shape, and they come in a foolproof container. "A box without hinges, key, or lid, yet a golden treasure inside is hid," according to J. R. R. Tolkien.

The egg is the humble, unnoticed ingredient in many dishes. Alexander-Balthazar-Laurent Grimod de la Reynière, author of *Almanach des Gourmands* (an annual French restaurant guide published between 1803 and 1812) and one of the earliest restaurant critics and food reviewers, noted that "The Egg is to cuisine what the article is to speech." Gratin, mousse, soufflé, stuffing, pâté, sauce, pasta, soup, cake, cookies—the humble egg plays an integral if unnoticed role in all of these and many, many more dishes. How convenient that they come in a perfect container and can keep for a month or more whether refrigerated or left on the counter at room temperature, a blessing for cooks in many parts of the world where households have no way of keeping them chilled.

Larousse Gastronomique includes more than four hundred recipes for *oeufs*. Soft-boiled eggs, *mollet* eggs, and hard-cooked eggs. Eggs *en cocotte*, cold eggs in aspic, scrambled eggs, fried eggs, deep-fried eggs, and, of course, omelets.

I love eggs—period. I don't care how the cook prepares them.

The species of animal that laid them doesn't matter much to me either. I've enjoyed the eggs of ostriches, quail, turtles, and of course, chickens, especially those from the coop scrupulously tended by my neighbor Nathalya, a beautiful woman originally from Jamaica whose flock of happy ducks and chickens keeps many residents of my town in good supply of delicious eggs.

Rather than languishing for their entire short, miserable lives in cages barely big enough for them to turn around in as virtually all factory-farmed laying hens do, Nathalya's chickens have plenty of room to run, flap, and enjoy dust baths in the sunshine. They scratch for any seeds and insects they can find on the ground and in addition receive poultry feed, cracked corn, stale bread, and vegetable scraps from Nathalya's kitchen. I like knowing exactly what the chickens that lay my eggs eat and that they lead happy lives. You may not have a farmer like Nathalya living just down the road, but you probably do have a farmers' market nearby with at least one vendor selling organic eggs from free-range chickens.

The difference in the quality of eggs from free-range chickens is easy to see. Crack an industrially produced supermarket egg into a pan, and a flat, pale yellow yolk will greet you. The clear white will spread out to form a thin puddle. Do the same thing with an egg laid by hens like Nathalya raises and the yolks, ranging in color from vibrant gold to fiery orange, will stand up as if to salute. You will notice two clearly defined types of albumen in the whites. A thick, viscous one forms a clearly visible raised circle surrounding the yolk; the other has a thinner texture and spreads outward.

Taste aside, I simply prefer to cook with eggs from organic pastured hens. With their thick whites and high lecithin content, they deliver much more volume in recipes than supermarket eggs, and they lend a beautifully firm texture to soufflés, pastry creams, custards,

Next spread, left: *Chicken with Pear*, 2020; right: *Chicken with Artichoke*, 2020

Jacques 20

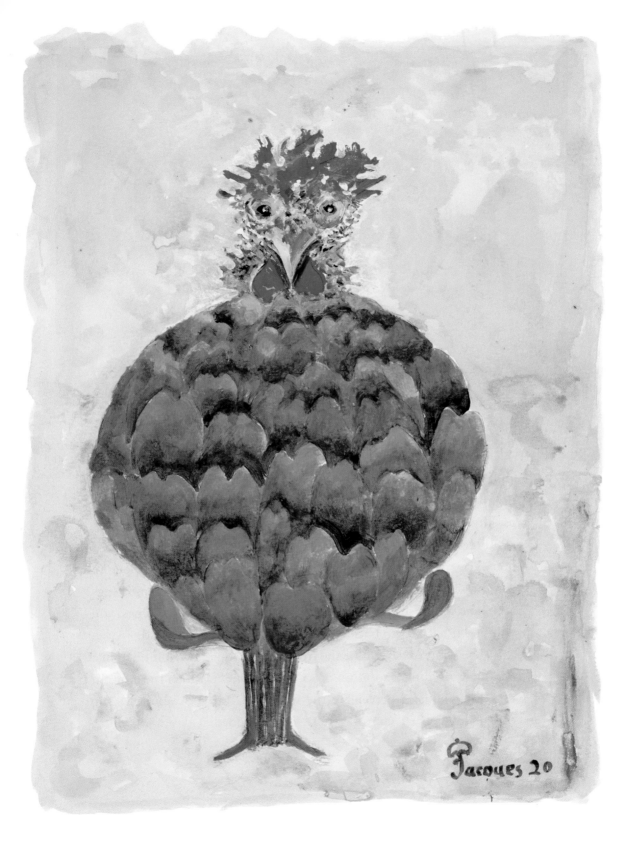

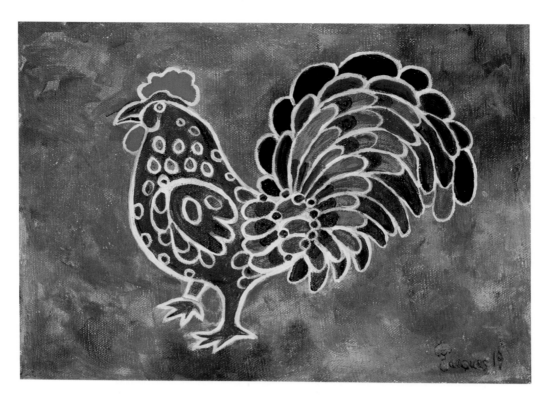

Blue Rooster, 2019

and other mixtures that require thickening. Although they may be slightly more expensive than store-bought, the difference in price is usually minimal, and the results produced are night and day.

But let's not forget taste. Nathalya's eggs have a rich, round flavor that varies according to the season and what the chickens happen to come across while foraging in their yard. In comparison, farmed eggs are bland and tasteless. But be warned: After trying "real" eggs, you will find it hard to go back to the standard commercial kind.

If you want to determine the freshness of your eggs, put them in a container holding a solution of salt and water in which the amount of salt is about 12 percent of the weight of water, or about ¼ cup of salt for every 1 cup of water. An egg laid that day will sink to

the bottom. A three-day-old egg will sink about halfway down the container. A two-week-old egg floats on the top. That's because the rounder end of the egg has an air chamber like a bubble that barely exists in an ultra-fresh egg. As the liquid in the egg evaporates through the shell over time, the bubble grows, making the egg more buoyant. When you prepare hard-cooked eggs, this bubble expands with the heat and can crack the shell. To avoid this, simply prick a hole in the round end with a thumbtack or pushpin to create an escape route for the expanding air.

To determine whether that egg in your fridge is raw or hard-cooked before you crack it open, give it a spin on the counter. A hard-cooked egg rotates like a top because its insides are solid. A raw egg wobbles and falls over because of its liquid interior.

Nathalya's Jamaican Curried Chicken

Half of the chicks that hatch in Nathalya's coop are males and will never join her egg-laying flock. But she makes a virtue out of this reproductive necessity by putting them (along with the occasional superannuated hen) to good use in an assortment of Jamaican dishes, including an outstanding curried chicken stew. It is over-the-top spicy because she uses Scotch bonnet peppers (famous for their searing role in jerk sauce), red pepper flakes, and Jamaican curry powder, which is hotter than other varieties. To begin, she cuts 1-inch pieces of meat from the bones, removes the skin, and then washes the meat with vinegar, which is something I had never heard of. Then, she rinses the pieces of meat with running water until they are nice and clean. She marinates the chicken with oil and the curry powder and some Maggi all-purpose seasoning. Eventually, she heats oil in a

large skillet, adds the seasoned chicken for a few minutes until it develops a nice sear, and then puts in water, along with potatoes and carrots. The stew cooks for 30 to 40 minutes to create her delicious specialty: an extremely flavorful, highly seasoned taste of the islands. You might want to have a well-chilled Red Stripe beer or a glass of planter's punch at hand to extinguish the "flames."

Occasionally, I've had dishes that blur the boundary between chicken and egg. In Vietnam, the restaurant at the hotel where we were staying served what appeared to be hard-cooked eggs for breakfast. The dish is called *balut*, and cutting it into halves revealed not a yolk but a cooked embryo—a tiny, curled-up, naked chick. The Vietnamese consider it a delicacy. For the preparation, they select fertilized eggs between twelve and fourteen days old (a chick takes between twenty and twenty-one days to hatch). Once I got over the surprise of seeing the embryonic chicks, I found the breakfast unusual but enjoyable. Quite good, in fact.

I can't say the same for the offering at a street market in Beijing, which I visited with Gloria and some friends a few years later. Strolling along, we came upon a man tending a cart piled high with eggs. A powerful flashlight hung from one corner. Customers waited in line, selected their eggs, and held them up to the light before committing to a purchase. After buying their eggs, they cracked them open on the spot and removed an embryo that was about the same age as the one I had for breakfast in Vietnam. They dipped it in a bowl of coarse salt, and gulped it down then and there, raw. Game for any new taste experience and encouraged by the long line of eager customers, I had to believe that I would find this experience at very least interesting, if not delicious. I joined the queue, chose my egg,

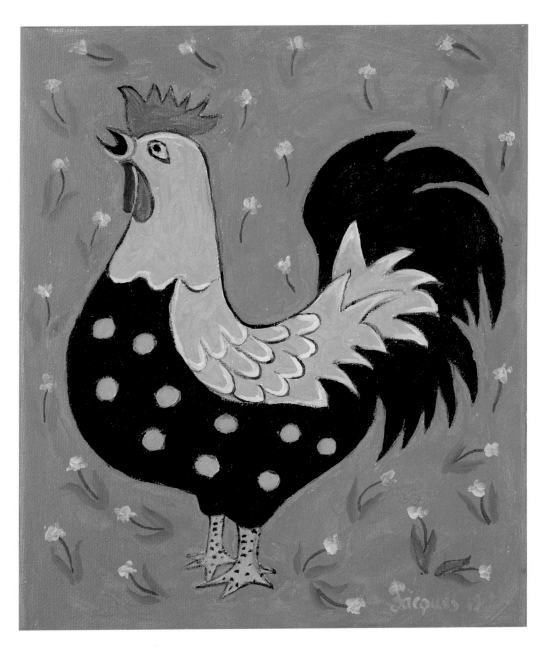

Black and Yellow Rooster, 2019

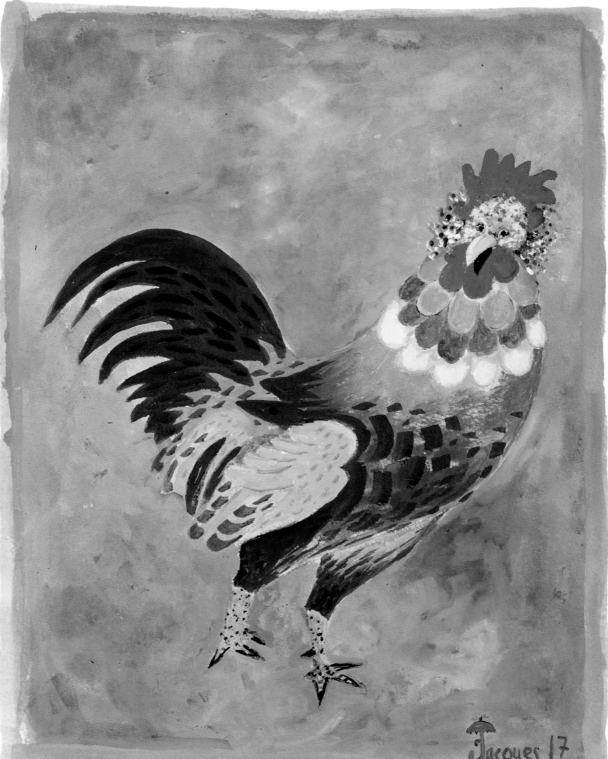
Jacques 17

scanned it with the flashlight to see an X-ray-like image of the resident chick, and cracked the shell. I could not bring myself to swallow its contents. My refusal to try a raw chicken embryo remains the only time that I have been unable to dine on an egg dish.

※ ※ ※

Breakfast, lunch, and dinner—eggs show up for any meal. Without them, I would be unable to cook. It's that simple. I rely on a full gamut of egg preparations.

Maman's Eggs Gratinée
※

When I was a boy in wartime France, simple, hard-cooked eggs played an important role in our sustenance. We didn't have much to eat, and eggs replaced meat (a treat available only every couple of weeks or so) as one of the primary sources of protein at home.

Maman made a great gratin of hard-cooked eggs, which she shelled, then quartered or sliced, and placed in a baking pan on top of any number of ingredients: mushrooms, potatoes, pasta, spinach, Swiss chard—basically any leftovers on hand. The dish was covered with a béchamel, velouté (chicken stock thickened with a roux), or tomato sauce and sprinkled with grated Gruyère cheese. Her secret for successful hard-cooked-egg gratins involved making absolutely sure that she cooked the eggs properly, boiling them for just 9 or 10 minutes and immediately cooling them under cold water. This method prevents the development of a sulfurous taste and smell and the formation of a greenish ring around the yolk, sure signs of overcooking.

Facing page: *Dandy Cock,* 2017

Eggs Jeannette

❧

I christened Maman's most famous (and perhaps my family's favorite) egg dish Eggs Jeannette after her. Maman split hard-cooked eggs in half lengthwise and removed the yolks. She made a persillade by chopping garlic and parsley together and mashed it into the yolks, along with salt and pepper. She added a few tablespoons of milk to blend the ingredients, then she spooned them back into the hollowed-out whites, setting aside a few tablespoons' worth for a sauce.

I suppose she could have stopped there and had very good stuffed eggs. But Maman elevated the dish to something truly special by frying the filled eggs stuffed-side down in a skillet with a dash of butter or oil. They browned beautifully after a couple of minutes. To complete the dish, she topped the eggs with a sauce made from the yolk mixture she reserved along with Dijon-style mustard, peanut oil, and a dribble of vinegar.

Gloria thought so highly of the dish that she decided to include it on the menu of a large Christmas party one year. For a festive twist in the Yuletide spirit, she decided to use quail's eggs, three dozen to be precise. Shelling, halving, and stuffing the tiny eggs proved to be so persnickety that neither of us tried to improve on Eggs Jeannette that way again.

❧ ❧ ❧

In 1976 I visited a little upstart restaurant in Berkeley, California, with James Beard. He had sung the praises for the cooking philosophy of the young restaurateur. The server arrived with a simple salad of mixed greens accompanied by halved hard-cooked eggs. They

were perfectly cooked with slightly creamy yolks. Tasting them, I realized that this restaurant was something special. At a time when most chefs wouldn't have given a second thought to hard-cooked eggs, whoever ran the place had taken the trouble to obtain pastured eggs and prepare them with great care. I knew I was in for a memorable meal. Chef Jeremiah Tower and the place's owner, Alice Waters, delivered.

We had started the meal with oysters on the half shell garnished with pieces of sautéed breakfast sausage, a novelty for me, followed by beautiful slices of pink roasted leg of lamb with a gratin of potato. We finished the delightful meal with cream puff dough filled with Chantilly.

<div align="center">❧ ❧ ❧</div>

The classic repertoire offers dozens of ways to use hard-cooked eggs. Blend yolks with preparations of lobster, truffles, ham, mushrooms, artichoke hearts, onions, cheese, or herbs. Glaze them with velouté, tomato, red wine, truffle, or Madeira sauce. Serve them for breakfast or lunch, or as a first course for an elegant dinner. With a few hard-cooked eggs and a bit of imagination, you have an embarrassment of riches.

Eggs en Cocotte

<div align="center">❧</div>

If you want easy elegance and something a little out-of-the-ordinary, try eggs en cocotte, a starter on the menus of fancy restaurants. In French, a cocotte is a small heatproof container, like a soufflé mold, that holds about ¾ cup. You butter the insides and bottom of the cocotte and scatter in herbs, mushrooms, or even truffles if you are feeling flush and want to celebrate. Crack in one raw egg, place the

cocotte in a simmering saucepan with enough water to come about one-third of the way up the sides, cover it, and cook for a few minutes. When done, the center should still be runny, like that of a poached egg.

You can pour a little cream over the egg and eat it in the cocotte or invert the egg onto a slice of brioche or any other good toasted white bread and add the garnishes of your choice to create an *oeuf moulé*—an unmolded egg. Eggs en cocotte can also be finished with a demi-glace or Champagne sauce and served with asparagus, fish, or marrow, or many other garnishes.

Gloria loved eggs en cocotte with shrimp. For that, I put diced raw shrimp in a saucepan with heavy cream, salt, pepper, chopped tarragon, and a dribble of Cognac. I bring the mixture barely to a boil, then remove it from the heat. I spoon a few tablespoons of the mixture into each cocotte and top it with an egg. The cocottes are cooked in a double boiler for 4 or 5 minutes. We would eat them with small spoons and brioche toast. I wholeheartedly recommend this dish the next time you find yourself asking, "What should we have for lunch?"

Oeufs en Gelée

On a warm day, I like to prepare cold egg dishes such as *mollet* eggs in aspic, which Gloria and I had at least once a week during the summer. I cook them as I would hard-cooked eggs, but for less time—about 7 minutes. When shelled, the white should remain soft (the word *mollet* in French) but be firm enough to hold its egg shape. The yolk will still be runny. I put the *mollet* eggs in cups with tarragon

Facing page: *Dancing Rooster, 2019*

leaves and sometimes diced ham. I heat a mixture of clear and strong chicken or beef stock, unflavored gelatin, herbs, and a dash of sherry to boil. I let the mixture cool, then fill the containers to the brim, covering the eggs, and chill the filled cups in the refrigerator until the liquid sets to form aspic. To serve, I unmold the aspic and serve the *oeufs en gelée* by themselves as either a light lunch or the first course of a dinner, one of my favorite ways to start a summer meal.

During the summer following our wedding, a wealthy fellow Gloria met through her job running a recording studio in New York invited us to dinner at his home in East Hampton on Long Island. Gloria informed me that she had volunteered *my* services to cook dinner for the family. What better way to start a tony Hamptons dinner on a hot evening, I thought, than *oeufs en gelée*?

The guy fancied himself a connoisseur of fine cuisine. He bragged about eating at Le Pavillon during my tenure there and being a regular at many other great New York restaurants, including La Côte Basque and Lafayette. The house had everything a seaside Hamptons mansion needed, right down to a heliport for speedy commutes into and out of the city well above the traffic jams. The kitchen radiated opulence, including marble countertops, an array of expensive appliances, and a professional-quality stove. The image held until I opened a cupboard door and confronted a mismatched set of cheap, flimsy tools and cookware of the kind found in a mid-level efficiency motel. Our hosts obviously lacked even the bare rudiments necessary to undertake serious cooking. I even had to go out to buy a decent skillet.

Nonetheless, I soldiered along in this show kitchen, cooking the *mollet* eggs, preparing the aspic, refrigerating the dish. At serving time, I unmolded my beautiful eggs and presented them on lettuce

Flower Chicken, 2018

Blue Chicken, 2016

leaves. The man's grade-school-aged son looked perplexed as he cut into his egg and tentatively placed a tidbit in his mouth. He grimaced, turned querulously to his mother, and whined, "Mom, it's a cold egg, raw inside, with salty Jell-O."

Yikes! I had to burst out laughing. It was a pretty accurate, albeit brutally honest, description of the dish. I'm sure his parents felt the same way he did. You can always count on kids to be straightforward with their feelings.

Scrambled Eggs Done Right

There are two basic ways to cook scrambled eggs, and most people have strong feelings about the one they prefer. Many like theirs cooked rapidly and with large, firm curds. Others thoroughly beat their eggs, sometimes adding a bit of cream, and cook them in a sturdy saucepan over low heat, constantly whisking them to get the smallest possible curd and a creamy texture.

I favor the second approach. My personal scrambling method involves holding back a few tablespoons of the raw mixture. I whisk the eggs until I can see the bottom of the pan, then add the reserved egg mixture with a bit of cream to cool the eggs and stop the cooking. Sometimes I serve them with a demi-glace with Madeira and diced ham.

At Les Prés d'Eugénie, the three-Michelin-star restaurant in southwestern France, the nouvelle cuisine pioneer Michel Guérard developed a haute version of scrambled eggs by filling an eggshell with scrambled eggs topped with a generous tablespoon of caviar—chicken eggs *and* fish eggs. My friend Roland Passot served a similarly high-end version of scrambled eggs at his San Francisco restaurant La Folie, substituting truffles for the caviar.

Mirror Eggs

✦

I usually opt for a simple fried egg, sometimes for breakfast but more often for lunch. I melt butter in a small skillet and crack open two eggs. I cook them slowly, so the whites stay tender. Then I sprinkle in about a teaspoon of water and cover the pan. This generates steam, which glazes the tops of the eggs. The result is *oeufs miroir*, literally, mirror eggs, similar to sunny-side up in America. The yolks should be runny, like those of poached eggs. Another technique is to heat butter in a small gratin dish, break your egg into it, and cook in a hot oven until the egg is cooked to your liking.

Deep-Fried Eggs

✦

While working at the Plaza Athénée as a breakfast cook, I made my share of *oeufs miroir*, but guests often ordered deep-fried eggs, a familiar classic then but rarely made today. To make them, I slipped one egg at a time into a saucepan of hot peanut oil, as you would lower an egg into water when poaching. Since the white would immediately begin spreading out across the surface of the oil, I had to work fast to contain the white by corralling it against the yolk with two wooden spoons and holding it in place around the yolk for a few seconds, until the white turned deep brown but the yolk remained runny. We usually served eggs cooked this way on a piece of toast with a slice or two of crisp bacon, a grilled tomato, and grilled white mushrooms.

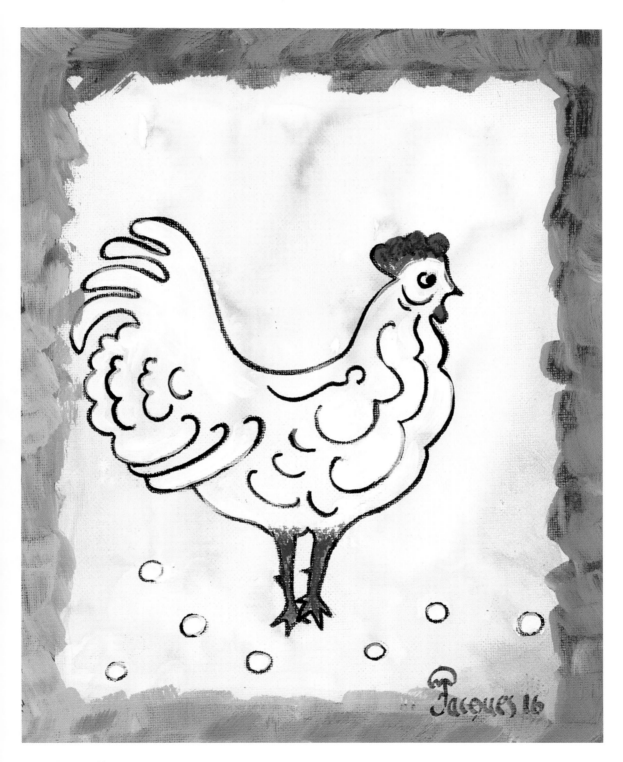

Bresse Chicken, 2016

Poulet and Legumes, 2020

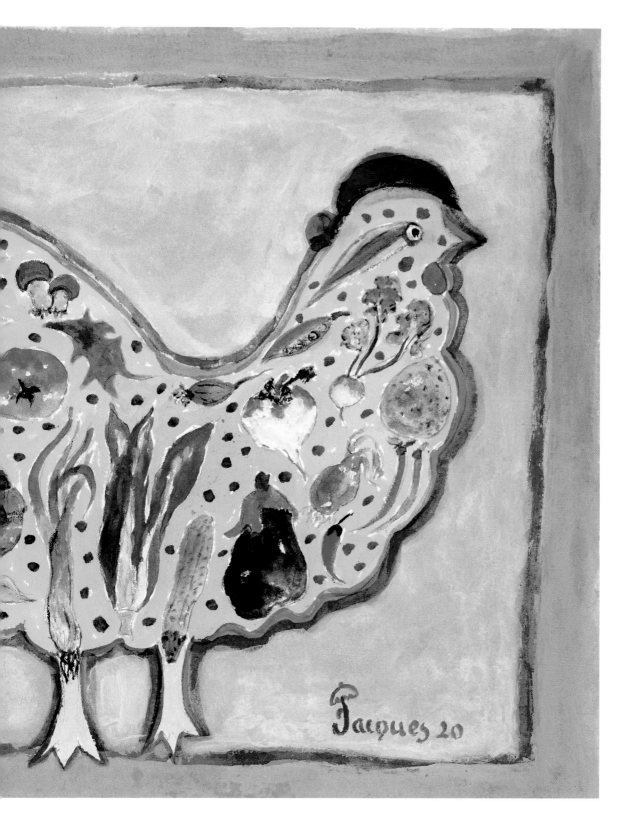

Poaching 101

❧

Whether done in the kitchens of the Plaza Athénée or in your own home, poaching eggs requires only three ingredients: eggs, a pan of boiling water, and a dash of distilled vinegar, which prevents the whites from spreading too much. Vinegar's acid also helps the whites stay tender. When the first egg hits the boiling water-vinegar mixture, the boiling stops, and you shouldn't allow the water to boil again during the cooking. Rather, simmer the eggs gently for 4 or 5 minutes, keeping the water just below the boiling point. When they are done to your liking, lift the eggs with a slotted spoon and immediately immerse them in ice water to stop the cooking.

In professional kitchens, chefs poach eggs in advance. When an order comes in, the cooks place precooked eggs in sieves that they lower into boiling water just long enough to reheat the eggs and commonly serve them with hollandaise, béarnaise, or tomato sauce.

For a special occasion, I place poached eggs in hollowed-out artichoke bottoms filled with creamed spinach or creamed mushrooms, coat them with mornay sauce (béchamel with cheese), and glaze them under a broiler.

You may feel that the last thing you need is another kitchen gadget, so I'm somewhat hesitant to recommend that you poach your eggs in an immersion circulator, popular for sous vide preparations. Professional sous vide machines cost thousands of dollars, but now you can get home models in the same price range as blenders. You drop an egg, shell and all, into 150°F water and leave it in the circulator for an hour, then crack it as you would normally. A glistening ovoid shape emerges, its yolk and white with the same creamy, velvety texture. Well worth trying.

Poached Eggs in Red Wine Sauce

❧

One of the glories of lower Burgundy, where I come from, is the egg in *meurette*. A traditional dish, it consists of eggs poached in red wine and served with a red wine sauce garnished with shallots, *lardons* (diced pancetta), mushrooms, and garlic. It is conventionally served with toasted *gros pain*, a country loaf.

There is no need to put vinegar in the poaching liquid, as the acid in the wine achieves the same result. After the eggs are poached, the wine used to poach the egg is reduced by half. Chopped garlic or shallots are sautéed with diced *lardons* and button mushrooms in another pan. The reduced wine is then added and thickened with a bit of *beurre manié* (butter and flour worked together into a paste), salt, pepper, and finished with butter. A glorious and delicious concoction of Burgundy.

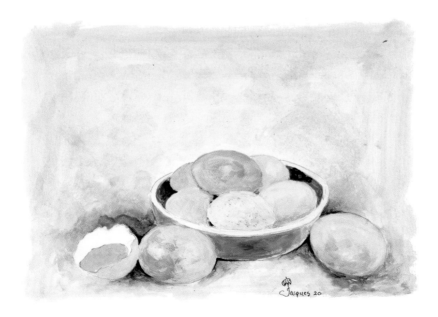

Eggs 1, 2020

Omelets for Every Occasion

Among avid cooks, there are few better ways to start an argument than asking, "What is the proper way to cook an omelet?" Having made hundreds of omelets in my lifetime, I'm here to settle the dispute. There is no single proper way, but rather many.

Country-Style Omelet

❧

To make a straightforward omelet like those served in bistros in France and diners in America, I beat eggs in a bowl with a fork, then add salt and pepper, and cheese, ham, and/or herbs, depending on my mood. I pour that mixture into a skillet sizzling with hot butter and cook over high heat. With the tines of a fork or the end of a spatula, I pull the sides of the cooking eggs back toward the center of the pan just after they have begun to set to create large curds, a process I repeat until the mixture is firmly set but still a bit wet. At that point, I fold the omelet in half with a spatula and add another piece of butter to the pan to brown the omelet's undersides. Then I immediately invert the pan over a plate and serve. My mother always made omelets like this. The French call this version a country-style omelet.

Western Omelet

❧

To make a flat, or Western, omelet (called an *omelet basquaise* in France, meaning from the Basque region), I sauté Basque ham (similar to prosciutto) with chopped red onion, red and green bell peppers, and tomatoes and pour beaten eggs into the skillet with the

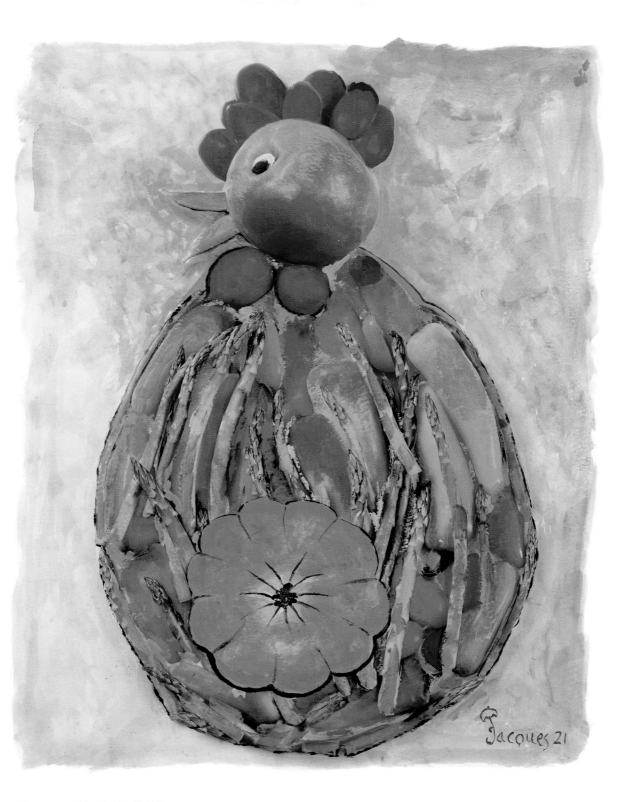

Chicken and Vegetables 3, 2021

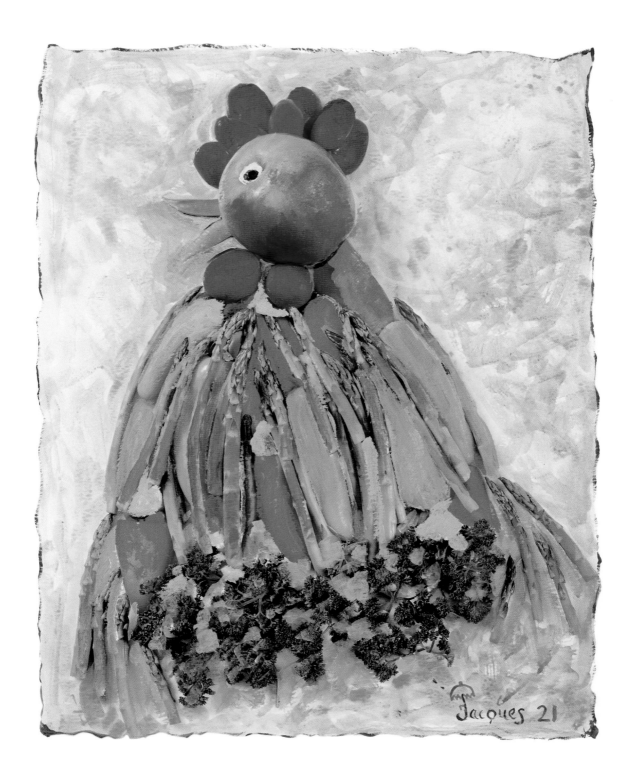

Chicken and Vegetables 4, 2021

ham and cooked vegetables, cook it a couple of minutes, flip it over, and eventually turn it out onto a plate.

Spanish Omelet and Italian Frittata

❧

A flat Spanish omelet, called a *tortilla* in Spain, is similar to a Western omelet. It calls for pouring beaten eggs over sautéed sliced or diced potatoes and onions. You find tortillas in almost every small restaurant in Spain, usually on the bar cut into pizza-style pieces. Patrons take wedges, a perfect snack to go with a glass of Rioja. To make a quick, flavorful dinner on a hot summer evening, I follow the same steps to make a flat omelet called a *frittata* in Italy, using sautéed potatoes, pancetta, scallions, onions, garlic, and herbs, to which I add beaten eggs. With a big green salad, a bottle of chilled rosé or white wine, and a few nibbles of cheese, you've got a thoroughly satisfying meal.

Classic French Omelet

❧

The technique for a classic French omelet is a bit more difficult to master. There are 150 variations in the *Répertoire de la Cuisine,* a shorthand reference guide to Escoffier's recipes. I move the beaten eggs rapidly in a pan, shaking the pan hard with one hand while stirring the eggs with a fork in the other until their texture resembles that of French scrambled eggs—creamy small curds. When the eggs have almost set but remain moist, I tilt the pan so that the contents slide to one side. I fold the lip of the omelet nearest me back toward

the center, then tap the handle of the pan gently with my hand so the other lip rises above the edge of the pan. Then I fold it back so that it meets the first. Finally, I invert the pan over a plate. The omelet should come out uniformly beige, smooth, and soft and be creamy inside.

Each time I applied for a new job as a young cook in Paris, the head chef invariably greeted me with the challenge "Make an omelet!" meaning, of course, the classic French kind. By watching me, my potential boss could quickly and accurately assess my culinary skills. Many restaurant chefs still use the same fail-safe test before offering newcomers a job.

At the Meurice Hotel in Paris and at Le Pavillon in New York, cooks on our brigade stuffed classic omelets with morel mushrooms, inverted them onto plates, and coated them with chicken stock thickened with a roux (a velouté) that we enriched with cream and combined with hollandaise sauce. The jewel in Le Pavillon's egg repertoire was the Omelet Pavillon.

Omelet Pavillon

❧

The base for this popular dish is the classic French omelet. But I think of the version we prepared for our guests at Le Pavillon as a classic omelet on steroids. After making the omelets in the traditional way, we filled them with morsels of lobster and turned them out into copper gratin dishes. We coated them with a Mornay sauce by adding grated Gruyère cheese to a standard béchamel, then sprinkled on grated Parmesan, and ran the dish under the broiler.

Facing page: *Surprised Cock,* 2017

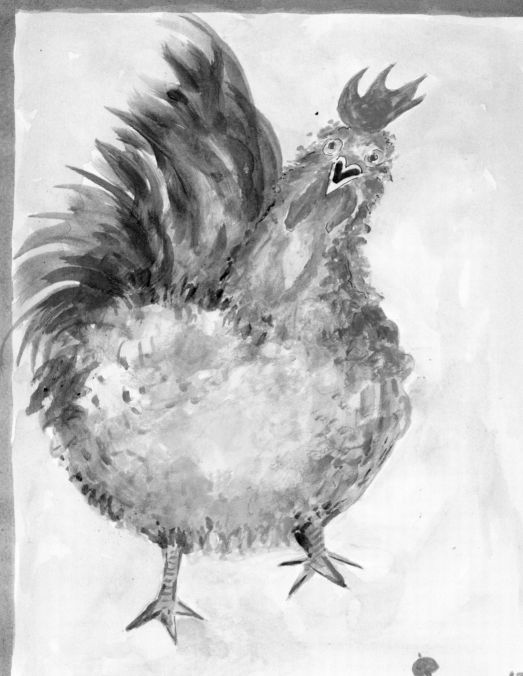

Jacques 17

Omelet with Caviar

Similarly, I once created a luxurious omelet especially for Gloria, who loved both eggs and caviar (fish eggs). After inverting a classic one-egg omelet stuffed with salmon caviar onto a plate, I enclosed it in a layer of pressed caviar called Payusnaya. Prized for its intense flavor, it has a consistency that allowed me to roll it out into a thin sheet in which I wrapped her omelet. Every bite was a perfect marriage of two of her favorite things.

Omelette Fines Herbes

As I rite of spring, I serve *omelette fines herbes,* the classic herbs used being parsley, chives, tarragon, and chervil, a delicate herb with the faint taste of anise. All you need to make it is fresh herbs, sweet butter, and the best eggs you can lay your hands on. One year, I scored chicken, duck, pheasant, quail, and guinea fowl eggs on a visit to Nathalya, my egg supplier. I thought, "Why not?" and cracked all the different species' eggs into one bowl and made a large, special *omelette fines herbes.* It was excellent.

My biggest omelet challenge came in the late 1990s during the filming of an episode of *Julia and Jacques Cooking at Home.* With the cameras rolling, Julia asked if I would like to demonstrate how to make an omelet. When I said, "Sure," she reached under a counter and produced an ostrich egg. I had no idea how to deal with a single, softball-sized egg that had as much heft as two dozen ordi-

Curious Chicken, 2017

nary chicken eggs. I couldn't even crack the damn thing, not on the counter, not on the edge of a heavy skillet, not with a large chef's knife. Finally, Julia pulled out an electric power drill and instructed me to bore a hole to breach the seemingly indestructible shell.

When I finally succeeded, the surge of white and yolk from the gigantic egg threatened to overflow the bowl. The resulting omelet filled Julia's largest skillet and could have served ten hungry diners a delicious breakfast. If you didn't know better, you'd have said that ostrich eggs taste, well, like chicken.

Next spread, left: *The Rooster King,* 2017; right: *Imperial Rooster,* 2019

Which Came First?

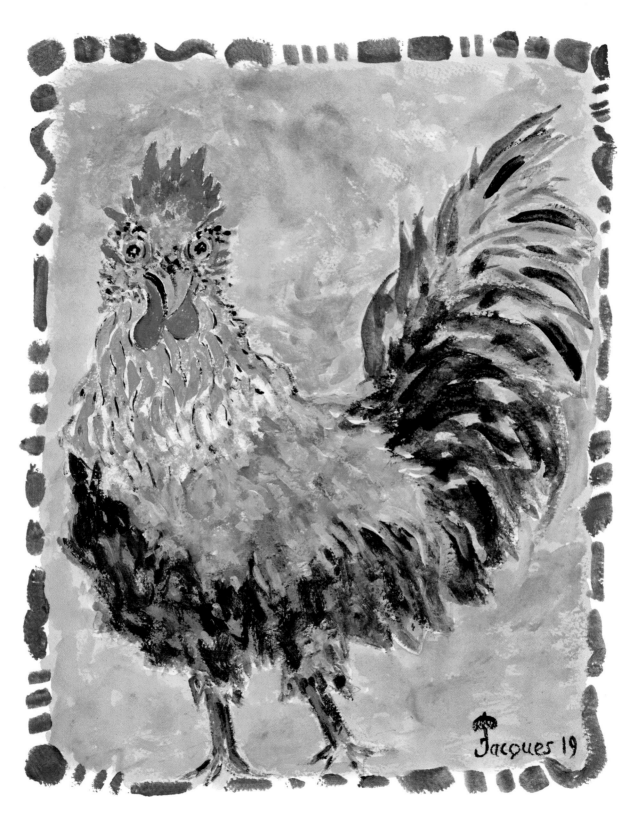

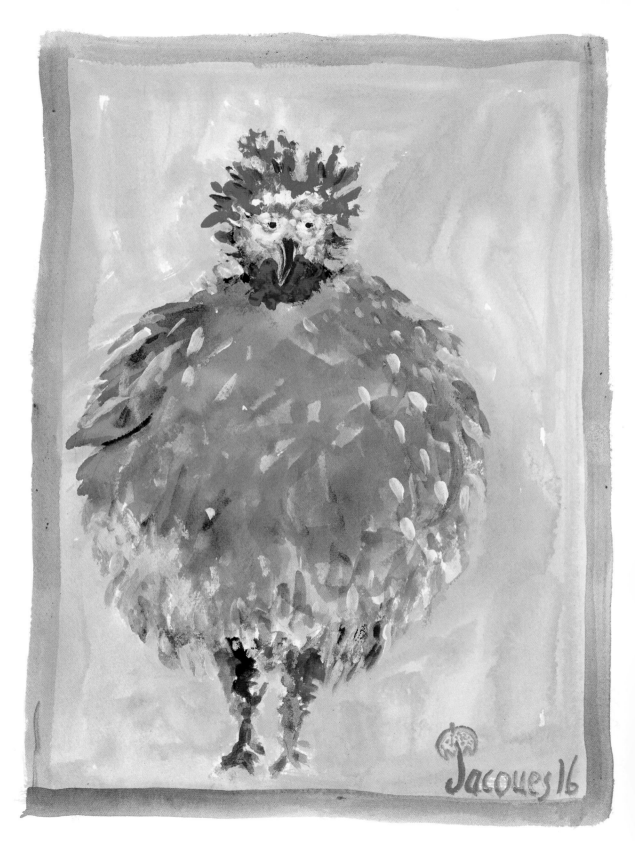

One Chicken, Every Occasion

———

A T THE MOMENT, a three-pound chicken rests in my refrigerator. I picked it up on my last trip to the grocery store with no clear idea of how I would prepare it. Which is fine. In the kitchen, chickens are egalitarian creatures. Bring one home and it can be adapted to any style of cooking, from simple country fare to the heights of haute cuisine.

When Gloria and I were at home together, I often roasted a chicken for just the two of us. We enjoyed the chicken in its own juices with a green salad, bread, and some wine. The French classify such a meal as "country cooking."

From time to time, Gloria would tell me that she wanted to have a couple of friends over for a last-minute dinner. Preparing a meal suitable for unexpected guests poses no problem if you have a chicken in your fridge. To gussy up the bird a little bit, I place some mushrooms around it as it cooks. For a side dish, I prepare *petits pois à la française*, peas sautéed with lettuce. Dinner ends with a plate of cheeses and perhaps a simple dessert of in-season fruit. The French call this slightly more elegant way of eating "bourgeois cooking."

Facing page: *The Harried Chicken,* 2016

If a holiday or another special occasion looms, I can transform that same chicken into a superlative meal worthy of a great restaurant. After roasting the chicken, I make a sauce from a brown stock that I reduce by half and thicken with potato starch and enrich with a splash of dry vermouth before adding the defatted cooking juices. I accompany the bird with wild mushrooms such as cèpes (also called boletus or porcini) or, if I have any on hand, a few slices of truffle. Braised endive also goes well with this dish.

The meal may start with a clear chicken consommé and include a first course of trout sautéed in butter and almonds, then proceed to the chicken, a salad, and cheeses and dessert, most likely involving fruit. We kick off the evening on the right note with Champagne, followed by white wine, red wine, and maybe a dessert wine like Sauternes. A beautiful tablecloth adorns the table along with flowers, our best silverware, and candles. I may even adorn myself with a jacket and sometimes a tie. Country cooking, to bourgeois, to haute cuisine—dress up the humble chicken and it can go anywhere.

❧ ❧ ❧

Chicken and egg cooking, chicken stories, chicken lore, and chicken painting are all aspects of who I am. From early on, chickens and eggs have been tightly woven into my professional and social life. The unique characteristic of chicken is that it fits and is part of all levels of cooking in all parts of the world, from very rich to very poor. It is truly universal and essential in all cuisines—French, Italian, Spanish, Chinese, African, Indian, Arab, and many others. It will appear on the plate of a three-star Michelin restaurant as well as in a diner, hospital cafeteria, small bistro, hotel menu, or food truck. I have cooked and eaten chicken all my life in all different forms from soup to roast to grilled, from stew to salad to fried, and in pâté.

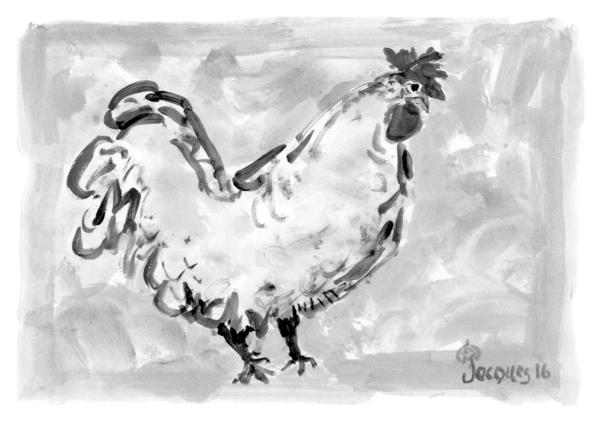

The French Chicken, 2016

Chicken will certainly be on the table at my last meal, along with a bottle of Champagne. Maybe I'll start with scrambled eggs and truffles. After that, I will serve a capon consommé with a chicken quenelle. Or perhaps I'll include Danny Kaye's chicken salad? Gloria's arroz con pollo? Maman's chicken? Cousin Merrett's *gâteau de foies de volaille*? Bichon's grilled chicken? The choices are endless. . . . One thing I know for sure, I intend to linger over a very, very long meal.

The Refined Chicken, 2020

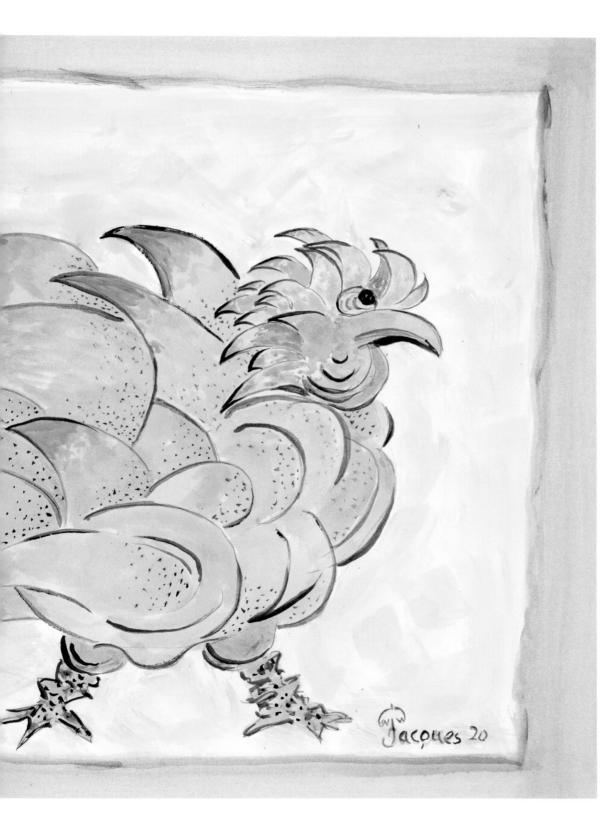

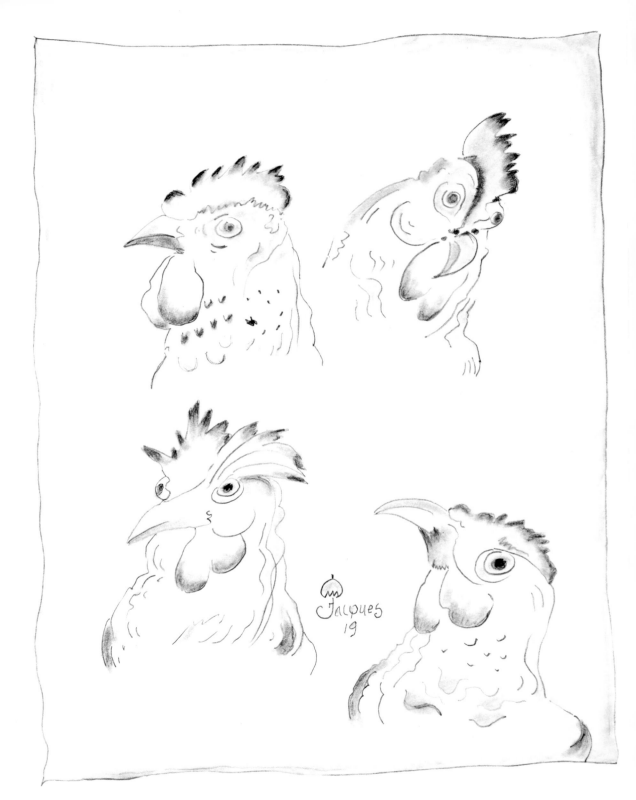

Chicken Heads 2, 2019

Recipe Index

—◆—

Arroz con Pollo, 106–7

Banker's Chicken, 148–50
Bichon's Grilled Chicken, 129
Blood Sausage, Senegalese, 143
Bouillabaisse, Chicken, 30
Bread
 Dough, Whole Chicken Baked in, 14
 The Very Best French Toast, 65

Carrots
 Cream of Chicken Soup Potagerie, 122
 Roast Chicken with Winter Vegetables,
 56
Caviar
 Omelet with, 208
 Scrambled Eggs Done Right, 195
Cheese
 Country-Style Omelet, 202
 Maman's Eggs Gratinée, 187
 Omelet Pavillon, 206
 Petite Marmite from Le Meurice, 140
 Whole Chicken Baked in Bread, 14
Chicken recipes
 Arroz con Pollo, 106–7
 Banker's Chicken, 148–50
 Basic Chicken Stock, 42
 The Best Chicken Salad, 124
 Bichon's Grilled Chicken, 129
 Chicken Bercy, 101
 Chicken Bouillabaisse, 30
 Chicken Breast à la Susie, 166

Chicken Chasseur, 77
Chicken Cracklings, 134
Chicken Foie Gras, 151
Chicken Kiev, 157
Chicken Liver Mousse, 154–56
Chicken Neck Sausages and Fricassees,
 140–41
Chicken Quenelles, 27
Chicken with Vinegar Sauce, 29
Chimichurri Chicken, 106
Coq au Vin, 142
Cousin Merret's Chicken Liver "Cake,"
 26–27
Cream of Chicken Soup Potagerie, 122
Enraged Chicken, 146
Gizzards, Gizzards, and More
 Gizzards, 138
Grilled Chicken, 52
Julia and Jacques's Dueling Chickens,
 165
For a Liver Lover, 150–51
Maman's Chicken, Three Ways, 18–19
Mr. Aicardi's Roasted Poularde, 76
My Home Version of HoJo's Southern
 Fried Chicken, 90
Nathalya's Jamaican Curried Chicken,
 183–84
Petite Marmite from Le Meurice, 140
Poularde à la Néva, 115–17
Poulet Pavillon, 84
Roast Chicken with Winter Vegetables, 56
Russian Tea Room Mousse, 157

Chicken recipes (*cont.*)
 Salade Bressane, 159
 Senegalese Blood Sausage, 143
 Spicy Chinese Chicken Feet, 146
 Tarragon Chicken, 46
 The Ultimate Meal, 170–71
 Whole Chicken Baked in Bread, 14
Chimichurri Chicken, 106
Chinese Chicken Feet, Spicy, 146
Coq au Vin, 142
Country-Style Omelet, 202
Cousin Merret's Chicken Liver "Cake,"
 26–27
Cracklings, Chicken, 134
Cream of Chicken Soup Potagerie, 122
Curried Chicken, Nathalya's Jamaican,
 183–84

Deep-Fried Eggs, 196

Egg recipes
 Classic French Omelet, 205–6
 Country-Style Omelet, 202
 Deep-Fried Eggs, 196
 Eggs Benedict, 72
 Eggs en Cocotte, 189–90
 Eggs Jeannette, 188
 Hollandaise Sauce, 72
 Maman's Eggs Gratinée, 187
 Mirror Eggs, 196
 Oeufs en Gelée, 190–92
 Omelet Pavillon, 206
 Omelette Fines Herbes, 208
 Omelet with Caviar, 208
 Poached Eggs in Red Wine Sauce, 201
 Poaching 101, 200
 Scrambled Eggs Done Right, 195
 Snow Eggs, 68
 Spanish Omelet and Italian Frittata, 205
 The Very Best French Toast, 65
 Western Omelet, 202–5
Enraged Chicken, 146

Feet, Spicy Chinese Chicken, 146
Foie Gras, Chicken, 151
French Omelet, Classic, 205–6
French Toast, The Very Best, 65
Frisée
 Salade Bressane, 159

Frittata, Italian, and Spanish Omelet, 205

Garlic
 Chimichurri Chicken, 106
 Eggs Jeannette, 188
Gizzards
 Gizzards, and More Gizzards, 138
 Petite Marmite from Le Meurice, 140
Salade Bressane, 159
Grilled Chicken, 52
Grilled Chicken, Bichon's, 129

Ham
 Country-Style Omelet, 202
 Eggs Benedict, 72
 Oeufs en Gelée, 190–92
 Western Omelet, 202–5
Herbs. *See also* Parsley; Tarragon
 Omelette Fines Herbes, 208
HoJo's Southern Fried Chicken, My
 Home Version of, 90

Italian Frittata and Spanish Omelet, 205

Jamaican Curried Chicken, Nathalya's,
 183–84
Julia and Jacques's Dueling Chickens, 165

Livers
 Chicken Foie Gras, 151
 Chicken Liver Mousse, 154–56
 Cousin Merret's Chicken Liver "Cake,"
 26–27
 For a Liver Lover, 150–51
 Russian Tea Room Mousse, 157
 Salade Bressane, 159
Lobster
 Omelet Pavillon, 206

Maman's Eggs Gratinée, 187
Mirror Eggs, 196
Mousse
 Chicken Liver, 154–56
 Russian Tea Room, 157
Mr. Aicardi's Roasted Poularde, 76
Mushrooms
 Chicken Bercy, 101
 Chicken Chasseur, 77
 Coq au Vin, 142

Cousin Merret's Chicken Liver "Cake," 26–27
Cream of Chicken Soup Potagerie, 122
Eggs en Cocotte, 189–90
Maman's Eggs Gratinée, 187
Mr. Aicardi's Roasted Poularde, 76
Poached Eggs in Red Wine Sauce, 201
Whole Chicken Baked in Bread, 14

Nathalya's Jamaican Curried Chicken, 183–84

Oeufs en Gelée, 190–92
Omelets
 with Caviar, 208
 Classic French, 205–6
 Country-Style, 202
 Omelette Fines Herbes, 208
 Pavillon, 206
 Spanish, and Italian Frittata, 205
 Western, 202–5

Parsley
 Chimichurri Chicken, 106
 Eggs Jeannette, 188
 Omelette Fines Herbes, 208
Peppers
 Enraged Chicken, 146
 Nathalya's Jamaican Curried Chicken, 183–84
 Western Omelet, 202–5
Petite Marmite from Le Meurice, 140
Poached Eggs in Red Wine Sauce, 201
Poaching 101, 200
Potatoes
 Chicken Bouillabaisse, 30
 Maman's Eggs Gratinée, 187
 Roast Chicken with Winter Vegetables, 56
 Salade Bressane, 159
 Spanish Omelet and Italian Frittata, 205
 The Ultimate Meal, 170–71
Poularde à la Néva, 115–17
Poulet Pavillon, 84
Quenelles, Chicken, 27

Red Wine Sauce, Poached Eggs in, 201
Rice
 Arroz con Pollo, 106–7

Mr. Aicardi's Roasted Poularde, 76
Russian Tea Room Mousse, 157

Salads
 Chicken, The Best, 124
 Salade Bressane, 159
 in The Ultimate Meal, 171
Sausage(s)
 Arroz con Pollo, 106–7
 Blood, Senegalese, 143
 Chicken Bercy, 101
 Chicken Bouillabaisse, 30
 Chicken Neck, and Fricassees, 140–41
Scrambled Eggs Done Right, 195
Senegalese Blood Sausage, 143
Shrimp, Eggs en Cocotte with, 190
Snow Eggs, 68
Soup, Cream of Chicken, Potagerie, 122
Spanish Omelet and Italian Frittata, 205
Spinach
 Maman's Eggs Gratinée, 187
 Whole Chicken Baked in Bread, 14
Stews
 Chicken Bouillabaisse, 30
 Coq au Vin, 142
 Gizzards, Gizzards, and More Gizzards, 138
 Nathalya's Jamaican Curried Chicken, 183–84
Stock, Basic Chicken, 42

Tarragon
 Chicken, 46
 Oeufs en Gelée, 190–92
 Omelette Fines Herbes, 208
Tomatoes
 Arroz con Pollo, 106–7
 Chicken Chasseur, 77
 Cousin Merret's Chicken Liver "Cake," 26–27
 Western Omelet, 202–5

The Ultimate Meal, 170–71
Vegetables. See also specific vegetables
 Winter, Roast Chicken with, 56
Vinegar Sauce, Chicken with, 29

Western Omelet, 202–5
Wine, Red, Sauce, Poached Eggs in, 201

Index

Note: Page references in *italics* indicate paintings.

Adolphus hotel, 100
Aicardi, Monsieur, 75–76
Aix-les-Bains, France, 51
Algeria, 71
Almanach des Gourmands (Grimod de la Reynière), 178
Angèle (waitress), 45–49
Angry Chicken, 2017, *xiv–xv*
Apples and Chicken, 2020, *164*
The Art of Cooking (Pépin), xi, 124, 166
Aykroyd, Dan, 162

balut (embryonic eggs), 184
Barnyard Brawl, 2016, *152–53*
Beard, James, 188–89
Beijing, China, 184–87
Bélassé, Carmen, 143–46
Bélassé, Marcel, 143
Bellegarde, France, 55
Benedict, Mrs. Legrand, 71
Berkeley, CA, 188–89
Bibiche (black mutt), 15–18
Black and Yellow Rooster, 2019, *185*
Black Chicken, 2017, *85*
Black Mother Hen, 2016, *69*
blood, cooking with, 142–43
Blue Chicken, 2016, *194*
Blue Cock, 2016, *155*

The Blue Cockerel, 2020, *10*
Blue Rooster, 2019, *182*
Boston, MA, 166–68
Boston University, 168, 170–74
bota bags, 111
Bourg-en-Bresse, France, 11, 35
"bourgeois cooking," 213
Brazier, Eugénie, 31
Bresse, France, 3
Bresse Chicken, 2016, *197*
Bresse de Bény breed, 3–6, 64
Brillat-Savarin, Jean Anthelme, 3
buclé (foot-cleaning method), 147

California
 Berkeley, 188–89
 Los Angeles, 123
capitaine, cooked Senegalese-style, 143–44
Carême, Marie-Antoine, 116
Carson, Johnny, 162
Ceremonial Rooster, 2017, *47*
Chef Cullet, 51–52
Chef Jauget, 35–45
Chicken and Cabbage, 2020, *43*
Chicken and Eggplant, 2020, *54*
Chicken and Herbs, 2019, *160*
Chicken and Herbs 2, 2020, *24–25*
Chicken and Leeks, 2020, *34*
Chicken and Treviso, 2020, *58–59*
Chicken and Vegetables, 2021, *28*
Chicken and Vegetables 2, 2021, *108*

Chicken and Vegetables 3, 2021, 203
Chicken and Vegetables 4, 2021, 204
Chicken Cook, 2021, 38–39
Chicken Goddess, 2018, 22
Chicken Heads, 2013, 132
Chicken Heads 2, 2019, 218
chicken potpie, mass producing, 93–99
chicken recipes
 Arroz con Pollo, 106–7
 Banker's Chicken, 148–50
 Basic Chicken Stock, 42
 The Best Chicken Salad, 124
 Bichon's Grilled Chicken, 129
 Chicken Bercy, 101
 Chicken Bouillabaisse, 30
 Chicken Breast à la Susie, 166
 Chicken Chasseur, 77
 Chicken Cracklings, 134
 Chicken Foie Gras, 151
 Chicken Kiev, 157
 Chicken Liver Mousse, 154–56
 Chicken Neck Sausages and Fricassees,
 140–41
 Chicken Quenelles, 27
 Chicken with Vinegar Sauce, 29
 Chimichurri Chicken, 106
 Coq au Vin, 142
 Cousin Merret's Chicken Liver "Cake,"
 26–27
 Cream of Chicken Soup Potagerie, 122
 Enraged Chicken, 146
 Gizzards, Gizzards, and More
 Gizzards, 138
 Grilled Chicken, 52
 Julia and Jacques's Dueling Chickens,
 165
 For a Liver Lover, 150–51
 Maman's Chicken, Three Ways, 18–19
 Mr. Aicardi's Roasted Poularde, 76
 My Home Version of HoJo's Southern
 Fried Chicken, 90
 Nathalya's Jamaican Curried Chicken,
 183–84
 Petite Marmite from Le Meurice, 140
 Poularde à la Néva, 115–17
 Poulet Pavillon, 84
 Roast Chicken with Winter Vegetables,
 56

 Russian Tea Room Mousse, 157
 Salade Bressane, 159
 Senegalese Blood Sausage, 143
 Spicy Chinese Chicken Feet, 146
 Tarragon Chicken, 46
 The Ultimate Meal, 170–71
 Whole Chicken Baked in Bread, 14
chickens
 black-skinned (Silkies), 128
 blood, 142–43
 "bonus" ingredients from, 133
 Bresse de Bény, 3–6, 64
 broody hens, 18
 Chinese silk, 128
 cooked in a pig's bladder, 31
 cooking for every occasion, 213–14
 cooking in clay, 12–14
 deboning, 162–63
 different meanings in French, 2
 embryonic, 184–87
 Estaire, 64
 eviscerating, 35
 factory-farm laying hens, 179
 Faverolle, 64
 feet, 146–47
 gallbladder, 150
 gizzards, 135, 138–40
 Houdan, 64
 La Flèche, 64
 livers, 150–59
 loose, capturing, 11–12
 making stock from carcass, 134
 neck bones, 140–41
 organic free-range hens, 7–8, 179
 "oysters" on, 148
 plucking, 35
 pope's nose or tail, 141
 rendered fat from, 135
 roosters, 1, 2, 183
 slaughtering, 18
 universality of, 214
Chickens and Snail, 2016, 172–73
Chicken with Artichoke, 2020, 181
Chicken with Carrots, 2020, 57
Chicken with Onion and Garlic, 2020,
 16–17
Chicken with Pear, 2020, 180
Chicken with Squash, 2020, 113

Child, Julia, 161–68, 208–9
Chinatown, 125
Chinese silk chickens, 128
Christopoulos (HoJo chemist), 91
Claiborne, Craig, 103–4, 115
clambakes, East Hampton, 103–4
Classic French Cooking (Time-Life
 Books), 115–17
The Classic Cock, 2017, *114*
Claudine (daughter), 21–23, 129, 168
Claudine's Book, 2013, *92*
Cock and Snails, 2016, *4–5*
Cock on Board, 2013, *87*
Cock on Yellow Background, 2016, *32–33*
The Cock, 2013, *xxvii*
Cock Too, 2016, *44*
Cocorico, 2016, *xxviii*
cocotte (term of endearment), 2
cocotte minute (pressure cooker), 2
Concise Encyclopedia of Gastronomy
 (Simon), 6
Connecticut, xi, 154
cooking, ritual of, xix–xx
"country cooking," 213
Cullet, Chef, 51–52
Curious Chicken, 2017, *209*

Dakar, Senegal, 142–46
Dallas, TX, 99–100
Dancing Rooster, 2019, *191*
Dandy Cock, 2017, *186*
Darr, Sally, 122
David, Elizabeth, 7, 31
De Gaulle, Charles, 77
De Gaulle, Yvonne, 77
Denizot, Monsieur, 42, 45

East Hampton, Long Island, NY, 103, 192
Échezeaux wine, 100–101
egg recipes
 Classic French Omelet, 205–6
 Country-Style Omelet, 202
 Deep-Fried Eggs, 196
 Eggs Benedict, 72
 Eggs en Cocotte, 189–90
 Eggs Jeannette, 188
 Hollandaise Sauce, 72
 Maman's Eggs Gratinée, 187

 Mirror Eggs, 196
 Oeufs en Gelée, 190–92
 Omelet Pavillon, 206
 Omelette Fines Herbes, 208
 Omelet with Caviar, 208
 Poached Eggs in Red Wine Sauce, 201
 Poaching 101, 200
 Scrambled Eggs Done Right, 195
 Snow Eggs, 68
 Spanish Omelet and Italian Frittata,
 205
 The Very Best French Toast, 65
 Western Omelet, 202–5
eggs
 from factory-farm laying hens, 179
 hard-cooked, serving ideas, 189
 hard-cooking, note about, 183
 integral but unnoticed role in recipes,
 178
 in literature, 177–78
 omelet cooking methods, 202–9
 from organic free-range hens, 7–8,
 179–82
 ostrich, 208–9
 as the perfect food, 178
 in shell, differentiating raw from hard-
 cooked, 183
 testing freshness of, 182–83
 versatility of, 6–7
Eggs 1, 2020, *201*
Ellis, Alice Thomas, 177
Escoffier, Georges Auguste, 27, 72, 205
Everyday Cooking with Jacques Pépin
 (Pépin), xi

false morels, 21, 23
Fanciful Chicken, 2019, *136–37*
fat, rendered, 135
feet, cooking with, 146–47
fish, cooked Senegalese-style, 143–44
Flower Chicken, 2018, *193*
food safety protocols, 90
food science and chemistry, 90–91
Foods of the World Time-Life series, 115
France
 Aix-les-Bains, 51
 Bellegarde, 55
 Bourg-en-Bresse, 11, 35

Bresse, 3
Gascony, 134, 135
Lyon, 26, 30, 31
Miribel, 129
Neyron, 14
Paris, 60–65, 75–77
Franey, Pierre
　East Hampton home, 103–4
　hires Jacques at La Pavillon, 83
　Peking chicken prank, 125–28
　work at Howard Johnson's, 84, 86
　work on *Classic French Cooking,* 115
French "bourgeois cooking," 213
French "country cooking," 213
French Culinary Institute, 125
French Navy, 71–77
French Provincial Cooking (David), 7
French Room restaurant, 100–101
The French Chicken, 2016, *215*
Frenzied Chicken, 2020, *156*
Futuristic Rooster, 2019, *80*

Gaillard, Félix, 75
gallbladder, 150
Gallic roosters, 2
Gascony, France, 134, 135
Gaston (miniature poodle), 134
Giobbi, Edward, 12–14
gizzards, 135, 138–40
Gloria's French Café, 154
Gourmet magazine, 122
Grape Chicken, 2020, *169*
Grimod de la Reynière, Alexander-
　　Balthazar-Laurent, 178
Guérard, Michel, 195
Gyromitra (false morels), 21, 23

The Harried Chicken, 2016, *212*
Hélène (aunt), 21
Heller, Susie, 166
Hen Plate, 2000, *63*
Henry IV, King of France, 6
hens
　broody, 18
　factory-farm laying, 179
　organic free-range, 7–8, 179
Hippie Cock, 2017, *149*
Hoover, Herbert, 6

hotels
　Adolphus, 100
　Le Meurice, 62, 140, 206
　L'Hôtel d'Albion, 51–52
　L'Hôtel de la Gare, 55–56
　L'Hôtel de l'Europe, 35–49
　L'Hôtel l'Amour, 15
　L'Hôtel Matignon, 75, 77
　Plaza Athénée, 62–65, 128, 148, 163,
　　196, 200
Howard Johnson's, 84–99, 120

Imperial Chicken, 2020, *131*
Imperial Rooster, 2019, *211*
The Irate Mother Hen, 2020, *13*
Italian Family Cooking (Giobbi), 12

Jauget, Chef, 35–45
Johnson, Howard, Jr., 120
Johnson, Howard, Sr., 84–86
Julia and Jacques Cooking at Home, 166,
　208–9

Kaye, Danny, 122–24
Kennedy, Jack, 83, 99
Kennedy, Joseph, 83
King Henry IV, 6
The King of the Coop, 2018, *x*
Kitchen Chickens, 2017, *175*
KQED, 166

La Folie, 195
La Grande Cocotte, 2017, *73*
La Mère Brazier, 31
La Pépinière, 75
La Petite Auberge, 129
La Potagerie, 120–22
Larousse Gastronomique, 178
Lars (mushroom forager), 23
L'Art Culinaire Moderne (Pellaprat), 75
Leaning Chicken, 2013, *48*
Le Coq Galois, 2021, *88–89*
Le Guide Culinaire (Escoffier), 72
Le Meurice hotel, 62, 140, 206
Le Pavillon, 81–84, 206
Le Pélican, 109
Le Petit Café, 26
Les Halles, Paris, 64

les mères de Lyon, 31
Les Poulets, 2014, 78–79
Les Prés d'Eugénie, 195
Lévi-Strauss, Claude, xix
L'Hôtel d'Albion, 51–52
L'Hôtel de la Gare, 55–56
L'Hôtel de l'Europe, 35–49
L'Hôtel l'Amour, 15
L'Hôtel Matignon, 75, 77
livers, cooking with, 150–59
lobster, American, 104
Los Angeles, CA, 123
Lunatic Chicken, 2019, 97
Lyon, France, 26, 30, 31

Madame Saint-Oyant, 55–56
Madison, CT, xi, 154
Maman (mother)
 chicken slaughtering method, 140–41,
 142
 cooks at L'Hôtel l'Amour, 15
 coq au vin made by, 142
 egg gratin made by, 187
 Eggs Jeannette made by, 188
 Le Pélican restaurant, 109
 poule au pot recipe, 18–19
 poulet à la crème recipe, 19
 riz au gras recipe, 19
 Spain vacation, 109
ma poule (my hen), 2
Massachusetts, 166–68
Menus (Pépin), xii
Merret (cousin), 26–27
Merry Rooster, 2019, 20
Mighty Fowl, 2018, *102*
The Militant Chicken, 2018, *xxvi*
Miribel, France, 129
mon poulet (my chicken), 2
Monsieur Aicardi, 75–76
Monsieur Denizot, 42, 45
morels, false, 21, 23
Mr. Piper, 2016, 53
Mrs. Legrand Benedict, 71
mushrooms, toxic (false morel), 21, 23

Nathalya (CT neighbor), 180, 182
Navy, French, 71–77
neck bones, 140–41

New England clambakes, 103–4
New York
 East Hampton, Long Island, 103, 192
 New York City, 81–84, 120, 125, 157
New York Times, 103
Neyron, France, 14

oeufs bénédictine (eggs Benedict), 71–72
oeufs en gelée (eggs in aspic), 192–95
oeufs miroir (mirror eggs), 196
omelet cooking methods, 202–9
ostrich eggs, 208–9
"oysters," chicken, 148

paella, 111
paintings. *See also specific paintings*
 creative process, xxi
 as expression of human enlightenment,
 xix–xx
 ideas for, xxi
 list of, viii–ix
Palais des Tuileries, 75
Papa (father), 15, 109–11
Paris, France
 early cooking jobs, 60–65
 Navy cooking jobs, 75–77
Passot, Roland, 195
Paulette (waitress), 109
Pellaprat, Henry Paul, 75
Pépin, Bichon, 109, 128–29
Pépin, Gloria
 arroz con pollo made by, 106
 chicken liver mousse made by, 157
 and chicken livers, 151
 and chicken necks, 141
 and eggs and caviar, 208
 and eggs en cocotte, 190
 Eggs Jeannette variation by, 188
 last-minute dinner parties, 213
 and *mollet* eggs in aspic, 190
 parents of, 106
 and pope's nose, 141
 recording studio job, 192
 restaurant run by, 154
Pépin, Jacques
 The Art of Cooking, xi, 124, 166
 childhood, 11–18
 Classic French Cooking, 115–17

cooking and friendship with Julia,
 161–68, 208–9
cooks at Gloria's French Café, 154
cooks at Le Pavillon, 81–84
cooks at L'Hôtel de la Gare, 55–56
cooks for Charles de Gaulle, 77
early chef jobs in Paris, 60–65
Everyday Cooking with Jacques Pépin,
 xi
family vacation in Spain, 109–11
French Navy chef jobs, 71–77
Howard Johnson's years, 84–99
Julia and Jacques Cooking at Home
 TV series, 166, 208–9
launches La Potagerie, 120–22
L'Hôtel de l'Europe apprenticeship,
 35–49
Menus, xii
saison at L'Hôtel d'Albion, 51–52
teaches at Boston University, 170–74
teaches at French Culinary Institute,
 125
trip to Dallas, 100–103
website, xii
weekends in East Hampton, 103–4
Pépin, Roland, 71, 109, 142
peppers, hot, 146
piment enragée (enraged pepper), 146
Pineapple Chicken, 2020, 82
Plaza Athénée, 62–65, 128, 148, 163, 196,
 200
Polka-Dot Cock, 2017, 158
pomme cocotte (potato dish), 2
pope's nose, or tail, 141
Poulet and Legumes, 2020, 198–99
Poulet de Foissiat, 2017, 74
poulet en vessie (chicken cooked in pig's
 bladder), 31
poultry fat, 135
Proud Rooster, 2013, *xviii*
The Proud Cock, 2021, 167
Proust, Marcel, 1

Ranhofer, Charles, 71
recipes. *See also* chicken recipes; egg
 recipes; *separate recipe index*
 as conduit to memory and imagination,
 xxiv

creative process, xxi
 ideas for, xxi
 narrative style, xxv
 range of ingredients, xxiv
Red Chicken, 2016, *141*
The Refined Chicken, 2020, *216–17*
Reflecting Rooster, 2019, *50*
rendered fat, 135
Répertoire de la Cuisine (Escoffier), 205
restaurants
 French Room, 100–101
 Gloria's French Café, 154
 Howard Johnson's, 84–99, 120
 La Folie, 195
 La Mère Brazier, 31
 La Petite Auberge, 129
 La Potagerie, 120–22
 Le Pavillon, 81–84, 206
 Le Pélican, 109
 Le Petit Café, 26
 Les Prés d'Eugénie, 195
 Russian Tea Room, 157
retort sterilization, 90
Robert (fellow apprentice), 60
Rollie (son-in-law), 21–23, 134
roosters
 crowing at sunrise, 1
 Gallic, 2
 symbolism, 2
 used for stews, 183
The Rooster King, 2017, *210*
Rooster and Chick, 2018, *105*
Royal Rooster, 2017, *70*
Russian Tea Room, 157

Saint-Oyant, Madame, 55–56
Saturday Night Live, 162
School of Hospitality and Hotel
 Management, 168
Screaming Rooster, 2017, *145–46*
Senegal, 142–46
Shadow Cock, 2017, *66*
Shorey (granddaughter), 23
Silkie breed, 128
Simon, André, 6
Snyder, Tom, 161
Sot l'y laisse ("the fool leaves it"), 148
Soulé, Henri, 81–83

Spain, 109–11
Startled Chanticleer, 2019, *121*
Stately Chicken, 2017, *139*
Stylized Chickens, 2016, *118–19*
Stylized Rooster, 2017, *110*
Sumptuous Rooster, 2018, *123*
Super Chicken, 2017, *112*
Surprised Cock, 2017, *207*
Szurdak, Jean-Claude, 23

tapas, 111
The Tattle Cock, 2017, *67*
Tender Chicken, 2019, *130*
Three Chickens, 2016, *xxi–xxiii*
Three Chickens of Bresse, 2021, *94–95*
Time-Life *Foods of the World* series, 115
Tolkien, J.R.R., 178
Tomorrow Show, 161
Tonight Show, 162
Tower, Jeremiah, 189
Tufted Cockerel, 2018, *60*
The 27th Kingdom (Ellis), 177–78
Two Hens, 2016, *126–27*

Ultimate Meal class, 170–74
Untroubled Chicken, 2019, *9*

Vietnam, 184
vol au vent financière (banker's chicken),
 148–49

Wacky Chicken, 2019, *98*
Waters, Alice, 189
West Africa, 142
wine
 Échezeaux, 100–101
 Spanish, 109–11
wineskins, 111

Yellow Mother Hen, 2016, *176*
Yugoslavia, xxiv

zakuski (Russian hors d'oeuvres), 157
Zimmerman, Gloria, 154